MONEY-MAKING PHOTOGRAPHY
By Bill Hurter

Cover photograph by
Bill Hurter. Cover design
by Al Isaacs.

MIKE STENSVOLD
Coordinating Editor

BOOK DIVISION
Erwin M. Rosen
Executive Editor
Spencer Murray
Senior Editor
Al Hall
Editor
Dick Fischer
Art Director
Chriss Ohliger Jay
Managing Editor
Jim Norris
Managing Editor
Eric Rickman
Photo Editor
George Fukuda
Assistant Art Director
Kathleen Zawrotney
Editorial Assistant

With photography, as with many other hobbies, very often the satisfaction of involvement is sufficient reward. But the challenge to artistic creativity in producing outstanding photos can be heightened when the aim is to have someone purchase your pictures—it seems to merit special laurels for your skill as a photographer. This book will help you add that dimension to your photographic accomplishments.

In these days of increasing costs for film, equipment and chemicals, it becomes especially practical to have your hobby help pay for itself. If this soon begins to border on a successful part-time business, so much the better for your ego—and your wallet.

The bridge from hobbying to earning is a short one actually, and quite easy to cross. A glance at the table of contents on the opposite page will reveal many likely avenues as you venture forth from the realm of the artiste into the world of the entrepreneur. Your favorite photographic subject areas probably include several such points of departure. With a little study of the insightful tips in the corresponding chapters, you can very quickly be on your way to making money with *your* photography.

(*Money-Making Photography* is one of a continuing series of self-help photo books from Petersen Publishing Company. Look for others in your bookstore or at your photo dealer.)

MONEY-MAKING PHOTOGRAPHY
Vol. 2—Petersen's Photographic Library

By Bill Hurter and the editors of
PhotoGraphic Magazine. Copyright ©1980 by
Petersen Publishing Co., 8490 Sunset Blvd.,
Los Angeles, CA 90069. Phone (213)
657-5100. All rights reserved. No part of this
book may be reproduced without written
permission from the publisher. Printed
in U.S.A.

Library of Congress Catalog
Card Number 80-81784

ISBN 0-8227-4040-0

PHOTOGRAPHIC MAGAZINE
Paul R. Farber/Publisher
Karen Geller-Shinn/Editor
Jim Creason/Art Director
Mike Stensvold/Technical Editor
Markene Kruse-Smith/Senior Editor
Bill Hurter/Feature Editor

Rod Long/Associate Editor
Franklin D. Cameron/Managing Editor
Peggy Sealfon/East Coast Editor
Allison Eve Kuhns/Assistant Art Director
Charles Marah/Far East Correspondent
Natalie Carrol/Administrative Assistant

PETERSEN PUBLISHING COMPANY
R.E. Petersen/Chairman of the Board
F.R. Waingrow/President
Robert E. Brown/Sr. Vice President
Dick Day/Sr. Vice President
Jim P. Walsh/Sr. Vice President, National
Advertising Director
Robert MacLeod/Vice President, Publisher
Thomas J. Siatos/Vice President, Publisher
Philip E. Trimbach/Vice President, Finance
William Porter/Vice President,
Circulation Director
James J. Krenek/Vice President, Manufacturing
Leo D. LaRew/Treasurer/Assistant Secretary

Dick Watson/Controller
Lou Abbott/Director, Production
John Carrington/Director, Book Sales
and Marketing
Maria Cox/Director, Data Processing
Bob D'Olivo/Director, Photography
Lawrence Freeman/Director, Subscription Sales
Nigel P. Heaton/Director, Circulation
Administration and Systems
Al Isaacs/Director, Graphics
Carol Johnson/Director, Advertising Administration
Don McGlathery/Director, Research
Jack Thompson/Assistant Director, Circulation

Money-Making Photography

Introduction

Anyone who loves photography will love this book, because the plain and simple truth is that if you enjoy taking photographs, then you'll enjoy making money from taking photographs even more. That's what this book will show you—how to make money taking pictures.

This book is not for the working professional photographer, the person who makes his living from taking pictures; it is for the person who does something else for a living but who loves to take photographs in his spare time. Many of the techniques described could certainly lead to a career in professional photography, but it is not the aim of this book to inspire a whole new generation of professional photographers.

Rather, the purpose of *Money-Making Photography* is to give the amateur photographer a chance to become more serious about his or her avocation and have more fun taking pictures than ever before. That is, after all, the main reason why all of us got involved in photography in the first place—photography is a lot of fun.

This book will give you a chance to tie in some of your other interests as well. If you enjoy sports, there is a section on making money with your sports photographs. If you like children and enjoy taking pictures of kids, there is a section on that too. Perhaps you will find some new interests you will want to explore as well. There are many interesting areas of photography here to choose from.

If you're thinking that this new-found money won't be free and that you'll end up making sizable investments before you earn one thin dime, you're wrong. This book is geared for the person who has only a minimal amount of equipment. Certainly there are techniques that will require you to spend some additional money on new equipment, and there will be times when you'll want to spend extra money on promoting yourself and your abilities, but that money can come back to you many fold in terms of fun and profit.

You need not be skeptical either about making a profit from something you love like photography. There is a lot of money to be made in photography with simple techniques done on a small scale. The fact that you enjoy

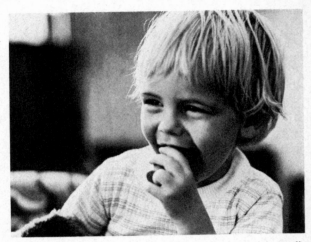

Good photographs of children are a snap to sell. With a minimum of equipment and skill you can set yourself up as a profitable child photographer if you happen to have a knack with kids.

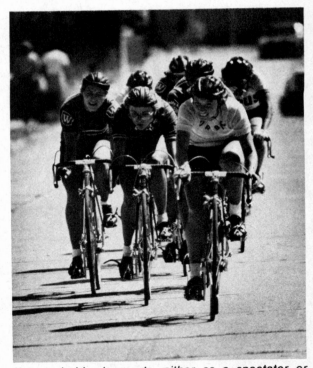

If your hobby is sports, either as a spectator or participant, turn that interest into a money-making sidelight. The more you know about a given sport or activity, the better the photos will be, and the more likely they will be to sell.

The enjoyment of taking photographs is what this book is all about. This scenic night photo could sell in a variety of markets—from a gift photo to an annual report.

what you do is the first step toward making a small business successful.

While some basic knowledge of photography is necessary to perform many of the techniques presented here, the majority of the ideas are simple and are merely extensions of your basic photographic skills. The techniques and procedures are not presented in any order; you can read the last chapter first if you like. You won't be dazzled by a lot of mystical mumbo-jumbo either. The ideas are presented as simply as possible. In addition to technical descriptions—how to master the technique—there are guidelines on competitively pricing your photographs. Inflation and an unstable economy make it impractical to give strict prices to be followed. Instead, I will show how to price your product and how to make a profit in spite of rising prices.

In addition, where applicable, names and addresses of suppliers and distributors are given. In fact, a whole section has been de-voted to gimmicks and gadgets that are imaginative photographic money makers. Also, where possible, I have made reference to other photographic source books and magazines for the purpose of rounding out or expanding a given photographic technique.

With each technique will also come an overview of the type of market you will be dealing with—who your potential customers are, how to interest them in your product or service, and finally, how to make sales and how to get repeat sales.

You don't have to be proficient at all the techniques outlined here. Pick only those that interest you. Practice the techniques, study the pricing outline, and then try your hand at selling. Beyond the basics though, have a good time with the techniques—they will not only help you enhance your photographic horizons and provide you with hours of unparalleled enjoyment, but you will make money doing something you love—taking pictures.

Business and Pricing

The reason why most amateur photographers don't make money with their cameras is that they don't treat photography as a business. If you can deliver quality results, consistently and promptly, why shouldn't you be rewarded monetarily? After all, people won't respect you or your work if you are afraid to charge a decent price for your efforts.

Even though your photography is a part-time venture, your main income coming from elsewhere, you must treat it as a business if you are going to make one thin dime. This chapter will tell you how to think in terms of costs vs. prices and help you to avoid that cardinal sin in business—charging less for your product than it cost you to produce.

Getting Started

Two things that will help a great deal in establishing your business acumen are knowledge of photographic costs and the ability to judge the cost of your time and work. Both of these things come with experience, but you will achieve a better business sense in a shorter period of time if you keep records of your photographic experiences. Business is not magic; it can be predicted and it is painfully logical.

The first thing you must ask yourself before you embark on your free-lance business is, do I have enough equipment to do the jobs I will be advertising? Some small businesses require nothing more than your camera and a flash, like wedding photography or photographing real estate, but if you decide to set yourself up as an inexpensive lab offering the services of processing, proofing and printing, then you'd better have all the equipment you need beforehand. If after you have decided to advertise your services in one particular field you discover that you need several hundred dollars' worth of equipment, you will be bankrupt before your business gets off the ground.

It goes without saying that you should also be very good at the particular discipline you are interested in and have confidence in your skills. You can't expect a potential client to believe in you if you're not sure of your own abilities.

You should also be well versed in the outside photo services you will need: who your suppliers will be, the labs or retouchers you will use, etc. Know their prices and know them. Tell them what you are planning to do and ask their advice, and also tell them that you are planning to use their services exclusively and find out if any discounting will be possible.

Be as familiar as possible with peripheral

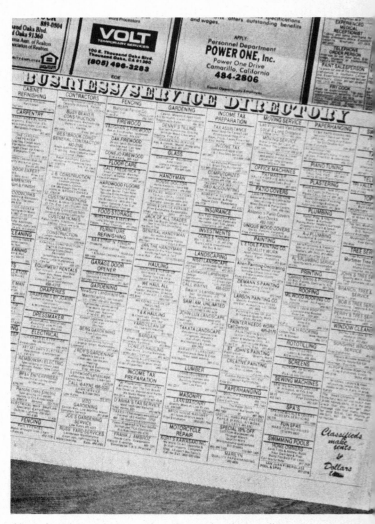

Your local newspaper often has a business directory such as this one in the classified advertising section. It is a great way to advertise your services and will inexpensively provide your fledgling business with much needed visibility.

photo and business services that you might think you will need. For instance, if you will be using a specific brand of enlarging paper, know the competition and plan on the day when you may not be able to get your favorite brand. Also, make a few phone calls to printers, framers or advertising agencies. Call these people you may not deal with directly but with whom your potential clients might deal. Get to know how they operate and what their services are by merely asking them a list of general questions over the phone. Don't be afraid to ask the occasional stupid question; you won't find out unless you ask.

You will also need some office supplies—the basics being stationery, envelopes, rubber stamps, and a typewriter. Later you might need things like invoice forms and personalized letterhead and business envelopes. A good initial investment is a box of 500 business cards. They are cheap to have made and printers have hundreds of beautiful type faces from which to choose. It looks pretty ridiculous to give a potential customer a piece of paper with your name and number chicken-scratched on it. A business card sits on desks and tables and is free advertising for you and your business. If you're not sure what you want to call your business or even if you want to call it anything, just have your cards printed up with your name and what you do; for instance, Horace Schmudlapp, Photographer. Have your home address and your phone number and anything else pertinent, like portraits or weddings or real estate photography. Ask the printer to help you choose something that is catchy looking but yet fits your personality. You can also have these made in different colors and on different paper surfaces and stocks.

Promotion and Advertising

Once you have all the photographic equipment you think you'll need and your business supplies are intact, you are ready to put out some feelers and start promoting your services. For this you will need to invest a few dollars in well-placed ads in local newspapers and shopping circulars. You will also need to do some running around to community centers, grocery stores and supermarkets, local colleges or any place that has a public bulletin board. I have always been fond of the laundromat for promoting my services. People have nothing to do but wait for their clothes, not what you'd call a highly enjoyable activity, and they will be receptive to messages of services offered.

Supermarkets are also good because many have large well-placed bulletin boards with current material. Make up some colorful cards with attractive printing and maybe even a drawing, state your services and fees if applicable, and give your name and phone number. It helps if the phone number is larger than the other type. These can be professionally done like your business cards or they can be hand-done; you be the judge. It all depends on what you want to spend.

For your newspaper ads, make a few calls and find out what space rates are and/or if the publication has a classified section. Most local papers do and they are quite reasonable. Some papers, like my local paper, have a regular classified section and then in addition, have a special business/service directory of classified advertising. This is a great place to advertise your photographic services because it is a small, specially bordered section of the newspaper and it features the ads broken up according to category, like "Photographers" or "Piano Tuners."

To give you an idea of what this might cost you, I live in a town of 80,000. The paper is *the* local newspaper and the space rate for this special section is $23.40—for 26 days worth of consecutive ads! Not bad. Of course, in different locales you will pay more or less, and in big cities you will have the additional problem of your ad getting lost in a huge classified section and have to pay high rates on top of that.

Once a business contact has been made, allow yourself enough time to do the job properly and to deliver the work promptly. If the job is a wedding for instance, make sure you have enough time to order your supplies and that your lab will be able to deliver the prints within the time alloted by your customer.

Make sure that if the job is a large one like a wedding, you make some arrangements for gradual payment. Have the person leave you

a deposit, say ⅓ to ½ of the anticipated price, when the agreement is made. The other half will be payable upon delivery. This helps defray expenses and also commits the customer to a sale, something that may not be established 100 percent unless he or she has parted with some of his or her hard-earned cash.

Keeping Records

Maintain records of all your business expenses. Keep track of each job by assigning it a number, then record all the monies taken in and paid out for that job and keep it all in one safe place. Eastman Kodak, in the *Encyclopedia of Practical Photography* (published by Amphoto), advises that you give each job a number, by year. For instance, 79-21 would be the twenty-first job you did in 1979. They further recommend you keep track of all expenses, income, payables (a list of expenses to be paid by you), receivables (money owed you), taxes (like sales tax), and overhead (a figure that must be computed over an average period of time or average number of jobs). Information like that from each job, when compared to the same information for other jobs and evaluated over a period of time, will help you determine how your business is doing and will also allow you to predict, to some degree, how your business will do in the coming months.

If you are going to be doing enough jobs in one year to warrant keeping detailed records, you will probably be making enough money to need a tax consultant. The money you make will be taxed as income but the expenses of running and improving your business can be deducted from your taxable income.

Taxes

Since federal and local governments require you to pay taxes on earned income, it is a good idea to get into the habit early on of keeping detailed records of your expenses and income. A simple notebook or ledger is all that is needed, and a little time spent in entering each and every assignment will fulfill your bookkeeping requirements.

You can deduct (from your taxable income) virtually every expense made toward the operation of your small business. All supplies and materials and equipment are deductible in full for that year. In addition, camera or darkroom equipment may be depreciated over a period of time (usually 5 to 10 years) and a deduction taken each year of that period. Mainte-

nance of your equipment is also a deductible item. Travel expenses to and from locations or to pick up supplies or props are all deductible to the tune of 17 cents a mile (this is a 1979 figure and may change with rising fuel prices). Simply keep track of your traveling accurately with gas receipts and mileage reports in a small notebook in your glove compartment.

If you become involved sufficiently to warrant putting aside entire rooms in your home or apartment for your business, this too is a legitimate deduction provided that the room(s) are used for no other purpose than your business. For instance, if you have a seven-room house and one of those rooms is a darkroom/studio/office or any one of the above, at tax time you could deduct 1/7 of the yearly totals for your gas, electric, rent, utilities, etc. You can also deduct business phone costs if accurate records are kept. It is advisable to check with your local Internal Revenue Service office, or your tax preparer, for clarification of your particular situation.

Camera insurance is also a deductible item as is your liability insurance. If you are an amateur making money with your cameras in your spare time, you can usually get a floater under your home owner's or renter's policy. However, if you are a professional, or are engaged in making money with your cameras when the equipment is lost or stolen, you may not be able to collect under your floater policy, and may need a special policy written specifically for your equipment. These professional's policies tend to be very expensive and not all that practical if you are only doing a small business. However, remember, it is a deductible item.

Be advised that if you start doing well and making good money, you will be in for a surprise at the end of the year when you must pay taxes on that income. Many photographers in that situation pay taxes quarterly or estimate their taxes and pay Uncle Sam that way. These estimates are usually on the high side, which is to your benefit since the difference will be subtracted from what is due at year end and the remainder refunded.

Licenses and Restrictions

In some areas of the country you may need a resale license or a business license to operate as a business man or woman. As a result of having that license, you may also be asked to charge sales tax to clients and in turn pay it to the state. Even if you are only a small

operation just doing spot jobs here and there, investigate the proper fees or licenses. It's better to be safe than sorry, and if you begin to do very well and cut into the trade of other local photographers, your competition will see to it that you are properly licensed.

In addition to a license, if you are taking photos for publications, get model releases; if taking photos of private property, get the proper permissions in writing. The only time you don't need model releases is when you are working for a strictly news-oriented publication or service and the photo's use will be construed as the covering of a newsworthy event. For just about every other application, a model release is required. This is for publication and any commercial application such as advertising or endorsement. There are a few gray areas where a release may not be required such as in a crowd situation and at a public event, but interpretations will tend to be in favor of a person's right of privacy. Forewarned is forearmed, so get a release and avoid complications later.

If you do a lot of portraits of children or pets, get a release signed at the time you deliver the prints. Say it is a matter of policy with you as you never know when someone will want to display your work or have it appear in a publication. A good general purpose release is as follows:

"I, _____ , hereby consent to and authorize the use of any and all photographs taken of me by you this day (or date) for reproduction by you or anyone authorized by you."

While this is very general, it gets across the central point that this person is giving you permission to use his/her likeness for general publication or display. If the photos are used for advertising, some compensation must be given the individual but you can modify your basic release to cover any contingency. The release should show your name as the photographer, and it should be dated, signed and witnessed. Your signature and the model's (self or guardian's) signature should also appear on the release.

Pricing

When you are just starting out, pricing is a hit-or-miss affair but it is probably the most crucial feature of running your own business. I have heard stories of major corporations going broke because they weren't charging enough for the product they sold. If it is easy enough for a large corporation to go bankrupt because of improper pricing, imagine how easy it will be for an individual. Although the variables affecting sales are much more complicated at the corporate level, the fundamentals are the same. A product or service's cost to the consumer or client should be determined by the following equation: costs plus overhead plus profit equals price. It's as simple as that. If you keep track of what a job costs, what it costs to run your business, and then add a margin of profit you think is reasonable, you will have a good price for your product.

Let's examine what kind of costs you will incur in your small business. First of all you have the obvious costs like supplies to do the job, lab fees, prop or model rental, retouching fees, etc. These are fees directly chargeable to the specific job. You will also have incidental costs like traveling expenses, food and lodging if necessary, and so on. In addition you will have costs that come under the heading of overhead. These are the costs of office supplies (remember your beautiful business cards and stationery?), postage, advertising and promotion, licenses, etc. These costs are not so obvious. They are hidden but should and must be reflected in the price of the

Legal-size file drawers are great for filing slides, negatives, contact sheets, job sheets and billing invoices. Slides can be stored in transparent sleeves along with the job information.

product or you will lose money.

Don't forget about a profit. This is not the cost of your time. Your time has a value that should be computed into the total costs, but a profit is something that is added on over and above the costs and the cost of your time.

With your small-scale photo operation, you can make on the order of a 15 to 20 percent profit or more depending on what the market will bear. In addition to that, every time you take your film to a lab or buy an album for a customer, you should be making money on that too. If your cost for an album is $15, charge the client $20 or $25. After all, your time is valuable, is it not? In a company with many divisions, each division is expected to turn a profit, so each facet of your small business should be making a profit and should not represent lost or wasted effort.

These small hidden profits are essential to the profitable running of your business. Take the example above; if it takes you an hour, start to finish, to go to the camera store, pick out the album and drive home, this is one hour subtracted from your daily hours of total productivity. If you drop a customer's film off at the lab, it might be another half hour. Surely you will charge for running around and travel costs, but shouldn't you also be reimbursed for the time you could have spent promoting yourself or cultivating new clients? That is why you must mark up these items and then pass that cost and markup onto the customer.

Let's figure out a hypothetical price for a hypothetical job. Say, for instance, you are asked to shoot a wedding and the client wants to know what you'll charge. This might be a brief rundown of your thinking:

Film for shooting $25
Processing and proofing
costs ... $25
Travel costs $15
Shooting time @ $15 per
hour ... $30
Printing lab costs*** $50
Album*** $25
Postage and delivery $5
Overhead* $29
Profit** .. $41
TOTAL .. $245

* Overhead here is figured by taking 20 percent of your fixed costs for the job. This does not include the amount you charge for your shooting time. It covers your operating costs and your running-around time, and encompasses those "hidden profits" talked about earlier.

**Profit is figured by taking 20 percent of the total; that is, costs plus overhead.

***On the cost of these items and services, you are adding a 100 percent markup to cover the time and effort to obtain them as well as the expertise needed to coordinate the several activities.

So, how much money will you end up stuffing into your pocket after this assignment? Your profit is $41; that is free and clear. Your wage for shooting the wedding is $30; this is your salary for the afternoon. The markup on printing and album costs nets you $25 and $12.50, which comes to $37.50; these are hidden profits but cost related. You charged $29

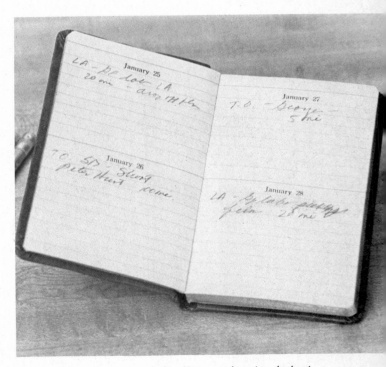

A travel log is a necessity if you plan to deduct your business on your income tax return. It will also help you keep track of your time and how much you spend on your business. Record your point of departure as well as your destination, the mileage and the reason for the trip.

for overhead and depending on how small and/or how expensive your business is to operate, you may end up keeping at least some of that figure. The total you can stuff into your pocket is $108! Not bad for an afternoon. And, if your overhead is low, you will take in even more.

You must realize that businesses are ongoing ventures. For instance, you cannot take your profits midstream unless you are planning an early retirement. You must plow some of those profits back into promotion, maintenance and expansion of your business if you want it to prosper.

The foregoing must be considered your *estimate*. It sounds pretty involved but it is not really that difficult to figure out. If for some reason, your costs vary—prices happen to go up for one or more items, or the client orders more than is expected initially—the price will change. However, it shouldn't change that much if you have done your homework and the prices of your costs are current. You will find that even if your final figure varies by as much as 10-15 percent, most people won't quibble, although it's always best to come as close as possible.

You can establish prices for every photographic endeavor using this line of thinking.

Large numbers of negatives can be stored in cardboard boxes such as these. Negative strips are stored in individual 35mm sleeves while the entire roll (4-6 strips) is stored in a larger 120-size glassine sleeve. The outer sleeve contains the negative information such as job number, subject and date. The three boxes you see here will conveniently store 175 separate rolls of film.

Just remember to add your costs, including your time, plus your overhead, plus your profit—and you will come up with a satisfactory price for any job.

Remember that whatever time you spend working on a given job should be charged as a cost to that job. Keeping a work sheet for each job will help get you in the habit of better analyzing your costs.

Other Fees

In addition to your shooting fee, which is obvious, jobs will have other ways for you to expend effort and thus charge a fee. For instance, maybe a job calls for special printing or processing which you must either perform yourself, or supervise. You really can't charge your full shooting fee for this time, so charge less—say your fee minus 25 to 40 percent depending on the job. This ensures you won't be losing money by spending time in the darkroom.

Another way photographers lose money on jobs is when they are called to a job and forced by circumstances to wait before shooting. A way to get around that and also to speed up the procedure altogether is to charge a waiting or stand-by fee that covers your time while you are waiting to get to work.

Similarly, travel to and from a job is a form of waiting, and many photographers will charge the client a hefty mileage figure—say 40¢ per mile to cover travel expenses and the cost in productivity of your driving.

There will be times when you are called on to research a topic to better photograph it. This often happens when you are photographing architecture and must spend time familiarizing yourself with blueprints or drawings. Many photographers have a research fee that is considerably less than their shooting fees or day-rate hourly wage, but nevertheless, covers their valuable time.

Consultation with clients would also come under this same heading and many photographers will charge for this as well. Take the case of our architectural photographer again. If working on a big job that might include progressive photos, details and final illustrations, it will be extremely important for photographer and architect to sit down and iron out precisely what the client's needs are. This may take hours or just a small amount of time from several days. Keep a job sheet to record telephone calls and visits, and charge by the hour to cover the cost of your time and the

value of your expertise.

Photographers also lose money when a job is canceled at the last minute. It means that by prior arrangement the client has restricted you from getting other jobs. The client should know that if he or she does cancel without prior warning, he or she will be liable for your fee which may be up to half the billing depending on the circumstances. Take for example, the client who contracts a photographer's services for a long period—say a builder or contractor who needs photos three or four times a week for three months. The photographer stops promotional schemes because he or she cannot handle extra work, orders supplies, and gears up in general for a large job. If the client suddenly cancels, the photographer's entire business could be in jeopardy unless he or she was smart and made a provision in the arrangements for such a cancellation.

Modes of Pricing

Photographers have many ways of pricing their services. Some photographers charge a day rate plus expenses. This covers all their costs (i.e., the "expenses" part) and all their profit and overhead in the day rate. The photographer's day rate is arrived at by computing all overhead, photographer's weekly or monthly salary, percentage of profit the photographer works at, and the most crucial variable, the photographer's reputation. Day rates vary from $100 per day to $3000 per day for a very exclusive or specialized photographer. Whatever the photographer is worth and whatever the market will bear is the maximum day rate chargeable.

Day rates usually consist of eight-hour days or half-day rates of four-hour days. Anything over that is considered overtime and charged accordingly, from 50 to 100 percent depending on the individual. Hourly rates are easily computed from the day rate figure.

All expenses are billed to the client and for this reason the client often assumes ownership of the finished material, particularly when the photographer is using color transparencies or when the photographer is working for a magazine or newspaper who has commissioned his talents.

Photographers can get around the sticky problem of ownership by pricing their work per job or per photograph. In this manner, the client is not billed directly for the costs, but rather the costs are incorporated into the charge per job or per photo. The client expects finished photographs, either prints or transparencies, for his money and nothing more.

Generally speaking, the photographer should put a price on everything he or she does, from consultation to driving to printing to the actual shooting. A separate schedule of fees should be worked out for the photographer's time—an hourly rate, or a day rate. Further, all photographic prints or transparencies should have a set value, from the proof sheet to a 4x5 print to a 16x20 print. For everything the photographer does or produces there should exist a separate schedule of prices. Whether the photographer charges by the job or on a day rate basis doesn't matter. He or she can change modes of pricing to meet the demands of the job. What is crucial, however, is that the photographer outline all his or her prices to the client, for both time and product.

Use the simple formula outlined earlier to compute each and every price you charge: costs plus overhead plus profits equal price. You can establish a good price for the smallest order to a largest job in this manner. Experience will aid you as you grow into the business of photography, but one tool I have

Loose-leaf binders are great for storing contact sheets. Simply mark the roll number on a light area of the sheet and number again on the back, punch with a three-hole punch and place in the book. These two books of contact sheets correspond to the 175 rolls of film stored in the cardboard boxes in the previous photo.

found invaluable in determining prices and establishing the overall value of a photographer's service is the *Blue Book of Photography Prices,* published by Photography Research Institute Carson Endowment, 21237 South Moneta Avenue, Carson, California 90745. This book is a subscription service that lists dozens of types of photography from public relations to portraiture to architecture, and gives an overview of the pricing structure within that area of photography as well as a schedule of prices currently being charged—a minimum charge and a maximum charge. The book doesn't tell you what to charge for your work, but it tells you what other photographers are getting for the same work. What makes this book invaluable is that it is a subscription that updates prices often, making it still valuable years after you have purchased it because the information is updated and valid for current-day circumstances.

Filing and Storage

Unless otherwise specified at the outset of a given job, the photographer should retain ownership of the originals; i.e., the negatives. If you shoot original slides for a client, obviously you can't retain the originals, but when you shoot negatives, they should remain in

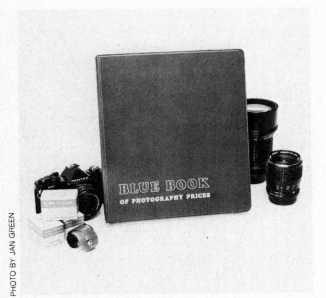

PHOTO BY JAN GREEN

The Blue Book of Photography Prices *is a great way to adequately figure the right price for the job. This is a subscription service that is constantly updating the information so that your prices may be as current as possible.*

your possession. You will be able to charge over and over again for reorders and reprints, and you may want to use the images in your own promotion if they are of excellent quality.

Once you have done a dozen or more jobs you will encounter a real problem native to photographers—filing. Most photographers I know have great big drawers that they use as filing cabinets. If someone calls up and asks for a print, it may take a week to find the negatives. Do yourself a favor and organize a filing system at the very beginning of your business days and you will never have any problems.

You can use a system that will incorporate your numbering system for your jobs. For instance, negative number 79-21-12-34 would be the 34th frame on roll 12 of your 21st job shot in 1979. Where possible, keep proof sheets available in one place and with corresponding job/negative numbers.

For slides, you may only retain duplicates of the originals and you will more than likely weed out the reject slides so that you will have only acceptable material on file. With negatives it is difficult to weed out the bad from the good, but with mounted slides you only have to keep the choice material, thus eliminating wasted space. Number them similarly for reference and repeat a given number only if you have duplicated the slide for your files. If you have precise duplicates from the shooting, number them the same as the ones you delivered to the client.

Whether you shoot slides or negatives, you need an alphabetical file for the client's name and job number. This will help you collate the job numbers with clients, and if someone calls up three years after you did a job, you will still be able to refer back to the alphabetical file to locate the film. You will find that people won't remember job numbers, especially years later. Be prepared, and money gleaned from reprints will be found treasure.

Once you get enough loose negatives, slides and proof sheets, you will want to get some cabinets or boxes that will make your filing a little more permanent. You can buy filing cabinets that will store strips of cut 35mm negatives, and you can use letter-size or legal file drawer cabinets for your slides or proof sheets. Larger negatives can be stored in either 3x5-inch or 4x6-inch file-card cabinets. This affords the slides and negatives some protection from aging and gives you easy access to your work.

Outdoor Portraits

Some of the most flattering and popular types of portraits are those taken outdoors in a beautiful setting. Outdoor portraits are rapidly replacing studio portraits in popularity because people feel more relaxed and enjoy seeing themselves outside more than in a clinical studio setting.

With a 35mm single-lens reflex camera, outdoor portraits are easy to make, but the same control that the portrait photographer uses in a studio must be used outdoors if the images are to be pleasing. In the studio you can control the lights and have them play any role you want. Outdoors you are at the mercy of the sun and sky and the time of day. The trick to outdoor portraiture is manipulating what you have in lighting and environment to make them echo the traditional lighting patterns found in the studio.

Equipment

What you will need in the way of camera equipment to make salable outdoor portraits is very minimal indeed. Your camera and normal lens can be used, although you must watch perspective with the normal lens. A slightly longer than normal focal length is often desirable in portraiture, usually from 85mm to about 135mm for the 35mm format. These short telephotos give a more natural perspective to the human form and aid in separating the subject from a distracting background.

A tripod and cable release are good ideas because they will not only help you steady your photographs but will enable you to concentrate more fully on composition and expression. With a long cable release, you can move away from the camera entirely to direct the subject into the most appealing pose.

Since you are at the mercy of the sun, clouds and time of day, you will also need some means of filling in harsh shadows. You can do this with a small electronic flash or you can bring along some fill cards. The most efficient fill cards are those made by wrapping silver foil (the dull side) on a large (2x2 feet is a good size) mat board or cardboard. The other side of the board can be spray-painted black and used in subtractive lighting techniques that are often very effective outdoors.

More about these techniques a little later.

Film choice is not a major consideration in outdoor portraiture, but you should have several different speed films on hand to meet the changing situations. Generally, you want to shoot at a relatively large aperture to diminish outdoor backgrounds. Usually between f/4 and f/5.6 is desirable unless you are photographing a full-length or ¾ pose of a model where increased depth of field might be needed. The medium- to slow-speed films are usually best for these applications, although there may be times when only a high-speed film will do the trick.

Lighting

The most important element in photographing people outdoors is the lighting. Proper use of available light will make or break a portrait and even if you have pose, expression and background all under control, if the lighting isn't correct, the pictures will be quite miserable.

Oddly enough, the most difficult lighting to use outdoors is bright sunlight. While sunlight amply describes most objects, it alters the shape and features of the human face drastically, creating harsh shadows in the eye sockets and unacceptable overall contrast. The results of portraits made in direct sunlight are anything but pleasing and your client will surely reject your efforts unless you alter the harshness of the light. One method of altering the effects of direct sunlight is to turn the model around and use the direct sunlight as a backlight. The sun will then be coming over the model's shoulders, leaving the face in shadow.

If you let your in-camera meter measure exposures of this type, you will have a very sorry-looking, underexposed portrait. You have to do one of two things. Either you expose just for the shadow area of the face, thus drastically overexposing the hair and shoulders, or you use fill cards or electronic flash to raise the light level of the shadowed face. Your choice may depend on the desired effect. For instance, if you want a high-key effect you may expose just for the face and allow the hair, shoulders and background to burn up (overexpose).

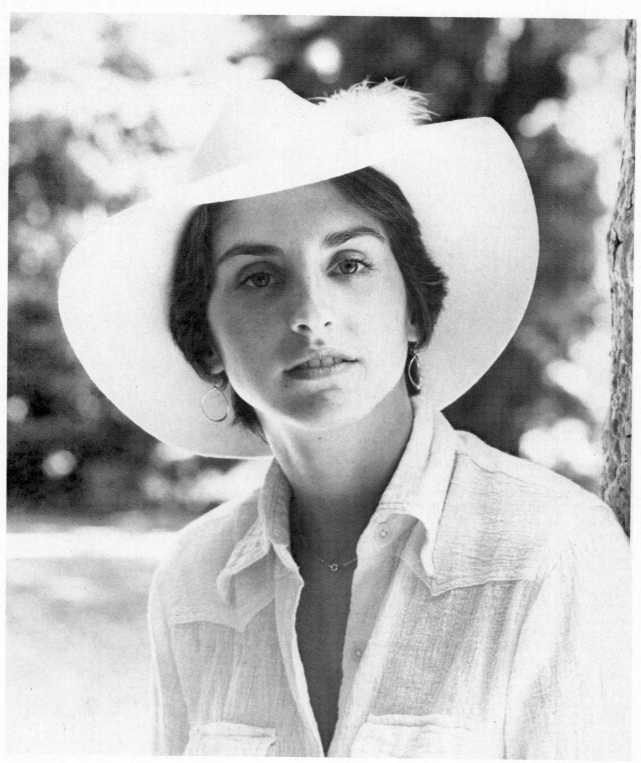

Working near the fringe of the shade is a great way to "catch" some of the bright sunlight without its harsh effects. Here, we set up under a tree that was adjacent to a small grove of trees. Notice the highlight on the model's right cheek. It is caused by the sun bouncing off the surrounding light-colored soil.

Using the sun as a backlight is an effective way to create beautiful outdoor portrait lighting. You must, however, raise the frontal lighting level. Here, that was done with a foil fill card underneath and to the side of the camera.

person sitting in the shade under some trees. Now place your palm about 8-10 inches above their head and about 6 inches in front of the plane of the face. Move your hand in and out and you will begin to see that by blocking the available light you do two things: you cut down on the light intensity, but more importantly, you diffuse the overhead nature of the lighting.

Since you obviously can't place your hand over the subject's head during exposure, this may seem a bit impractical. Instead, use your foil fill card or an ordinary white card and hold it several feet over the subject's head or suspend it there in some makeshift fashion and the effect will be even more pleasing than during your little experiment. With a cable release attached to your camera's shutter release you can sometimes angle the diffusing board into the right spot in the frame without disrupting your composition or actually getting into the picture yourself. The best bet by far

If you want a print or slide with a full range of tones, especially in the background, then you must raise the light level on the face. The easiest way to do this is with the foil fill cards. When using these cards for fill light, direct the light into the subject's face but not from the direction where the subject is looking. This will make them squint.

When using the sun as a backlight you must be particularly careful not to let any sunlight "spill" forward onto the nose. This elongates the nose severely. A little spill light is tolerable on men but only on the cheekbone and around the area of the temples.

You must also be careful to watch for shiny planes on the face. These patches of perspiration seem to develop after about 10 minutes' worth of shooting. Always carry a powder puff and some light pancake makeup and apply sparingly to diminish the shininess. This effect is particularly annoying when photographing women and must be avoided if at all possible.

The soft light of shaded areas is definitely easier to work with than direct sunlight but care must be excercised here as well. In ordinary shade produced by the normal blocking of the sun, the light has an overhead quality to it, and if you do not compensate for the light's direction, your portraits will show people with hollowed-out eye sockets and hollow cheeks. Try this little experiment. Examine a

Watch out for distracting backgrounds like this one. If I had been working at a smaller aperture (creating more depth of field), the effect would have been even more distracting.

is for you to have an assistant or friend along to help you with such things.

Be sure to remeter the exposure after you have included your diffusing board as your light level will be somewhat diminished.

Just because you're working in shade doesn't mean your light should be without direction. In fact, the most pleasing type of soft light is that which shows roundness of the facial planes and seems to be coming from a specific direction. There are several ways you can achieve directional soft lighting. The most obvious one is to look for an area that is just barely shaded. In other words, you will be photographing your subject at just the fringe of the sunlight or just into the shaded area. Here the light will be strongest. Turn your model away from the direction of the light, to the side. Now, you will notice that your soft light seems to be modeling the face, or in other words, since it has direction, it produces subtle highlights and shadows which give the face form and three-dimensionality. The face and figure will seem to have more depth if the light has a definite direction to it.

These fringe areas are ideal, but often you cannot find one with a suitable backdrop. What do you do then? You can use the technique of subtractive lighting mentioned earlier. Subtactive lighting can be seen in reverse whenever you use a white fill card to reflect light into a shadow. The shadow area's overall illumination is raised by bouncing light into it. By using a black card or screen instead of a white fill card, you are subtracting light out of a scene. Looked at another way, you are reflecting black into your shadows and this will lower the shadow light level. Sounds very theoretical, but it really works. If you have a very soft but nondirectional type of light, try using a black reflector to one side of the subject's face. This will make one side of the face darker than the other, thus heightening the illusion of roundness, and gives the face a more defi-

By the same token, opening the lens up and creating less depth of field minimizes the distracting background.

A better alternative was to use a slightly longer lens—here, a 135mm—and swivel the model around a few feet so that this more pleasing background became visible.

nite and pleasing form.

A particularly beautiful type of lighting found in shaded areas is sun filtering through trees. It gives small spots of sunlight. You must be very careful when using this type of lighting. It works best when the light filters through the trees acting as a backlight, illuminating the subject's hair and shoulders. The spotty lighting is very difficult to control when it falls directly on the face.

Often the spotty light will be two to three f-stops brighter than your base exposure. This not only gives your meter fits, but it makes it very difficult for the film to accommodate all those ranges of brightness. A great way to soften the harsh sunspots is to use a Kodak Kodapak sheet as a diffuser and hold it above and behind the subject's head much as your overhead diffusing screen was used.

For those not familiar with Kodapak, it is a translucent diffusing material that is milky white in color and can be used for softening

bright, direct sunlight. It comes in rolls or sheets and is generally stapled to a wooden frame. The frame size should approximate the size of your fill cards or overhead diffuser. Again, a 2x2-foot size is adequate and not too difficult to transport.

You don't have to buy Kodapak; you can use shower curtain material or some other similar material. Be advised however, that the material should be neutral in color or else you could get a color shift when using color film. I have used both materials and find them both acceptable but Kodapak tends to be a little warmer in tone, making it better for portrait work.

Sometimes you will be forced by circumstance to make portraits in direct sunlight. Kodapak may be the only way to accomplish that feat. You can place your Kodapak screen between the sun and your subject and the effect is like placing the subject in a light tent. The light is diffused, soft and warm overall. The only major problem you will have is getting the subject not to squint from all that bright light. A good idea is to have your model look away from the bright light and look at the darkest area within his or her viewing range. Also, having your subjects close their eyes until just before you make an exposure can help, although you will often make them self-conscious about squinting, a result that can be worse than if they had squinted.

Flash Outdoors

If you cannot control the available light the way you want, then bring some additional light with you. A small hot-shoe-mounting flash can be as valuable to outdoor portraiture as a canteen in the wilderness. And, contrary to what you may have read in the past, using flash outdoors is a simple, uncomplicated procedure if you understand a few basics about using multiple light sources.

In order to use flash outdoors effectively, you must think of the flash as an independent entity whose ouput is measured separately from your available-light exposure. Remember that by using flash you will be primarily trying to fill-in harsh shadows so, by necessity, your flash exposure will be less than your daylight exposure. The simple rule of thumb is this—if your flash exposure is at least one stop less than your daylight exposure, you will get adequate fill-light duplicating a basic 3:1 lighting ratio. As you decrease the light emanating from your flash, you also decrease the fill-light

Do not use wide-angles when making portraits or else the foreshortening effect will look like this.

A Kodapak sheet was suspended over the model's head here to reduce the strong overhead lighting direction caused by light filtering through the tall trees. The lighting is still overhead but much less objectionable.

in your shadow areas and effectively increase the overall lighting ratio. Put another way, the flash must be one stop less than your available-light exposure or it will become the main light source—something that will appear unnatural.

How do you vary the flash exposure? Simple. With a non-automatic flash, simply vary the flash-to-subject distance to change your exposure. Consult your scale on the back of the flash. Remember that you always must be at your camera's proper X-sync speed when using electronic flash. If your daylight exposure is 1/60 second at f/11, your flash exposure should be f/8. What if you are at a close working distance and your flash says f/11 is the proper exposure? You either have to move the flash unit back until you get an exposure of f/8 on your scale, or else put a layer or two of handkerchief over the flash head, which will cut down the intensity by about a stop. If you find that by backing up you alter your composition too radically, you

may have to change to a longer lens to match your former composition.

If using an automatic flash, you will not have to back up to reduce flash exposure. You can alter the ASA setting. For instance, if you are using ASA 100 film and your flash exposure says f/11, simply adjust the ASA speed to two times what it was to cut the flash exposure by one f-stop. To cut the exposure in half again, double the ASA again. In the first example, you would change your ASA to a setting of ASA 200 and if you want to cut flash exposure by two stops, change it to ASA 400.

An automatic flash senses the lens opening automatically, and compensates instantaneously for the set lens opening and given film speed. If you alter the information it has to work with—in other words, if you say that the flash is working with film that is one stop more sensitive than it really is—it will cut exposure one stop, automatically and instantaneously. If you tell the flash that it is using

Soft-focus is a great way to hide blemishes and create a misty romantic effect.

film that is four times faster than it really is—i.e., ASA 400—the flash will automatically cut exposure by two f-stops.

You can adjust your flash in the other direction to overpower your available light and thus, the flash will become the main light. You simply adjust the ASA setting to read ½ the actual film speed and it will double the effective light output by one f-stop. There may be times when the outdoor available light is unsatisfactory and you want to replace it with flash illumination. This is called flash-key and is done by either adjusting your automatic

Here are two examples of soft-focus filters of the homemade variety. A retaining ring is fitted with black nylon stocking material that has a series of varied holes burnt into it with a match head. You would be surprised how much different the two filters are. The one with the large hole in the center made the accompanying soft-focus photo.

flash as described or increasing the flash-to-subject distance.

You can achieve beautiful effects by using a diffused flash at the camera to overpower the available light. If careful you can get a studio-like soft light from your flash but still maintain the charm and beauty of the great outdoors.

Working outdoors requires special attention to detail on the part of the photographer. The background especially must be examined carefully. You should choose as neutral a background as possible and then examine it with the lens stopped down to the taking aperture by pressing the depth-of-field-preview button. As the background gets sharper in the viewfinder, you will see distracting elements that were not evident when the lens was wide open. Visually trace around your subject in the viewfinder and check for bright spots, twigs growing out of an ear, deep black holes in the background, etc. This is an exercise that should be carried out in all phases of photography, but nowhere is it more important than when you are photographing people outdoors.

As already mentioned, you should gear your exposure, where possible, toward shooting around f/5.6. This is a small enough aperture to get the frontal facial features in focus in a head-and-shoulders portrait. The ears and hair will fall out of focus but if you focus properly, you should hold the tip of the nose to the eyes and a little beyond.

Note: A lens's band of sharpness usually extends two thirds behind the point of focus and one third in front of the point of focus. But, this varies slightly from lens to lens. Some lenses have half their band of sharpness in front of the point of focus, half behind. It is important to use your depth-of-field previewer every time you change focus. This will tell you if you are getting the crucial areas in focus. With a close-up portrait you are concerned with only the major frontal planes of the face; not the ears, not the hair, and certainly not the background, which you want to throw out of focus by virtue of using a large aperture.

Even though outdoor lighting is soft and, as a result, will diminish many blemishes and/or wrinkles that might otherwise need retouching, it is often a good idea to bring along a diffusion disk or filter or a bonafide soft-focus lens. If you can't spring for a lens or even a filter, the photograph and caption accompany-

ing this description will tell you how to make an effective and cheap soft-focus filter.

Outdoor portraits are probably my favorite personal use of soft focus or diffusion. Colors become muted and soft and blend, and are highly conducive to meshing personality with nature—which is, after all, one of the sidelights of photographing outdoors.

Diffusion is not effective for men but can be great for couples and even children, not to mention women and young girls. The result can be romantic, or just thoughtful—it depends on the other ingredients, like posing and dress as well as background.

Another benefit of diffusion is that you can erase distracting details from your composition by diffusion. You can make a stone wall look like a villa, a garden look like a palace courtyard. Effects like the sun streaming through the trees will take on a heavenly glow. Facial features soften and years hide. Again, you must use soft-focus lenses, disks or filters at relatively large apertures, or their effects will be negated.

Composition, Posing and Expression

Now we come to the intangible aspects of outdoor portraiture—those elements of a picture that are often achieved through good taste and good sense.

The object of any posing maneuver is to make the subjects look more natural and at ease, and, to make them look more flattering. You are, in a sense, idealizing your subjects for posterity and if you are going to sell that likeness to them, it had better be a flattering likeness or you will end up with no sale. First, a few basics about posing and composition.

The basic rule in any portrait is that the subject's head and neck axis face a different direction than the shoulder axis. Put simply, this means that if your subject's body faces left, his or her head should face slightly right. Also, you almost never photograph persons with their shoulders squared and facing the camera. It makes them look too broad and bulky. Instead, you angle the shoulders one direction to make the figure recede slightly. It doesn't matter which side you twist them to but when you bring their face back in the other direction, remember that people always say they have a good side—and more often than not they do.

This posing maxim is valid whether you are doing a head-and-shoulders portrait or a full-length one. This posing system also insists that you adapt some compositional precepts as well. Generally, when posing your subjects in this way, you position them slightly behind an imaginary centerline dissecting the frame area. In other words, if the model is facing left, looking right in the picture area, he or she will be slightly behind the centerline of the vertical image area—slightly to the left of center.

In addition, you never position your subject too high or low in the viewing area. If the portrait is a head-and-shoulders portrait, the eyes should fall about ⅓ down from the top of the print. Your main center of interest—the eyes in a close-up portrait, the face in a ¾- or full-length portrait—should fall on one of the imaginary intersecting third lines (see diagram). If you think of the image area as a grid of thirds, your compositional duties become much more simple.

There are exceptions to every rule and the head-and-shoulder axis rule is no exception. In a profile you have the head and body fac-

The main center of your portrait's interest, say the eyes, should fall on or near an intersection on the grid of thirds to provide the most visual interest. The same rules hold when the image is a horizontal.

It is rare to find this much sideways direction to outdoor lighting but it is just what the doctor ordered for this model wearing a large hat. Sideways lighting is caused by sun bouncing off sandstone 10 feet to the right of the model.

When you can't control the light any other way, use flash. Here flash was bounced off a white fill card directly into the scene. The distance of flash/ fill card was altered until it would give me an exposure equivalent to the daylight reading. When bouncing flash, it is equal to an exposure of between two and three f-stops less than straight flash made from the same distance.

ing the same direction because there is no reasonable way to do it otherwise without twisting the model unnecessarily. Another exception is when photographing men: It is acceptable to photograph a gentleman facing the same direction, head and shoulders.

Now that you have all of these rather imposing rules for posing and composing, you must find an outdoor location that will permit you to place the subject *naturally* into one of these poses. Generally, you must position your subject either on the ground or on a fence if you want him sitting, and stand him next to a tree, wall or fence if you want him standing. It looks silly for your subject to be standing out in the middle of nowhere. Something to sit on or stand next to also gives the model some sense of security.

Now comes the tricky part. You want to get your subject to elicit a timeless and becoming expression. The first thing you have to do to get any kind of a natural expression is to have your subject relax. Have him pay attention to you but not what you are doing or the discomfort you are putting him through. Engaging conversation is about the best remedy. Choose something you know he might be interested in and take it from there. If he looks like he is into the stock market, talk about that. Subjects always like to talk about new cars, movies, current events, etc. Whatever you talk about, keep them interested and keep relaxed yourself. Most tension is generated by the photographer, and the subject picks up on it.

When you are all set, your preliminaries of lighting, composition, posing and background all attended to, stand up, walk away from the tripod and in a calm but forceful manner, issue the request for a given expression— "smile, look at me, tilt your head," and so forth. You must be in charge totally and like a doctor, the patient must trust you and feel confident in you if you are going to capture a relaxed and pleasing countenance.

If you or the client doesn't like the more formal posings, just relax the subject and fire away while you're talking. If he has a friend along, have him talk to his friend and while this is going on grab some candid shots. Don't let him move around, out of the light or composition; maintain control of the sitting.

Whichever route you take, your sitting should last for no more than about 20 minutes and in that time you ought to be able to get about two rolls of film and a variety of

expressions and poses—some formal, some candid.

Your repertoire of poses should include some smiling, some serious, some looking left, some right, some looking up, some down, a few profiles if called for, some with the mouth open, some with the mouth closed, some close-ups, some long shots, some using the subject's hands or folded arms, etc. The greater the variety, the more likely you will be to sell a number of the poses.

The secret to effective poses is to maintain eye contact with the subjects all the time you are working. Concentrate on the details of their appearance but keep them engaged with witty or interesting conversation. Periodically re-examine for mussed hair, wrinkled sleeves, and similar problems, and make sure that basics like exposure and lighting haven't changed since you began setting up.

When the sitting is over, you will feel very tired because good portraiture requires a lot

This is the difference between flash fill and flash-key, or where the sun is either the main light or the fill light. In the left photo, the flash was used as a fill light, the distance of the flash being adjusted so that the exposure was between one and two stops less than the daylight reading. Flash was moved off camera via a long sync cord. In the right photo, the flash was moved in so that it became the main light, overpowering the available light by a little over 1½ f-stops. The secret to both techniques is to be able to vary the flash-to-subject distance and thus, the intensity of the flash. A flash with variable power settings would accomplish the same thing.

of hard concentration and mental dexterity to balance all the technical tasks with a pleasant demeanor.

You will not be a great portrait photographer until you have practiced sufficiently on friends and relatives, but when you do feel confident in your portrait abilities, this is the time to try to market your services.

Word of mouth will be a great asset in your fledgling outdoor portraiture business, but you can promote it in any number of ways (see chapter on business).

Pricing

In pricing your portrait, you will have two pricing entities: a sitting fee and a print fee. That way if you don't get anything the client likes (and they will be picky since it is a picture of themselves and nobody looks like he thinks he looks), you won't be out your time and supplies. If the subject doesn't like a thing, however, it might be a good idea to reshoot it if the client seems to have valid objections. Don't take it as an insult if he doesn't like your work, but try to look at it objectively. Ask yourself, "Does he have a valid complaint?"

Pricing is a factor of costs, time and expertise. If you can deliver work as good as or better than the local studio charging $75 for a sitting fee, well, then you charge the same. Remember, however, that he has an established business and that you are just starting out. You can overprice your work and that way no one will ever get a chance to see how good your work really is.

Generally, a good starting place for a sitting fee is from $25 to $50. You can establish a minimum print order at the time you quote your sitting fee. These minimums are excellent ways to guarantee that the size of your order will be large enough to cover all your costs and produce a profit.

Have a printed price list on hand to give to customers. The price list should include all print sizes from wallet-size to 16x20 or larger and should include a discount for volume ordering. Generally your first print is the most expensive, with the second and succeeding prints costing less. Print prices should reflect your costs, overhead and profit. If you are curious about how much to charge for your prints, check out a price list from a commercial laboratory. Note not the prices, but the differences between sizes and the discounts available for volume ordering. If you are just beginning and are at a loss for print prices, try doubling or even tripling your lab's prices (this is if the lab is doing the printing), add your costs to that figure, plus your sitting fee and you have a reasonably priced job.

Remember that Rembrandt didn't become great overnight. It took years and years of refinement of basic talents. Don't be discouraged by early setbacks. Keep at it and you will not only gain a lot of personal satisfaction from making handsome outdoor portraits, but you will also be rewarded financially.

When flash output and available light readings are the same, you get results that look like this. The flash is softening the effects of daylight and giving a catchlight in the eyes but not overpowering the daylight. Using a low-powered flash helps give you a wider aperture, which in turn gives you a clean, out-of-focus background.

Composites and Portfolios

One of the most interesting and exciting ways of making money in photography is shooting modeling portfolios and composites. It is an interesting endeavor not only because of the prospect of working with attractive models, but because composites and portfolios represent a type of photographic decathlon where all of the photographer's skills and imagination are brought out to produce a unique collection of photographs in the minimum amount of time.

Modeling photography can also be financially rewarding. Most photographers who shoot portfolios charge by the job. For instance, eight different photos of a model might cost as much as $200, depending on the range and difficulty of the request and the time needed to shoot it.

You don't have to live in New York, Chicago or Los Angeles to be able to make a living shooting composites and portfolios. Modeling and acting portfolios are needed by aspiring professionals and beginners in even the tiniest burg.

A model's portfolio is a major tool of his or her trade. It is what the model or actor will take along on a job interview. It shows the versatility of looks and emotional appearances that the model can portray. A client will regard the portfolio as a major indication of whether the model is good for a specific job or assignment.

If you don't think modeling is a large part of your community's activities, check out the local newspaper, telephone book or department-store circular. Every time you see a product or service advertised with a human being in it, they have used a model (unless it is a drawing, and even then, a model may have been used). Trade shows and conventions constantly call on the services of models to demonstrate a product or idea, or simply to add a human touch to an otherwise impersonal display. Besides newspapers, magazines and circulars, local models are used extensively on area TV stations for advertising and promotion. Models are also used at openings, sales, demonstrations and other community activities.

The way most models circulate knowledge of their abilities is by sending out composites,

A good sample shooting for an actor's portfolio might include four different poses, some close-up and some longer shots. Various expressions and poses are called for. Note how the lighting differs greatly among the four photos. All photos were made on a 2¼-inch-square camera with available light. Fill cards were used for lighting control on the profile and backlit portraits.

which are printed circulars showing a few poses of the model, featuring his or her vital statistics height, weight, etc.), and giving the business information like phone number, and agent/representative if applicable. These composites can be photographic prints or printed material, but a person with a flair for this type of photography can cash in on both aspects of the business.

There are a variety of outlets for your photographic skills. Models can be found through modeling agencies, modeling schools, beauty schools, acting schools, theater workshops, college acting classes and theater groups. To start tapping this list of potential customers, you too will need to develop a portfolio.

Practice on family members, attractive friends and relatives, and anyone who will pose for your camera. A good photographic portfolio should include glamour photographs, humorous shots, fashion layouts, portraits, etc. Your portfolio should cover the range of good people photography. Virtually any type of photograph that is unique and says a lot about the character or personality of the model should be a part of your portfolio.

Once you have a good working portfolio of a dozen or more shots, start making the rounds of modeling and beauty schools in your area and explain to the manager or top administrator what your intentions are. Explain that you are a free-lancer and that you want to offer your services to the students. Your rates should be nominal and you should be willing to spend a lot of time with each model. This will aid you and the model. This is after all, in the beginning, a mutual arrangement that helps both parties get their respective careers off the ground.

If possible talk to the students themselves, show them your portfolio and a price list and

try to arrange a few bookings.

Once you have done a few portfolios, you will begin to see what is required for a good portfolio and your judgment of what you can achieve with each model in the way of looks and expressions will be better. You can then move on up to college and community theater groups (actors need portfolios almost more than models) and the various modeling agencies. Often you can make arrangements with a modeling agency to provide your photo services on a regular basis. Other times you can offer to shoot tests of various models from which the model will earn several prints and you another shot or two for your portfolio. Often this will lead to a good relationship with the agency and produce further assignments.

Every time an agency sends a model out to a job with portfolio in hand, they are offering you free advertising. If a client likes the way you did a certain shot of a model, he may request your services along with the model's. If you have done several shots in the model's portfolio, a client may recognize the fact that you and the model work well together and see it to his advantage to hire both the model and you for an assignment.

Like a model, you too should have a composite that you can leave with various agencies. Wherever models or actors congregate, leave a sample of your work. Try to get former clients to display your work on their premises along with a business card. Once you become established, start advertising in local papers, theater programs, and college and high school papers and yearbooks offering your specific services of shooting modeling and acting composites. Include an example of your photography if possible in the ad.

There are many photographers, particularly in my neck of the woods, Los Angeles, who make sizable yearly incomes doing nothing more than shooting composites. It can be a lucrative and exciting way to earn money with your cameras particularly in your area, where there may not be a lot of competition. At least it is worth investigating.

The Portfolio

A model's portfolio will represent the span of time he or she has been modeling and will display no less than a dozen different photos. Moods, clothes, styles and makeup will all be different to try to show off the versatility of the individual.

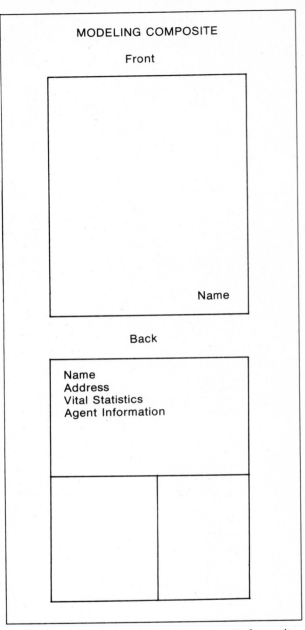

Here is a sample composite that accepts four photos. You can vary the layout as much as you want to include more or fewer photos but the basic format looks like this.

When models contract out your services to shoot a portfolio, the only time they will use your photos as their complete portfolio is when they are just starting out. Otherwise, they will use the best shots, at least six or eight. They will add these to their existing portfolio and as new jobs come along, your

It is a good thought to have an idea book with lots of cut-outs from magazines and newspapers. Show models and actors these when you first discuss the shooting and see what their preferences are—and if it is all within their budget and your abilities.

photos will eventually become obsolete and be replaced.

To get the maximum orders from your shootings, shoot each portfolio as if it were a beginning portfolio, each and every shot being used functionally to sell the services of the model.

Techniques

The photographic skills needed to put together salable modeling portfolios are extensive and varied. You must be able to shoot on location or in the studio. You must be able to elicit a variety of precise expressions from the model. You must know lighting, posing, make-up, hairstyling and, most importantly, you must be aware of the current trends in fashion and photography to be able to create a good portfolio. The more you know photographically, the more you can apply to deliver well-rounded portfolios. You must also be a good judge of a person's characterisitics,

knowing which aspects of a model's character to exploit.

All of these requirements sound very imposing, but like anything, shooting good composites and portfolios is an attained skill, perfected with practice and honed each time out on the job. Little by little you will perfect your skills if your goals are improvement and you shoot for excellence in your pictures.

Equipment

You don't need anything too extraordinary to shoot models. Your SLR, and a few lenses—a normal, wide-angle and short telephoto lens—will be quite acceptable. Also, you should have a tripod and a flash that you can take with you on location.

If you work in a studio, you will need a studio electronic flash system with at least two flash heads, umbrellas for each, and a collection of reflectors and diffusers.

You will need several gimmick filters—soft-

1

focus, star or multiple-image types. These will help you vary your photos without your having to change locations or the model's outfit.

You should also carry a long cable release so that you can move away from the camera and instruct the model personally. You need plenty of film, because the more film you shoot, the more your possible sales. You

1-8. *If someone wanted a portfolio shot, you might do something like this. The eight photos on these and the next four pages were all done in one day at a park having many different types of locations. Notice the number of changes of clothes and expressions from cute and girlish to sophisticated. The photos that were backlit called for flash fill to bring up the illumination, while the available-light shots merely called for well-placed fill cards.*

2

could also use a motor drive or auto winder to help capture those fleeting expressions.

Locations

If you are shooting in the studio, you can vary the look of the photos by changing seamless backgrounds, model's clothing or hairstyle, or your lighting. But more often than not, the basic mood and attitudes of the model remain the same in the studio. A real change of scene can effectively alter your model's range of expressions. A model will reflect the surroundings. This is why so many photographers choose to shuttle the model from location to location, making changes in clothing and makeup along the way. The result will be much more varied than a shooting done entirely in the studio. You can (and should) mix studio shots with outdoor locations if you have that capability and it is within the operating budget of the assignment.

When choosing an outdoor location, pick one with a variety of interesting aspects. For instance, one of my favorite locations is an old California mission. It has shaded areas with trees and gardens, it has stately porticos, beautiful fountains and long hallways and porches lit by diffused daylight. Of course, all locations can't be quite as exotic as this one, but you get the idea. Be able to come up with a minimum of three different settings at each location—for instance, under a shaded grove of trees, along a path way or near a sunlit garden. This will allow you to capture at least 10-12 different shots at this one location.

How do you capture 12 shots from only three areas of one location, you ask? Simple, if you are carrying three lenses, you use at least three different photographic points of view. You can make a tight close-up of the model's face with your short telephoto, a ¾- and a medium-length (from the waist up) shot with your normal lens, and a full-length shot that incorporates the scene and background with your wide-angle lens. Do this for all three settings within the single location and you have a dozen different shots from your shooting. If you combine locations or a studio and location shoot, you can see how many possibilities you can offer the client.

Be sure your location (or car or van) has a place for your model to change and do her hair or makeup. Even if photographing a male model, you still need a place for him to change and comb his hair.

Make sure your model has at least three

different changes of clothes with the facility to change hairstyle and makeup. You can mix different tops and bottoms and vary the combinations further. The tendency of the photographer is to keep the model in one outfit too long to avoid breaking up the continuity of the shooting. Your interests will best be served, however, if you don't remain too long at one location or with one pose or with the model in a single outfit.

Bring along some simple props that the model can work with. For a man, bring some cigarettes for a macho look, a hat for a different expression. For a woman, bring along an umbrella or glasses or a floppy hat. Props will not only change the appearance of the photo but will give the model a crutch, or support on which to act out some expression or mood.

The gamut of clothes that a model brings should range from formal to very casual. If the weather permits, you may want to do some summer bathing-suit shots as well as some cool-weather shots with sweaters or overcoats. Clothes should vary in color and the selection should include some light clothes and some dark clothes for variety.

Planning Session

Before you head out for a location with your model, be sure you know the needs and ideas of the model. Talk over the job beforehand and decide on props and location as well as change of clothes and be sure to cov-

3

er your photographic plans; i.e., whether you are going to portray the model in a soft and romantic light or whether a more athletic approach is to be used.

Be realistic and don't try to cram too much into a single day's worth of shooting. Realistically, you can't cover more than two or three locations in one day.

Make notes to yourself regarding the appearance of the model. Analyze face, eyes, figure, demeanor and posture for strong and weak points. Ask the model for an analysis of his or her own strong and weak points. Take these into consideration when planning your shooting session, and make suggestions as to angle, makeup or clothing. For instance, if the model is 5-10 pounds overweight, suggest

4

dark clothes and make a note to yourself to shoot from above head height to foreshorten the body.

This is a business session so treat it as that. It is also the time to get familiar with the model and break down communication barriers that will inhibit shooting. Earn the model's trust by being business-like and self-assured.

Once both of you are satisfied with the plans for the shoot, call it a day and then go to work on your own, preparing a list of things you will need. For instance, if you are shooting at a remote outdoor location, note what camera and flash equipment you will need, as well as the props you discussed and any reflectors, diffusers, and filters you think will be necessary. You may need to include some long folding flats that the model can use to change behind if you won't be near a restroom. Also, be sure to have hair spray, a comb, pancake makeup and a powder puff handy for last-minute adjustments.

Posing

Easily the most important aspect of a shooting session is getting the model in a good variety of poses and eliciting a wide range of emotional expressions.

Posing is a function of model/photographer rapport, and good coaching and direction on the part of the photographer. Models should inherently be good at posing, but they are not wizards; they need precise instructions to fit the desired framework of the photograph.

A photographer should offer only positive statements during a shoot. Models are sensitive, and if you constantly respond with negative remarks like, "No, you're not doing it right," the model may have a tendency to clam up and become even more unresponsive. Always be positive. Reinforce the good points and constantly tell the model that either he/she looks great, or the picture is just what you were after. It can't be emphasized enough; positive treatment will make your models even more responsive and will heighten their already good modeling sense. The more confident a model feels the more inclined he or she will be to do a better job. Flattery and encouragement are the ways to foster that confidence.

Always issue your directions calmly and with an air of confidence and authority. Speak loudly enough for the model to hear you, but don't yell. Be well versed in giving instructions in reverse. For instance, you tell the model to

raise her arm, which appears to you to be on the right of her body. It is actually her left arm in this instance. So practice issuing instructions in reverse.

Use your imagination to think up situations you want the model to act out. For instance, if you want your model to look mean and defiant, have her think of an imaginary situation (she has just been told she is fired from her job for not sleeping with the boss); that will elicit the emotion you are after. The models must trust you to act these things out, so never criticize or mock them if they can't quite get what you want. Just try another image-conjuring situation.

If you get stuck for ideas, bring along an idea book—a loose-leaf binder or notebook with cutouts of photographs with a variety of moods or expressions. Go through the book until either of you sees something you like. You can also bring along a handful of fashion magazines. They may provide some instant, on-the-job inspiration that could save the shoot.

Tension can be a by-product of a photographic shooting session. Anxiety is a deterrent to good photographs, so it must be eliminated. Tension manifests itself in the model's mouth and eyes. When eyes sparkle and the mouth is fluid and relaxed, there is no tension and the photographs will look natural. But when the model is uptight, the eyes will look blank and the expressions insincere. Tension can be alleviated by telling the model to close his or her eyes and take a deep breath two or three times. Use the image-conjuring method of thinking about a relaxing sylvan scene or about sleep or about anything associated with calm feelings.

Don't be afraid to come out from behind the camera and get into the pose yourself. If the model thinks the pose is unbecoming or can't get it right, show him or her exactly what you want. This inspires further trust and confidence in your talents as well as aiding dramatically in communication.

Actors are much easier to give direction to because they are used to responding to verbal commands from a director. Tell an actor what to do and he will usually respond by doing exactly what you ask for.

Models, on the other hand, tend to respond more intuitively to a verbal request. Often it is necessary to show a model what you want. On the other hand, it may be desirable to have a more spontaneous reaction to your verbal input and therefore you may want to restrict your verbal directions to a minimum.

Just as you want your model to run the gamut of expressions from happy to sad, so

5

6

must you change your photographic techniques to match the mood. If your model is light and happy, choose a bright sunlit background for the scene. If the mood is contemplative and pensive, select a background that is a little darker and lower key. Use soft-focus or diffusion to emphasize ethereal beauty, sharp direct light to highlight angular lines or handsome good looks. Get in tight for a close-up of the eyes and face, and then drop back for a full shot of the body. The two renditions of the same basic shot can look remarkably different.

As for specific poses, refer to the good posing techniques described in the chapter on outdoor portraiture. They certainly apply to fashion photography, although there is a lot more rule-breaking in fashion photography, primarily because models are supposed to have ideal figures and can thus be used in freer poses. Analyze poses that you have seen in magazines and get your model to emulate those poses. Also, rely on the model to display his/her own arsenal of poses.

For more information on posing consult the Petersen book, *Method Modeling,* by Valerie Cragin. It is designed as a reference book for photographer and model and lists dozens of basic poses as well as describing the fine points of modeling and fashion photography.

7

8

Diffusion is often called for to vary the day's shooting. There are two different types. Photo No. 1 was diffused at the camera with a homemade diffusion filter made of stocking material, while photo No. 2 was diffused at the enlarger for a more subtle effect. Diffusion at enlarger was done with an Arkay PicTrol soft-focus device.

It also covers in great detail such difficult-to-master aspects of modeling as makeup and hairstyling.

Speaking of makeup, you should know a few basics before going out on any assignment. Whether shooting black-and-white or color, for women you need a light foundation of pancake makeup followed by contouring makeup, which accents the jaw line, separates the nose and face (this is done by slightly darkening both sides of the nose bridge), and accents the cheek bones. Finally comes the eye makeup and lipstick, which should help tie together the outfit by matching the face with the clothes. As mentioned earlier, keep a puff and pancake makeup handy to spot down shiny patches on the skin, usually around the forehead or under the lips. These areas will begin to perspire and need to be periodically dabbed with powder.

Never overdo the makeup and don't allow your model to have complete control over her makeup. It should be *light* for color film and slightly heavier with black-and-white.

Hair should be done the night before and combed and sprayed just prior to shooting. Never use too much spray, because it will give a statuesque, unnatural look to the hair. Also, too much spray will dull the shine of the hair, particularly in black-and-white photos.

Before taking a single picture, analyze the scene from the tip of the model's nose to her toes. Analyze everything in the scene by tracing an imaginary line around the model in the viewfinder. Examine the lighting, background, clothes, hair, makeup, pose and finally, when you are satisfied that all the pictorial elements are working together, begin to work on the expressions and poses you want. Good modeling photography is a combination of good ideas, good execution and a strict attention to details.

Portfolio Pricing

When shooting an entire portfolio, or just the photos for a composite, it's usually best to offer the job as a package deal whereby for a set fee, usually from $100 to $300, the model will get 8, 10 or 12 quality 8x10 prints (whatever number of prints and whatever size you decide on). You process the film, have proof sheets made and allow the model and her agent to go over them, or they may ask you to go over the proof sheets with them. This can be extremely helpful to both of you be-

cause it allows you to strike the bad takes before the model says he or she wants them.

Usually, the model will purchase his own book for display and will just purchase the prints from you. Remember to include in your price your overhead and a profit, so be sure you have analyzed this type of job for hidden costs and hidden profits. (See the chapter on business for more details of the specific nature of pricing.)

If those prices seem high, offer a variety of print selections, say, a four-print offer or a six-print offer. Remember what goes into producing the variety needed to come up with four or six acceptable shots. It may have taken you a half-day's shooting at two separate locations.

If you need a refresher, you will have these costs: film, processing, proofing, traveling time to and from locations, consultation and shooting time, the time required to perform the bookkeeping, numbering and ordering procedures, planning and prop gathering time as well as your profit charge and a straight fee for your overhead.

Composites

When the model wants you to do the composite from start to finish, you have all of the above costs plus being required to negotiate with a printer the machinations of having the photos made into a pleasing layout with type. It is really a separate job in itself, but many photographers find it a fascinating aspect of the job. It is much like putting out a mini-magazine.

Models will generally want between two and eight photographs of themselves arranged in a cohesive and pleasing manner, and they will want it all tied together with their name in a compatible type face, with their vital statistics and agent/representative information.

You can cut costs way down on composites by having a photographic comp designed using a copy of three or four photographs made with type and vital information either on the flat with the photos, or printed in later using a litho mask. A commercial photographer can do the job for you or you can do it yourself, it is not difficult, but you will need a 4x5 camera to do the copying, and you will need to know how to use high-contrast emulsions as well.

If you are going to create a more complicated composite, using offset printing or lithography, consult several local printers until you find an outfit whose price you like and who look like they will be easy to deal with. Find out what their requirements are for camera-ready art and then inform your client of what they will get and for how much. Usually, you should double the printing cost at least. If there is a lot of extra work associated with the project, you can charge more.

Decide if you or the print shop is going to handle the layout and be sure to get an OK from the client on the layout before any material goes to the printer. A rough layout appears in an accompanying photo. Type can be set down in the desired spot with rectangles left vacant for inserting photos. Photos are numbered to correspond to the layout.

Be sure to get a first proof from the printer before he runs off the entire print run. If you are ordering 500 composites for your client, you'd better be sure they are not too dark or too light. To insure a good reproduction, do not give the printer prints that are too rich and dark. The ink will tend to spread and the photographs will lose vital detail. It is always better to have a print that is of good overall contrast but just a little on the light side.

You can cut your costs at the printer by ordering in greater numbers or by choosing less expensive paper stock, but you should satisfy the needs of your client first before any price cutting.

If you do both the photography and the composite-making, make sure to charge for your efforts as if they were two independent jobs. After all, you must treat them as if they were. One added benefit you will receive, besides the satisfaction of completing a project from start to finish, is that you will have a very nice addition to your personal portfolio. In fact, if the project turns out really well, have a hundred more printed up at the time you place your print order to use as calling cards. Simply rubber stamp your legend on the comp so it can be seen that you are advertising your photographic services, not the model's.

Regardless of the extent to which you get involved in photographing models and actors, it can't be denied that this is a fascinating way to earn money with your camera. You meet a variety of interesting people from your community and get the opportunity to promote your photographic talents within a group of people who are very much in the public eye. You may find that besides being lucrative financially, it is a good way of showcasing your small photo business.

Weddings

One of the most lucrative and enjoyable ways to make extra money with your camera is photographing weddings. Most amateur photographers assume that weddings are too difficult for them and that the rewards are not that great. But just the contrary is true. Weddings can offer sizable profits, and the diversity of photography found within a single wedding is enough to keep even the most jaded photographer satisfied.

Before starting out, you will need some hard practice. Practice is often difficult to come by, especially since you need to shoot actual weddings to gain experience. One way you can gain experience is to attend as many weddings as you're invited to and offer to supplement the photos taken by the regular photographer. This will cost you money even if you give the couple the photos at cost, but it is the only way to log experience.

You don't need a lot of fancy equipment to be a good wedding photographer. What you need are good instincts, good reflexes and timing, and a lot of diplomacy. The priceless moments that happen at a wedding happen only once, and if you don't have the abilities to capture those moments you won't be a success. In addition to being able to capture the events of the wedding as they unfold, you must also be able to direct the participants, in a minimum amount of time, into poses that are suitable and an expected part of good wedding coverage. Some of those poses are traditional and some will be spontaneous but you must be quick and efficient if you are going to make it as a wedding photographer.

You must also be able to think of the affair as a series of events that form a cohesive unit; a story, if you will. You need to think of the wedding as an album with a prearranged number of parts that tell the story of this wedding. More about this a little later.

Equipment

A wedding photographer's list of equipment is minimal compared to that needed for other types of commercial photography. For the wedding itself, you need your camera, either 35mm or 120-size format, with a normal and a short telephoto lens. Wide-angles are sometimes good for groups and interiors but the

distortion they provide is usually not an acceptable byproduct. You will need a reliable and powerful flash unit and several sync cords. You may also want to have some special-effects filters like a cross-star or haze filter as well as a matte box for double exposures and vignettes.

Many wedding photographers like to work with two cameras—one with high-speed color negative film like Kodak Kodacolor 400 or Fuji

1

400 color print film, and another camera with flash attached using an ASA 100 color print film. The camera with flash will be the workhorse while the other camera can be used for available-light shots in dimly lit areas or for candid shots where flash might prove to be objectionable.

Your flash should be attached to a solidly connected flash bracket (not the camera hotshoe), and the flash should be easily removed for bounce light or off-camera flash. The flash should have a short recycling time and for this reason, it is often a good idea to have a flash using a dry-cell battery as a power source. Electronic flash units using many flashlight or penlight batteries will not have as great a reliability factor or as fast a recycling time as a camera using a larger dry-cell power pack.

The more powerful the flash unit, the better off you are. With a powerful unit you can easily make bounce-light exposures even in large rooms, thus varying the look of your wedding coverage. You should have a basic working aperture of f/11 at an average working distance of around 10 feet. (This, by the way, is a guide number of 110.)

Even if you don't have a surplus of camera equipment, you can do a respectable job using only one camera, one lens and a flash. In fact it is sometimes even preferable to having several cameras and lenses. You then force yourself to get close to the events and are not hampered by reaching for a spare lens at precisely the wrong moment. Whatever the equipment you use, be sure to check it over carefully the night before and see that everything is working and that batteries are fresh. And, despite the fact that your sync cord may be working at the time of the checkup, do yourself a favor and carry a spare or two; they have a nasty habit of malfunctioning at just the worst possible moment.

The Wedding Script

More valuable than the finest camera equipment is a list of the shots you are going to make. This is the basis of your album story and is also the cornerstone of your pricing. There are certain key photographs that are

2

1,2. A bridal portrait is often the first picture to be made because it is likely to be sent to the local newspaper. Shoot the bridal portrait before the wedding (photo No. 1) or at the reception (photo No. 2). Use black-and-white film, and make an extra shot on color negative film. If you don't have the time to shoot a separate black-and-white, the one made on color negative material will be OK, although lab processing may make getting a quick print to the paper an impossibility.

not only traditional in wedding albums, but also pivotal story-telling pictures. The list can be modified to meet the client's finances but must certainly include such obvious favorites as the bride throwing the bouquet and the bride and groom cutting the cake. It may also include such formal posings as the couple wishes to include.

When you are just starting out you should write down the list of shots in your script and tape the list to the inside of your camera bag. Check off the shots as you go along and if you see you haven't gotten a shot, set it up or make arrangements to reenact it later. Once you get all of the shots on your list, the rest is gravy, but get the primary photographs first.

The following is a chronological script that will encompass many more photos than you will probably be able to sell. However, it is important to note, the more photos you make, the more you are likely to sell. Also, note that the shots made at one location must be completed before you or the wedding troupe moves on. You can't return to the bride's house, for instance, to make a mirror photograph once the wedding has started.

At the bride's house before the wedding:
1. Bride getting dressed
2. Bride's mother helping bride with veil
3. Close-up of bride in mirror
4. Formal garden portraits of bride
5. Bride with bridesmaids
6. Bride talking with father prior to leaving for church
7. Leaving for church

At the church:
1. Groom waiting with best man
2. Bridesmaids and flower girl entering the church
3. Groom and best man waiting at the altar
4. Mother(s) and families being seated
5. Bride and father entering the church
6. Father kissing the daughter and giving her away
7. Bride and groom meeting for first time before they face the priest or minister
8. Long shot and candids of wedding party at altar
9. Available-light shot of whole wedding, usually made from the back of the church
10. The ring exchange
11. Making the vows

12. Bride and groom kissing
13. Bride and groom leaving (After bride and groom have reached the last pew and before leaving the church, the families, wedding party and minister are called back into the church for some additional group pictures.)
14. Entire wedding party
15. Just bride and bridesmaids
16. Groom and ushers
17. Bride and groom with both families
18. Bride and groom with bride's family
19. Bride and groom with groom's family
20. Bride and groom with minister
21. Bride and groom with just flower girl and ring bearer (if present)
22. Formal posing with bride and groom (Note: The bride and groom may prefer these shots be made elsewhere—at the reception, or on the church grounds; however, they are easier to make for the photographer if the wedding party proper and families are isolated from the wedding guests.)
23. Bride and groom leaving church with rice being thrown
24. Bride and groom leaving for reception in automobile

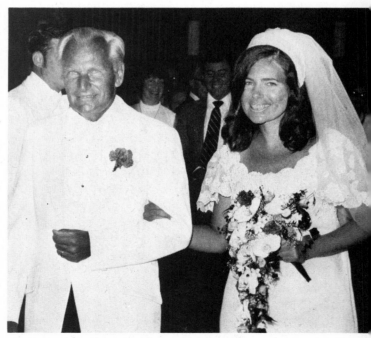

The bride entering the church and being given away by her father is a very important shot for continuity in your album.

At the reception:

25. Bride and groom entering the reception
26. Receiving line
27. Bride and groom being toasted
28. First dance of bride and groom
29. Candid shots of wedding party and bride and groom at head table
30. Bride's father toasting bride and groom
31. Bride and her father dancing
32. Groom and his mother dancing
33. Overview of reception and dance floor
34. Bride and groom dancing
35. Candid shots of family tables, especially of bride's and groom's parents
36. Candids of bride and groom with guests
37. Cutting the cake
38. Bride throwing her bouquet
39. Groom removing bride's garter
40. Groom throwing garter
41. Close-up of rings
42. Close-up of wedding book or invitations
43. Bride and groom leaving reception
44. Bride and groom leaving in car.

Obviously weddings and circumstances differ and different religions and nationalities have different customs and traditions that will need to be photographed, but if you have the basic elements of the story, your album will be a success. There will also be other situations that will warrant photographs, so don't limit yourself to the strict outline of your script.

Pricing

When discussing prices with the couple, show them the various parts of the wedding with examples from past weddings. They can

Group photos made at the church should be done quickly and quietly. Note the posing and the interleaving of shoulders throughout the group.

be as extravagant as they want but the list of photos will give them a very good idea of what to expect.

There are many basic packages but a very popular one is the 12-photo album. This tells the story with a minimum of prints and while it does not leave room for many candids, if your client wants the wedding photographed inexpensively, this is one way to go.

You can also offer smaller eight-photo albums in 5x7 print sizes for the families of the bride and groom, and these should include the group photos of the families and the key shots of the wedding itself as well as a good portrait of the bride and groom.

When pricing the total job, remember to include your costs, plus your time and overhead plus your profit. Figure out what your costs will be before you sit down with a prospective client so that you won't have to do any guessing. If your clients will want any formal posings that cannot be done at the wedding and will require a separate sitting, figure that into the fee also. If they want any special effects that must be done by the lab, figure that into the cost as well.

You can offer a series of packages such as single 12, 15 or 20 8x10 print albums; or two 5x7, eight-photo albums and a larger album, or any combination thereof. Remember that if your lab doesn't handle albums as part of their service, you must include the time you will spend running around to different camera stores looking at albums into your total cost.

You may simply want to deliver so many prints and leave the album responsibility to the clients. Often they have a book that was passed down in their family and they want it to be their wedding album. Other times they will just want to forego the expense.

If you want to order custom albums you should write to one of the companies specializing in wedding albums. Leather Craftsmen, Inc., 314 Hendrickson Avenue, Lynbrook, New York 11563 specializes in fine albums in a variety of styles, surfaces and materials. They even offer albums with wooden covers. Another major manufacturer of albums is Art Leather Manufacturing Co., 37 Moultrie Street, Brooklyn, New York 11222. They offer specialty albums that feature four or five photos per page and can hold up to a hundred photos. The more services you can offer a potential client the better off you will be. For more information on pricing weddings, see the chapter on business and pricing.

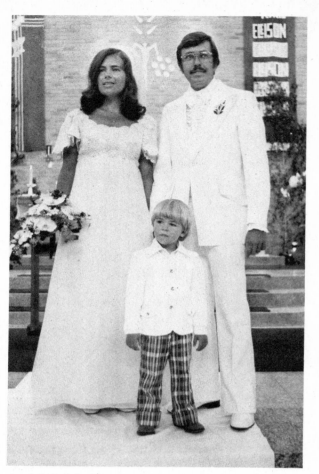

A picture of the bride and groom and their ringbearer or flower girl is often a nice touch and will likely be purchased by both the bride and groom and both families.

Large group shots should be made at the reception, out of doors if possible. This is a photo of the groom's parents and their guests.

Lighting

For the most part you will have only one chance—possibly two—to make a good picture of a given event at the wedding. For this reason, you must be 100-percent sure of your exposures by being certain of the proper light output of your flash and the actual film speed when used with your equipment.

To make sure of the rated flash power, conduct a guide-number test with a roll of slide film. The way you do this is to seat a fair-skinned subject in brightly colored clothes exactly 10 feet from the flash and camera. Make a series of exposures on the slide film at ⅓-

Either look for and photograph candids like photo No. 1 or else set them up and try to retain that candid atmosphere (photo No. 2). These shots should be part of your shooting script.

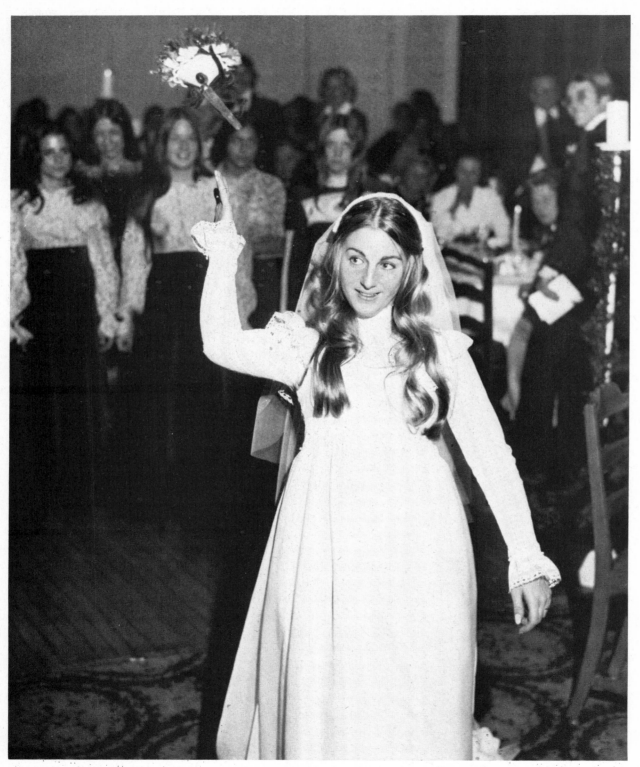

For the photo of the bride throwing her bouquet, set it up so that you can choose the best angle. Have the bride throw the bouquet on your cue and if you don't think you got the shot, set it up again. Here, the flash was angled to both illuminate the bride and the bridesmaids behind her.

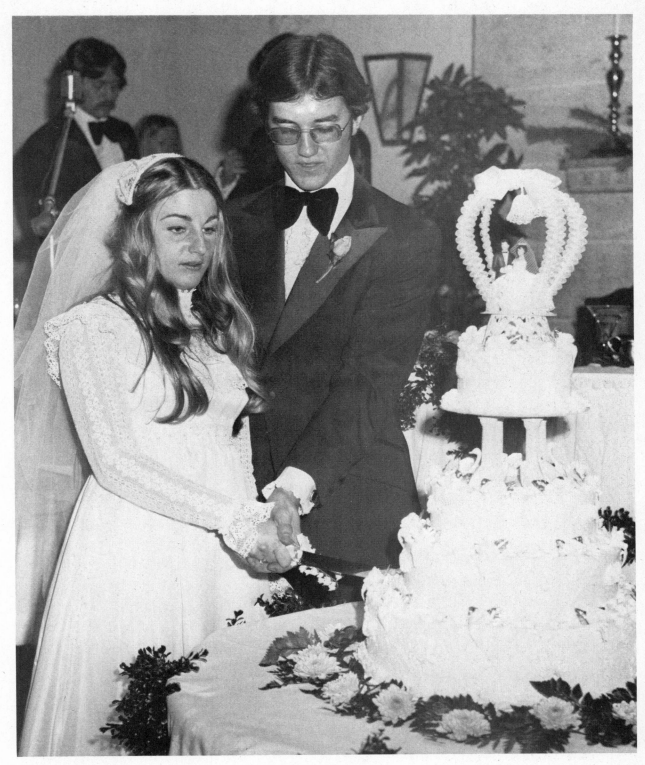

The cake cutting will usually have to be a posed setup shot since you want to position the bride and groom in a good spot relative to the cake. Wedding cakes are very difficult to photograph because they are usually between the photographer and the couple. Position it to the side as shown and you will have less trouble.

stop intervals from three stops below what you expect the aperture to be, to three stops above what you expect it to be. When you get the film back, place the slides in a row from dark to light on a light box and examine them. The perfectly exposed slide is the one you are interested in. It is easy to tell the best exposure when all the slides are compared. Be sure you have made note of which exposure is which either by labeling a board that the model can hold in each exposure or by keeping track of each frame number.

If your best exposure is f/11, your guide number is 110; if your best exposure is f/8, your guide number is 80. You simply multiply the f-number by 10 to give you the guide number. If the number is an intermediary one, say ⅓ stop less than f/11, simply multiply f/8 by 1.26 and it will give you the equivalent of ⅔ f/stops more exposure (or ⅓ stop less than f/11). For instance, f/8 X 1.26 equals f/10,

Candids like this will help the bride and groom remember their wonderful day.

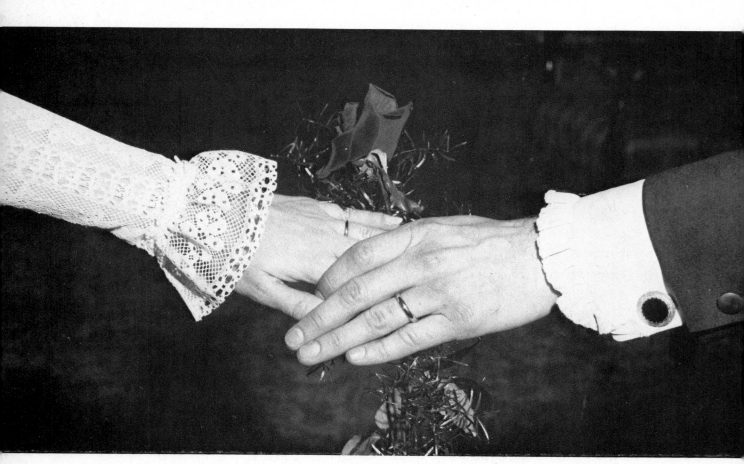

Set up a shot with the bride and groom's wedding rings. It takes care to photograph hands well. Do not get too close, and never put a finger joint at the print border—it makes hands look as if they aren't attached.

which would give you a guide number of 100 in this example. If your best slide is ⅓ stop more than a given f-stop, multiply by 1.12. For instance if your best exposure is ⅓ stop more than f/11, multiply by 1.12 and you get f/12.3, or a guide number of 120 for simplicity's sake.

What this guide number means is that you now have a very accurate indication of how much light your flash puts out, and that information can be put to use in making perfect exposures. Simply divide the flash-to-subject distance in feet into the guide number and you have the working aperture. For instance, if your group is 12 feet away and your guide number is 80, divide 12 into 80 and you get a number of 6.6, or roughly ½ f/stop between f/5.6 and f/8. This will give you a perfect exposure provided your main subject is exactly 12 feet away. If you're not sure, check the distance scale on your camera lens and it will get you close. This is especially convenient if you are bad at estimating distances.

One of the hardest shots to make is the bride and groom leaving the church. Clear yourself plenty of room and allow yourself a few minutes after doing the photos inside the church to get outside and set up.

If you want to use bounce flash, simply compute the guide number in the same way except figure in the distance from the flash to the ceiling or wall you are bouncing the light off of, and then add the distance back down to the subject. If your subject is five feet away and you are working with a 10-foot ceiling, it might be five feet up to the ceiling from the flash and eight feet back down to your subject. Divide 13 into 120 and you get 9.2 or an exposure of between f/8 and f/11. But, for bounce light you must open up the lens an additional 2-3 stop. I always use 2½ stops and then vary that figure as room conditions warrant. In this situation, the exposure would now be slightly less than f/4.

These computations are even more impor-

tant if you have an automatic flash because the manufacturers tend to pad rated flash output, making it difficult to accurately gauge exposure. The problem is compounded by the fact that conditions may be such that you may have to compensate for dark walls or some other problem that the automatic sensor and an overactive output rating will not cover. If you have an automatic flash, conduct the tests and if you find that exposures are equal to what they would be on auto, only override that feature when conditions warrant; i.e., when walls are dark or light or you are bouncing light off the ceiling. If the flash is actually putting out less light than it indicates, use it on manual all the time with your own guide number calculations or adjust the

2

1,2. *Often at weddings you will need to get the flash away from the camera, either to avoid "red-eye" problems or to counteract problems like the wedding cake. You can hand hold your flash away from the camera (photo No. 1) or use a handy bracket like the Siegalite (photo No. 2).*

1

flash's ASA dial to make the difference.

Generally the best flash exposures for skin tones are obtained when the flash is moved away from the camera by either holding the flash in one hand extended outward or by means of an extending bracket. I usually hold my flash directly over the camera's viewfinder by about 1½ feet. This does two things. It produces a basic overhead lighting, which gives dimension to the cheekbones, and it serves to keep the shadows behind the subject and out of view. Otherwise, if the flash is on the bracket, slightly off center, the shadows fall to either side of the subject and if the people are against a light-colored background the shadows will be very distracting.

When bouncing flash, hold the flash at a 45-degree angle and visualize the direct angle the light will take when it bounces off the specific point you are aiming at. It should then bounce back and fully illuminate your subjects. Bounce light is particulaly appealing for candid shots made at the head table where you may want to capitalize on the light produced by table candles. If your available-light exposure is close to that of the bounce light exposure, be careful as you may get some ghost movement.

When outdoors, use the sun as a backlight or else fill in the harsh shadows of daylight with fill-in flash (see chapter on outdoor portraits). Pictures made on color negative film in shade will be very satisfactory, but watch the backgrounds. You may find it useful, for in-

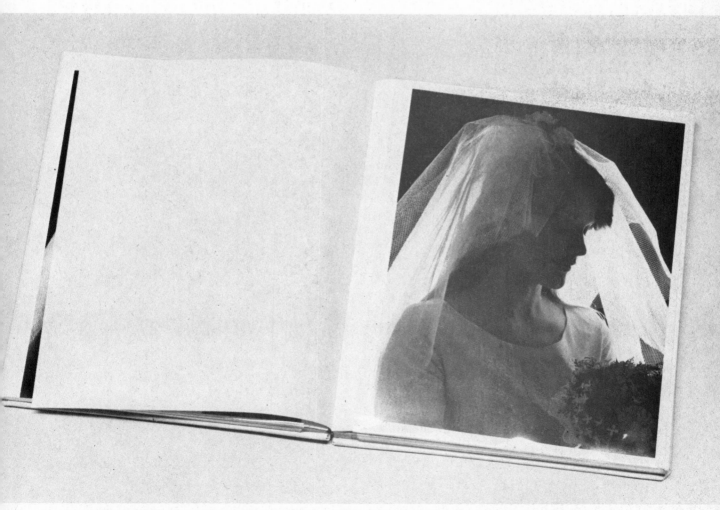

A wedding album of your own best wedding photos is a great way for potential clients to gauge your work and best decide which photographs they want for their own wedding.

stance, when making a group shot in shade to do one by available light and one with flash-fill to cover yourself.

In most instances you will not have the time to carry multiple flash or many fill cards, so learn to use what you've got. You can vary the lighting exceptionally well using the three modes discussed: straight flash, bounce flash and available light (with or without flash-fill).

Posing

Posing subjects at weddings is a simple procedure primarily because there isn't the time to get elaborate with poses. Remember, however, never photograph people head on; have them stand sideways slightly. This is particularly true of groups. When photographing large groups, half of the people—say the half to the right of middle as you face the group—should all be angled toward the center of the group. The opposite will be true for those on the other side of center.

For small groups, have the people place their far shoulder slightly behind the shoulder of the person next to them. If you have trouble visualizing this, remember that the group should stand close together so you can make a good tight photograph. The ¾-length poses are much better than full-length shots when you don't have too many people in the group because you can see the faces and expressions more clearly.

As far as expressions go, follow the rules of good portraiture. Keep the people engaged conversationally and elicit an expression by joking or talking with them. You don't have much time so the expressions on the people's faces have to be good. The more people there are in the group, the more control you must have of the situation. Keep them loose and relaxed and work quickly.

Keep backgrounds clean and fill the frame with the group or couple except where you have a beautiful environment you want to include in the photo; then the couple or group should be incorporated into the scene so it is a scenic photograph with people included.

Special Effects

Some final words are needed regarding special effects. You can raise the overall appeal of your wedding book to potential clients by including some of the fancier special effects that have come to be expected from the wedding photographer.

Among the most effective effects are the

soft focus or misties that can be done by diffusing the image with stocking material or with some Scotch tape. Another favorite is the use of the cross-star filter, especially when candles can be incorporated. The star patterns act as a grid for the the bride and groom and help create a striking composition.

Other special effects can be done by the lab. Larger labs like Color King, P.O. Box

PHOTO BY JAN GREEN

A smaller matte box is great for 35mm cameras and can hold vignettes, masks, filters or other special effects items. This particular lens shade is made by Precision lens shades.

PHOTO BY JAN GREEN

For special masking effects use a matte box like this one by Lindahl Specialties called the Bell-O-Shade.

1986, Hollywood, Florida 33022, perform a whole regimen of special effects from superimposing a photo onto sheet music to double-printing the bride and groom into a series of masks from a heart shape to a champagne glass. Many labs offer these services at nominal fees. Some tasteful examples of special effects will really help dazzle a potential client.

You can achieve your own double exposures by using a matte box (see photo). A matte box uses masks to screen off part of the image while you make one exposure and then allows you to reverse masks to fill in the blank part of the frame with another image. SLR cameras are preferable to rangefinder cameras and will greatly facilitate precise matching of the images.

Once you have a good sampling of wedding photos in your "book," you will be well on your way to establishing yourself as a solvent wedding photographer. As mentioned earlier, use any way you can to get invited to weddings and shoot as much as you can to build up your portfolio. Make your mistakes before you have paying clients depending on you for their priceless wedding photographs.

This is a typical wedding photographer's flash and camera outfit. Note that flash and camera are connected as one unit, yet flash is easily removed for bounce. Cords and power pack are not shown.

Sports

One of the most enjoyable ways I know of to make money with your camera is by photographing sports. At any level of athletic competition there is drama, excitement and most importantly, action.

Photographing action is exasperating at first because it takes much practice before you become even competent at shooting sports. But your first successes will more than make up for all the initial failures. Your biggest investment, then, for this type of money-making venture, is time.

Once you become proficient at capturing the action, there are a variety of outlets for your sales. You can sell to the athletes themselves, who always want to see how they look performing; you can sell to the competitors' parents if the performers are young enough; you can sell to leagues or coaches for instructional purposes or analysis. If your shots are not only good action shots, but striking pictorials as well, your market expands to include stores, or marts or even agency sales if you have enough good photos from which selections can be made.

But backing up a little, the most important element needed in sports photography is timing. You can train your reflexes to extract only the most crucial moment from a sporting scene but, as noted, that takes time. How do

Photographing sports can be a great way to extend your interest in sports and make a few dollars on the side. This stop-action photograph of USC quarterback Paul McDonald could have a lot of uses—press and public relations. (Photo courtesy USC).

Knowing when to shoot can make all the difference. Here a kicker is frozen at the apex of his kick. Anticipating this peak-of-action moment helped create the picture.

you begin, you ask? The answer is to photograph anything that moves. Photograph the neighborhood kids playing, your dog, passing cars; in short, anything that moves, whether predictably or unpredictably. You can practice with film in the camera or without film but the idea is to practice fast focusing in and out on fast moving objects and to practice isolating the key moment in the action.

Set up a timetable for yourself with realistic goals. For instance, tell yourself that for the next three weekends you are going to photograph at least five forms of action and that each week you are going to show noticeable improvement. Concentrate on your perfor-

mance while you're shooting and analyze ways to improve your tracking capability and reflexes. Once you have a fairly good feeling about going out to shoot the action, you are ready to try your hand at actually photographing a few sporting events.

Getting In

Probably one of the most frequently asked questions of professional photographers is, "How do I get in to cover the game?". There are a lot of ways but at the entrance level of sports photography, the honest approach is the best; tell the coach or official of the event that you are just learning and that you would

Panning with the subject, even at moderately slow shutter speeds, will give you a razor-sharp image if you are panning at the same speed the subject is moving. Here, bicycle racers and background are frozen with a 1/250-second shutter speed. By the way, bicycle races are an excellent place to sell your sports photos.

love to photograph the game, match, etc., and in exchange for his generosity, you will give him prints of your best efforts.

Most officials will respond favorably to that request, particularly if they are sure you know the ground rules of behavior for that particular sport. Later on, when you become familiar with various organizers or coaches, you can freely exchange a press pass to cover the event for a few 8x10s of the action. This frees you to make money by selling to athletes and parents, or creating your artistic masterpieces.

Equipment

It is not necessarily true that you need exotic telephoto lenses and expensive motor drives to be a good sports photographer. The truth is that you need fast reflexes and good picture sense and that you can get by with a minimum of equipment. In some instances, you may only need your camera and normal lens if you can get close enough to the action. Of course, you can fill the frame with longer lenses but I know many photographers making their living shooting sports who never use anything longer than a 300mm. So before you invest in zooms and tele lenses, try your hand at a number of events and determine for yourself what you need.

In the beginning, long lenses and motor drives are not helpful in your learning to shoot sports because they tend to take away from your efforts by making it too easy. If you can perfect your technique with your SLR and one or two lenses, imagine how good you can be with motors and long lenses.

If you can afford a second lens, I would recommend a lens in the 135-200mm focal length. You might consider a zoom in those focal lengths. While they are slower (transmit less light at their maximum apertures) than fixed-focal-length lenses, zoom lenses provide you with a great deal of flexibility in framing and composition.

Get used to using fast films like Kodak Tri-X and Ilford HP5 and familiarize yourself with push-processing by either doing it yourself or trying out various labs who offer the service. There are times when you will have to push-process your film (increase the film's rated speed by underexposing—i.e., ASA 400 to ASA 800—and overdeveloping), particularly if you have a night assignment or one indoors. Flash is sometimes the answer but if you are 75 yards from the action, there aren't many flash units that will do you much good.

Motor winders are extremely useful when photographing action because they free you from having to take your eye away from the viewfinder after you expose a frame. The low initial cost of these items makes them an ideal part of your equipment.

Techniques

There are a number of action-stopping techniques that you must call on if you are going to be a successful sports photographer. They will be briefly outlined here.

Exposure

You should, if you've been practicing, know how to get good exposures by now, but exposure becomes critical when photographing sports where the players have helmets or caps that obstruct facial features from clear view. For this reason you have to be sure of your exposures.

You may not always want to rely on your

One thing you can do to help the sharpness of your pictures is to tighten the film after you have loaded it into the camera. Simply rewind the take-up spool until you feel tension. This stretches the film tightly across the film plane, thus taking any slack out of the roll of film.

in-camera meter for determining exposure, particularly at night or indoors. If you use the meter to "average" the scene, you may be way off. Your best bet where you may have extreme lighting conditions is to get up close to a neutral gray (or similarly toned) object and take a reading of that and correlate your remaining exposures to that setting.

When outdoors, remember this handy rule: For frontlighted subjects in full sunlight the formula for proper exposure, regardless of what film you are using, is: 1/ASA at f/16. If you are using Ektachrome 200, your exposure would be 1/200 at f/16 but since there is usually no 1/200-second shutter speed on 35mm SLR's, you would round it off to 1/250

at f/16. When shooting events where the players have helmets or billed caps on that obscure their identities, open up at least ½ f-stop. When play is sidelit with bright sun, open up one full f-stop over the bright-sun reading. If the action is backlit, open up two f-stops.

Always choose the fastest possible shutter speed for any action situation unless you want to blur the images. For instance, if you have a choice of three operable shutter speed/f-stop combinations ranging from 1/30 at f/8 to 1/125 at f/4, you would choose the latter despite the fact that f/8 would give you more depth of field. People are used to seeing sports photos with a minimum depth of sharpness. Rely on fast and accurate focusing and the shortest possible shutter speeds for getting sharp pictures.

Panning

Probably the most effective means of stopping fast action is to "pan" with it. By panning is meant following the moving action laterally through the lens as a hunter would follow running prey through his sight. You can pan with the camera on or off a tripod and if you are steady and pan through after the exposure (instead of stopping abruptly), you can stop even a speeding race car with only a 1/15-second exposure. The panning motion should be smooth and fluid and you should squeeze the shutter release at the appropriate moment.

When panning with a slow shutter speed, you will totally blur the background while keeping the subject sharp. With faster shutter speeds the background will still be somewhat blurred but not nearly to the degree as with a slow shutter speed. If you want to diminish a distracting background that will detract from the excitement of your main subject, try panning with your subject at a shutter speed of 1/15 to 1/60-second. This should effectively blur out the background. For special effects, try panning at even slower speeds like 1/8 down to a full second. You can get some innovative images this way. You will be amazed that when you pan at the same approximate speed as the subject, keeping it centered in the viewfinder, you will get a surprisingly sharp subject despite the relatively long exposure.

You can reduce or eliminate camera movement by learning to squeeze the shutter instead of snapping it off. Use the finger tip and become sensitive to delicately activating the shutter.

Action's Direction and Shutter Speeds

It is useful to know that when shooting ac-

tion, you need a slower shutter speed to photograph action coming toward the camera than you do to stop action moving diagonally or laterally across your field of view.

For instance, suppose you are using Kodachrome, a slow color slide film, to photograph a motor race late in the afternoon. It's not the best film choice for this situation, but let's assume it's too late for you to do anything about it. The fastest possible shutter speed you can get with the existing light and your lenses is 1/125-second. This 1/125 will probably not stop action going diagonally or laterally across your field of view unless you pan, but you want the background of the spectators sharp. The answer is to position yourself so the cars are coming straight at you (in a manner of speaking—don't get on the racetrack). Then you would be able to freeze the

cars and background, depending on how close you are to the action (or how long a lens you have, which accomplishes the same thing as moving yourself close to the action).

Distance is another variable affecting shutter speed choice. The farther you are away from the subject (the smaller the image in the viewfinder), the slower the shutter speed needed to stop the action. Conversely, the larger the image or the closer you are to the action, the faster the shutter speed that is needed to freeze the action. I have photographed swimmers using long lenses and just focused in on their faces. For this, 1/2000-second was not fast enough to entirely freeze the action.

Generally speaking, however, a 1/250-second speed will stop most action, even very rapid action. It is always a good idea to use

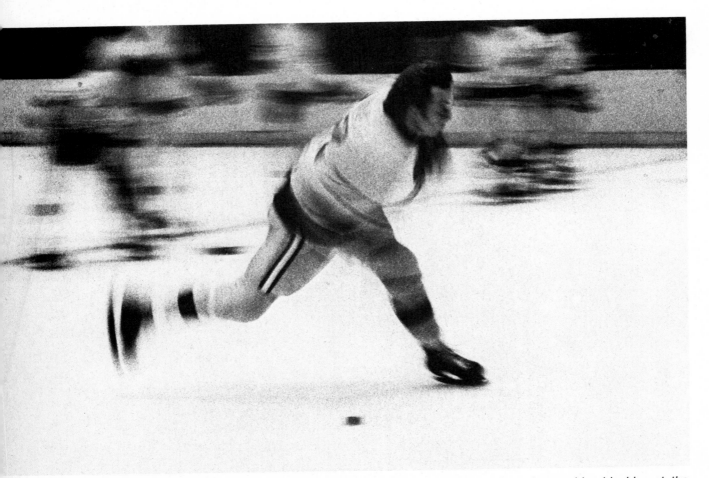

You can even get sharp pictures with a ⅛-second exposure. Although there is considerable blur at the periphery of the image, the main part of the image is sharp. This image was made by panning with slow shutter speed on shooting hockey player.

the fastest shutter speed possible and choose your film and equipment with that in mind.

A tripod helps immensely in eliminating movement. You can get away with using the next slower shutter speed to stop the same rate of action if your camera is on a tripod. You will find that by loosening the controls on the tripod and keeping a firm grip on camera and lens, you have as much freedom as if you were handholding the camera.

Focusing

Often it will be humanly impossible to focus fast enough to capture a sharp image of the action. You will then have to call upon the techniques known as *guess focusing* and *zone focusing.*

Guess focusing is a system of prefocusing the camera on a fixed point that you know the subject(s) must pass during the course of events. For instance, with a man on first in a baseball game, you would prefocus on second base in the event of a stolen base or double-play try. You would also use guess focusing for a sport like football where no one in the stadium knows what the next play will be. You can guess and if you guess a running play, you might prefocus the lens on the line of scrimmage and hope for the best.

Zone focusing is a system of prefocusing that incorporates the full use of a given lens's depth of field. Practically all lenses have depth-of-field scales inscribed on the barrels or have depth-of-field charts included in their instruction manuals. With this information you can gauge, at a given focused distance, the range of sharpness for every aperture on the lens. For instance, using a hypothetical 135mm lens, at f/8 the depth of field may extend from 10 feet to 13 feet. This is just an example but if you wanted your subject sharp and it had to move through a similar band, you could prefocus the lens at the most likely point within that area and get a sharp image.

Peak Action

If you merely photograph the action with a short shutter speed, you have photographed stop-action. But, if you capture the action at its high point, then you have captured peak action. All action (except certain forms of continuous action like racing) have a rise, a peak, and a fall or a conclusion to the action. For instance, consider a diver on a springboard. The diver jumps up in the air (the rise), stops in midair (the peak), and descends to the water (the fall). If you learn to look for the peaks of action, you will not only be capturing the action at its most important and energetic phase, but you will find that because the subject may be suspended momentarily in midair, like the diver, you will not need as fast a shutter speed to freeze the action. While it may take 1/125 or 1/250-second to stop the ascending or descending diver, it may only take 1/60-second to freeze the diver at the peak of action.

Knowledge of the Game

All of the techniques in the world won't do you any good if you are not a student of the

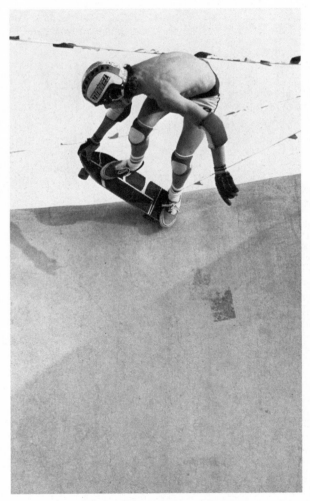

Every action has a rise and fall. In between, the subject hangs motionless in midair. This is the peak of action. Knowing when this will occur will allow you to photograph this split second. Here a skateboarder is caught in midair.

game you are covering. The more you know of the sport, the more you can anticipate where the action will occur. In addition, your timing and shot selection will improve greatly because you have become a more discriminating observer.

When you are just starting out photographing action, it is best to choose a sport that you know and like. The more you enjoy watching a certain sport, the more you will enjoy photographing it. Sounds pretty obvious but if you really enjoy all the complexities and nuances of a given game or sport, you will involve yourself on more than just a superficial level and your pictures will reflect that involvement in terms of quality.

Making Money Shooting Sports

Once you feel relatively competent shooting sports, it is time to reap some of the profits from all that practice. One of the easiest ways to gain experience as well as make a few dollars is to photograph Little League or Pop Warner competition. The action is unsophisticated but the competition is usually fierce and coaches and parents will be delighted to pay for a few reasonably priced prints. You won't get rich doing this because people generally won't spring for any more than $5 to $10 for a good 8x10, but you will build up your photographic and business skills, and at this level, your failures won't be noticed as

Racers of any kind are interested in photographs of themselves competing, especially if they are doing well. Recording the racers' numbers with their names and addresses before the race could lead to many sales after the race.

Even sailboat races have a potential as a money-making venture. You will need a long lens to shoot this type of race, however. This shot was made with a 1000mm Nikkor mirror lens.

much as if you blew the seventh game of the World Series.

It is always best to go through the coach when working with kids. Write him a letter or speak to him at practice and explain what you'd like to do. Ask him to tell the boys and girls that you will be taking photos of their games and practices for a while and to tell their parents that if they are interested in prints, to contact you.

You could also put up a sign on a fence to remind kids and parents of your services, and be sure to show up early at games and practices so people can avail themselves of your services. If you stick with it, people will begin to think you're part of the team.

When photographing adult amateur competitions, you can not only charge more for your services, but you can use a little more sophistication in your sales approach. Running races like marathons, half-marathons and mini-marathons attract huge groups of amateur runners. Races run recently in California have attracted as many as 25,000 runners! That's a lot of potential customers. The big thrill at such events is finishing the race, and that is where you can make your money, on the home stretch.

First, however, before the race has even started, you should have a sign-up booth. Using a big sign, high enough for many people to see, advertise "photos of runners finishing—no obligations." The runner must have already registered before you can sign him or her up because you need to know his running number. Once they are registered,

have runners fill out a name and address card and their number, and give them a big yellow or red dot to put right on their number, not obscuring it, but so that the dot and number are visible. You can get these dots at stationery stores. They come on transfer sheets and can be found in the label section of the store.

Position yourself on the home stretch, not actually at the finish line where there is usually too much excitement. Whenever you see one of your runners coming, prepare yourself and try to get off as many frames as possible. Usually two or three are all that you will be able to get.

Shoot negative film and have contact sheets made. If you shoot slides, give the lab instructions not to mount the slides. Have a contact sheet made from the strips of transparencies. Later, with a magnifier, examine the proofs to find the runners' number and then simply snip the proofs and enclose them in an envelope with your price list. You should make at least 100 to 200 percent over your cost because there is a lot of nuisance work involved in this type of business affair. People will usually pay 7-15 dollars for a machine-made, spotted 8x10 print of this type.

Don't sign up an unrealistic number of runners. All your shots won't turn out and you just simply won't be able to spot hundreds of different runners.

You will find, however, that most of the runners you photographed will want prints. If your success rate is good, you may even be able to deliver prints to all the people you signed up.

 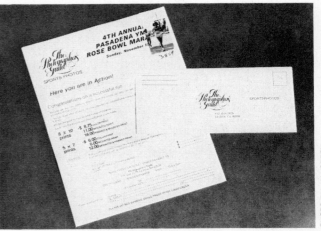

Here are two examples of organized money-making sports photography ventures. Proofs of racers are mounted on order forms along with a price list. See text for more details of how these work.

Marathons are not the only events that attract large numbers of amateur athletes. Bicycle touring races attract large numbers of riders and provide the same thrill in finishing as does a marathon. You can work the same type of business here but your reflexes will have to be a little keener to get consistently good frames of the speeding racers. It is best to position yourself diagonally or laterally across from the finish line so that the racers are not charging you head-on. They are very difficult to identify and photograph accurately when coming at you rapidly head-on.

If you are more ambitious and industrious, you can photograph the racers and runners and market your photos in a little different way. By contacting the race promoters in advance, and arranging permission to contract out your services for the entire field of participants, you greatly expand your potential market. For instance, at a marathon, instead of signing up each runner who wants to be photographed, you simply shoot as many runners as you can, using two cameras and an assistant to keep your cameras always loaded. When the race is over simply have the film processed and proofed normally.

Since you have the blessing of the promoters, and *you have arranged in advance for them to furnish you with a complete listing of the names and addresses of the participants, correlated by their race numbers,* you now set about the task of mailing a proof and price list to each participant you have photographed (see pg. 59). Very few participants will reject a good photo of them racing.

This system takes capital in advance; and, there is some risk. You may not sell all of the photos you take and since costs like processing, proofing and mailing are high, you will have to sell quite a few to break even and make a profit. But as with any venture with risk, you can stand to make quite a handsome profit.

You will need a commitment to this type of business as it takes a lot of coordinated effort after the race to make it work. It takes an accurate numbering and bookkeeping system at home and good clear photography at the race track. But if you are organized, you stand to make a healthy profit.

You can gain access to future events by taking out memberships to associations affiliated with the sport. For instance, with track, if you belonged to the Amateur Athletic Union (AAU), they would send you a schedule for

Sports analysis photographs can be a profitable line of work. Here an equestrian jumper's style (left to right, top to bottom) is isolated with the use of a high-speed, 10-frame-per-second Canon camera. High-resolution film was developed in Perfection fine-grain developer for maximum visual information. (Photos made with the help of Bill Anneman.)

the year's upcoming events and you could plan your shooting schedule that way. With motorcycle racing, there is the American Motorcycle Association (AMA) that would furnish you the information. Every sport has such an association and the membership fees would be a bona fide expense for the operation of

you won't need to assign the competitors a dot or a number; just have them list the time and place of their match. Simply show up and photograph "your client" and be sure to keep track of who is playing whom and on which court and when. For this type of venture you really have to have an organized system to avoid getting the players confused.

With the more advanced players, sometimes you can pick up a few extra dollars by documenting their game, or a certain aspect of it, during practice. Coaches or parents will pay good money to see certain phases of a swing or delivery isolated in still pictures so they can analyze what's wrong with a player's game.

Sports analysis photos are invaluable for a great variety of sports, not just tennis. In fact, it's difficult to think of a sport where clear photos of the style of a competitor would not be desirable. But before you can cash in on this aspect of your trade, you must be familiar with the players, and they with you. Also, you must have an exceptional familiarity with the game if your photos are to be meaningful.

Track and field events represent a real grab bag of photographic opportunities. In a track and field meet there are no fewer than a dozen separate events going on. Each represents different photographic problems, but by and large they are easy to photograph. Working for the organizers of a track and field event will allow you to cover the best of each of these sports and enable you to concentrate on the top competitors.

There are many opportunities for sales at these events as well: The organizers, who will want to republicize the event next year, parents of the athletes, coaches and the athletes themselves will be among your clients. The opportunities are so varied, you can't help but come up with some great shots.

Along these same lines are the Special Olympics, which are regional games held at different times of the year for "special" children. I have photographed these events in years past and there have been few events so personally satisfying to shoot as the Special Olympics. There is a lot of love as well as competition at these games, and everyone partakes. People will hound you for pictures after the games are over, and if you make arrangements with the various schools partaking in the games, you should be inundated with print orders afterwards.

If you have access to rapid processing, or can do the lab work yourself that day or eve-

your business and thus deductible from your income at tax time.

One word of caution is in order. Be sure to send out only the sharp and well-composed proofs. After all, since the racers didn't sign up for a picture, they won't be expecting one to come in the mail. But if you send them a proof that gets them interested enough to order one of your prints, and then the picture turns out blurred or unrecognizable, they will be mad, to say the least. You probably won't get paid either.

If you like tennis, try photographing club matches. You can use the same type of sign-up system as you did for the marathons but

Special Olympics are like no other sporting events in the world. The competition is good and there will be plenty of markets for good action photos, from parents to organizers.

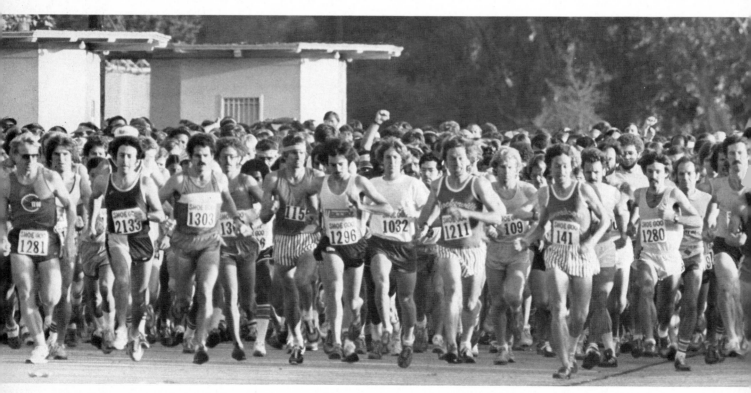

Marathons are a great way to make money with your cameras. In some of the larger runs you will have as many as 10,000 potential clients! See text for details on organizing such a business.

ning, you can capitalize on your promptness in more ways than one. If you can get film processed and proofed that same day, you can put the proofs on display that day and start taking orders immediately. If the event spans several days as track and field or Special Olympics tend to do, you can display the proofs the next day and have someone taking orders for you while you are out shooting that day's events.

Intramural teams for schools and businesses are another excellent way to make money in sports photography. Since intramurals are not newsworthy events, participants are ususally thrilled about the prospect of photos of their athletic prowess. Furthermore, prints can be displayed in business lobbies or dormitory waiting rooms and the exposure will surely help your growing business.

Another market is the art sales of your sports photographs. Sports of all kind are very popular and people are constantly looking for sources of good action shots for posters, displays and framed wall hangings. Your local department store may be interested in buying some of the larger prints, particularly if

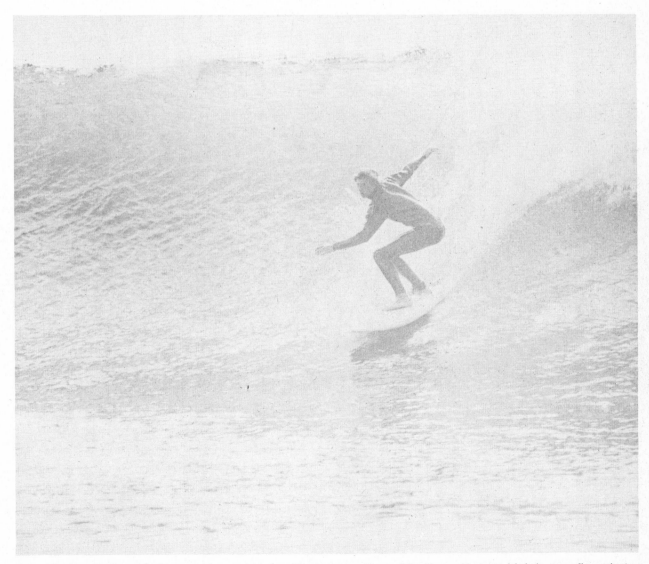

Special-effects pictorials have a big market as gift photos or for publications. Here, a high-key surfing photo is made even more delicate by underprinting. Anybody interested in surfing would be interested in purchasing well-presented prints of their favorite sport.

you have them nicely mounted and sprayed (to eliminate glare) so that all they have to do is frame them. You may even find some of the chain department stores who are interested in your sports photographs. If a few of your photos are picked up in a national chain of department stores for sale in all their branches or as a catalog item, you better contact an accountant who can help you count all the loot you will be receiving. A single photo sold in this manner could be worth as much as $5000 depending on the arrangements that are made.

On a much smaller scale, you can sell your sports prints through local marts or fairs or at shows and bazaars sponsored by a charitable organization. Display your mounted or framed prints in a consistent and pleasing way and make sure your material is prominently dis-

This is a special-effects shot of a basketball game taken while zooming in with a long shutter speed of one second. The lay-up is blurred as all action moves toward the basket. This special-purpose photo also has a lot of varied applications, from publicity and advertsing to gift-photo sales.

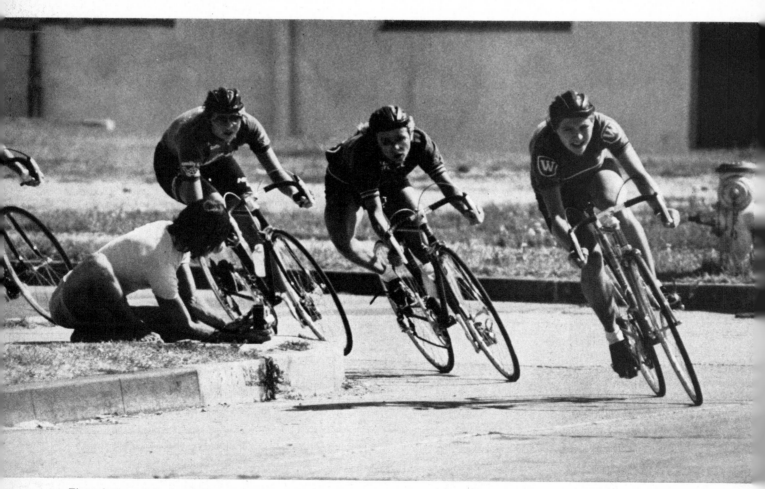

The photo made from the unusual angle will be the one most likely to sell. Note the photographer only a few feet away from the racers, obviously using a very wide-angle lens.

played if at all possible. People are likely to pay more for material they would hang in their homes, so be sure to price your work accordingly. Remember to include your frame or mounting costs as well as overhead and don't be afraid to charge more if it is a really great shot.

If you have a strong body of work, try to get it displayed around town as often as you can. Banks, local merchants who might want to tie in a sports theme with their merchandise, or even sporting goods stores will all be interested in displaying your work, particularly if it doesn't cost them anything. The payoff for you comes in additional exposure and publicity for your talents. This showcasing of your work can have a very positive effect on getting new assignments in the realm of sports as well as other areas of photography.

As the number of your sports shots grows, think about consulting a stock photo agency that can represent your work in a variety of different marketplaces. The standard fee is usually half the money received for use of your photos, but it is worth it because an agency can reach many more people than you can as an individual. Consult sources like the yearly *Photographer's Market*, published by Writer's Digest Books, or *Photographer's Market Place*, published by R.R. Bowker, for listings of various agencies as well as a healthy list of possible markets for your sports photos.

Regardless of the degree of your involvement in sports photography, there is no doubt that it is an excellent way to extend your interest in sports as well as an excellent way to make money with your cameras.

You can extend your coverage with a remote unit like this one sold by Ritz cameras. It allows you to activate the camera by means of a radio transmitter from a good distance away. This is ideal for hard-to-photograph sports. Arrange permission with the organizers first, however, to make sure your camera position will be undisturbed.

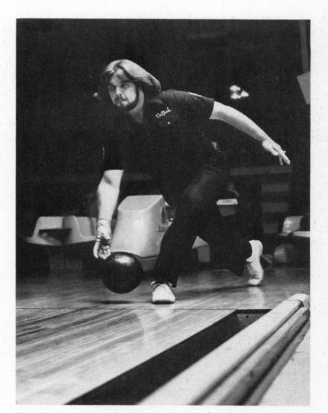

Bowlers and bowling leagues can be among your most active clients. Arrange with the league to present your services to teams. A good setup is needed. Here obvious permission was established with the bowling alley as the shot was made from an adjacent lane. Bowler Jon Griggs was photographed just after releasing the ball. Flash was bounced off side wall and ceiling above.

News and Public Relations

A lucrative field in many communities can be news and public relations photography. If you have the basics in equipment and skills, you can find an outlet for your news and PR shots. You may not be able to work for your city's major daily newspaper without the needed tools and experience, but there are hundreds of other markets just waiting to be tapped.

Virtually every company with more than 50 employees has a need for internal or external public relations photographs. Newsletters, weekly in-house magazines, spot bulletins, mail-out pieces, and press releases are just a few of the places photographs are used. Most times, if a business has a public relations director, he or she will do the photography. However, many firms soon discover that unless the publicist is a talented photographer, his efforts will cheapen the value of the finished piece. Therefore, they would rather hire a free-lancer to come in and do a good job for a reasonable price and thus free up the public relations person to do a better job at what he or she is most qualified to do.

There is also the area of spot news, which can be a lucrative business in a small community for a free-lancer with ambition. Many small-town papers simply can't afford full-time photographers. Or if they can, they will choose someone who will act as photographer and picture editor. Most small papers and magazines will use free-lancers to supplement their own coverage of an event, or expand their news-covering capability.

You can tap both of these markets with a strong portfolio and a sackful of good ideas. This is particularly true in the area of news photography. An editor will be twice as likely to listen to a talented photographer with a good portfolio and sound story ideas as he or she will to merely a talented photographer. Someone who knows the needs of the publication and the flow of events within the com-

Motor-driven 35mm SLRs are often the order of the day for the news photographer. They are generally equipped with two normal lenses, a wide-angle and a short telephoto. Two generations of motor-driven Nikons are pictured here.

munity can be invaluable to an editor, particularly since the free-lancer is not a salaried employee. Consider the publication's different sections and arm yourself with a half-dozen ideas that encompass several areas; for instance, with a newspaper, think along the lines of the sports, business and food sections if applicable.

Equipment

The same basic equipment can be used in both types of photography, although with news photography you will undoubtedly find more people using the 35mm format. With PR photography, many medium-format cameras are still in use because of the larger negative size. Regardless, most photographers doing this type of work have two camera bodies, a selection of lenses from very wide-angles to moderate wide-angles to short- and medium-length telephotos. In addition, a powerful electronic flash will be called on quite regularly to supplement existing light. Here is an area where the news and public relations photographers part ways. The news-oriented photographer is primarily interested in reality and capturing it and will therefore use flash only as a last resort. Even then, he or she will more than likely bounce the flash so as to make it appear more like natural, existing lighting. The PR photographer, on the other hand, will use flash without hesitation because it gives a sharp, well-lighted rendering of the scene or group. It may be less flattering overall than available light, but you usually only have to make one or two exposures to get your picture.

A handheld light meter, either an incident or a spot meter, is also a necessity. Rounding out the list is a lightweight camera bag that will both hold a lot of equipment and be comfortable for the photographer after working long hours.

The news and PR photographer is constant-

Timing and picture anticipation are needed to make good news pictures. Here, Richard Nixon is caught "V"-ing the crowd during his inaugural parade in 1973.

Camera bags for the news/PR photographer should be small, strong and light. Pictured here is the Omni bag, which holds quite a bit of equipment for its size.

ly on the go—the quicker and lighter he can travel, the better he likes it. This is why you see news photographers with two or three cameras around their necks, ready to jump on a story the minute anything significant happens. They usually have two normal lenses, a moderate wide-angle (say 35 or 28mm for 35mm format), and a short telephoto, say 85-100mm. They will also usually use one shorter and one longer lens as well.

Fast films are the order of the day for both black-and-white and color, and push-processing will be called for as often as not. PR photographers using flash do not find the need for push-processing the faster films; however, knowledge of push-processing will be helpful on occasion.

Mental Techniques

The techniques required for both types of photography are similar. You need good reflexes, good anticipation and good picture sense. Moreover, you have to be a good hustler to be successful at these types of photography. You can't be shy about picking a location or moving around the principals in a pho-

If assigned to "get a shot of the Vice-President," as was the assignment here, you must bring back more than the record shot. Look for situations that define the personality of the person. Here, then Vice-President Gerald Ford was photographed just as he was being announced to give a speech.

tograph. After all, the main difference between your pictures and another photographer's of the same event may only be the angle from which your photos were made.

Instinct is one of the most important ingredients necessary for this type of photography. You must be able to anticipate what will happen next as a story unfolds. In a sense, you must be able to predict what will occur next. When a story does not clearly present itself, you must be able to analyze the situation and create storytelling photos from the existing scene. This takes practice to perfect, and a lot of what is called instinct is just native talent. However, keeping attuned to the fact that a news event is a story will help you to think of it in terms of a pictorial narrative.

In everyday news situations, story elements are not always obvious. When you are called on to photograph a press conference of a politician, for instance, you must look for pictures that modify the obvious story. Get there early and stay late and look for the aspects of the politician's behavior that are not typical. Look for things that tell more than the fact that this person is making a public proclamation. Look for scenes that show the politician as a human being.

Of course with public relations photography your task is quite different. Your client wants a specific point of view projected, so instead of being a great investigator looking for different angles and viewpoints, you must be a good director and manipulator of people. This may sound quite cynical, but I have found that people in front of a camera in public are like sheep. They usually do not know what to do with their bodies, they desperately want and need direction, and usually they will do precisely what you tell them to do.

Learn to rely less on your meter and more on your photo sense. If at a loss, the film sheet packaged with each roll of film is like a spare light meter.

I once photographed a high-ranking government official in Washington, D.C., on a weekly basis; sometimes twice a week. He was always gruff and rude to me and although I didn't take it personally, I crossed him off my Christmas list early. I came to find out later that he was not always that way with people, just photographers. So, one day when I was photographing him with a number of guests, instead of issuing verbal instructions, I put my cameras down, walked over to the group and physically moved everyone into position. I told them how to look and where to look, and I guided their shoulders and hands into the exact position I wanted. I had always wanted to do this and once I did, I had immediate results. The photos were the best I had yet taken of this particular official and from that day on, he was never rude to me again. He also remarked that the pictures were among the finest he'd seen of himself.

The point of this story is that you must be sure of exactly what your client wants, and get the results by firm direction.

Speedy Camera Handling

Speed is another essential ingredient to either brand of photography. You must be able to get the shot you need quickly and surely. In news photography, the opportunity may not present itself again so you must have the technical expertise to get the shot right the first time.

Speed of operation comes from familiarity with your equipment. It has been said that you can never be too familiar with your own equipment. Knowing what the camera feels like as it nears the end of a roll, always remembering to turn on the flash, gauging apertures by touch, checking X-sync; these are all things that should be done instinctively and quickly so you can pay strict attention to the other aspects of the job. With certain types of PR shots, you may have less than one minute to make your pictures, or worse yet, the client may want two poses done in under a minute. You will find this true when the people are important or where there are many groups to be photographed in a short span of time.

You can reduce the time it takes to get ready to actually photograph an event by learning to make your exposure determinations without the use of a meter. For instance, if you shoot in one type of building that has fluorescent lighting, determine exposure by use of your meter, but remember the readings. If the opportunity presents itself to shoot more pictures elsewhere in the building, compare exposures. If they are the same, chances are the lighting is identical throughout the

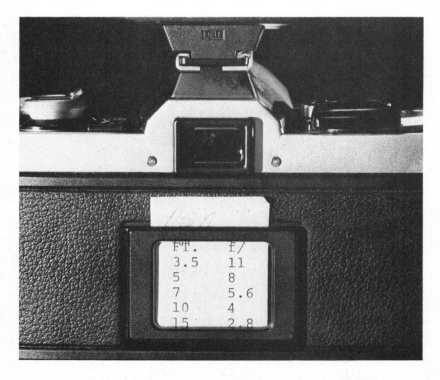

When using flash, learn the distance/f-stop combinations by heart. If you forget them, for the type of film you use, insert a reminder card on the back of the camera. Remember, you may need to use different guide numbers from those the flash manufacturer gives you. Test the guide number with a roll of slide film to be sure. The right aperture at 10 feet times 10 (100) equals your correct, effective guide number.

building. You will also note that when people are not under a bank of lights, the exposure will be less than if they are. Also you will soon get the hang of the types and numbers of lights used to illuminate indoor working situations. With time you will learn that for a certain type of fluorescent illumination you will need, for instance, 1/60 at f/4.5 to get a good exposure using Tri-X at E.I. 800 with development in Acufine. This is just an example, but you get the idea.

Switching film and equipment back and forth only hinders speedy operation. You should be able to determine exposure with your basic film types, indoors or out, without the use of a meter. For instance, working outdoors, if your subject is illuminated by bright sun, your exposure is equivalent to 1/ASA at f/16. If your subject is sidelit, the exposure is equivalent to 1/ASA at f/11. If backlit, exposure is equivalent to 1/ASA at f/8. If in shade, your exposure is equivalent to 1/ASA at f/5.6 and if in deep shade, the exposure is equivalent to 1/ASA at f/4. Of course you will need to interpolate shutter speeds and apertures to accommodate the requirements of each scene, but your base exposures can be determined without the use of a meter. If you have doubts, check the film sheet packaged with each roll of film. It's as good as a spare light meter.

Similarly, if you use flash, you should be able to quickly judge distances in your head, and set the flash aperture accordingly. More and more photographers rely on automatic flash units to determine exposure, but you need to know how to use distance and guide numbers for those situations that are out of the ordinary. For instance, you have positioned your subjects in front of a light wall. The principals are wearing light summer suits. Your flash sees this and when you press the shutter release, voila, your photos are two stops underexposed.

Instead of relying on automatic flash exposure, learn to use the guide number scale and

Large groups are often difficult to photograph. Here a single flash at the camera was angled upward to avoid overexposing the foreground. Expressions of the group were controlled by keeping them interested in what I was doing and not letting them lapse into self-consciousness as a group. See text for details.

This is the type of candid, on-the-job portrait a PR photographer might be expected to make. Here a portrait was made of a young architect at his desk with the emphasis on his eyes and face. Longer shots were taken, but this was the most effective of the job portraits made.

Here's another example of an on-the-job portrait you might be asked to make. This one is a formal-type of portrait as can be seen by the lighting which was accomplished with two 500-watt Photofloods. Portrait was made on a weekend so it would not interrupt work patterns and was done on 4x5 film so that it could be used as a formal portrait and also enlarged just for a head shot.

gauge distances quickly in your head. The formula is as follows: Flash-to-subject distance in feet divided into the guide number equals f-stop. A 10-foot distance with a guide number of 110 equals an exposure of f/11; simple as that. If you can't do division in your head quickly (a lot of photographers are like that), learn to remember the distance/aperture combinations for your flash and film combination. This is crucial to speedy camera handling. For instance, if at six feet proper exposure is f/16, mentally associate the 6s in your mind to more easily remember. If at four feet the exposure is f/22, think of some other way to recall the numbers. If your memory is as bad as your math, the other side of the film box top is a great place to write down the distance/f-stop combinations. Tape that to the camera back or insert it in the memo clip for easy reference.

Posing and Expression

Good posing for public relations shots is essential if you are to get repeat assignments. For a single person, working at a desk or pretending to be working, follow the rules of good portraiture and angle the body sideways so one shoulder is closer to the camera than the other. Try to make the props seem realistic and the work activity authentic. If you have arrived on the scene to make a candid photograph, you must make it look unposed.

The same is true of group photos. The people shown must be relaxed and either engaged in conversation with each other or looking at the camera. If they are looking at each other it is easy to get natural, pleasing expressions, provided they aren't talking with a person or persons they don't like.

It is much easier to get natural and authentic shots when the principals look at the camera. You have to rely on the familiar, "Say X#$¢&X$% (expletive deleted)" to get a good expression.

Always angle the subject's shoulders sideways so that they don't face head-on to the camera. People to the left of center (as you look at the group) should have their right shoulder forward, their left receding. The opposite is true for the people to the right of center as you look at the group. If it is a large group, interweave the shoulders and "stack" the people in close together. This is a pose unfamiliar to most people, but not at all displeasing.

Whether you want a smiling or serious pho-

Sometimes being in the right place at the right time can mean the difference between good pictures and none at all. These photos document a tornado that just whipped through a suburban shopping center. Photos were taken minutes later. Though not great, the photos helped create a good contact with the picture editor of the local paper, which later contributed to my being hired as a news photographer for a rival news agency.

tograph of people, you have to keep them absorbed in conversation. Most people talk most readily about themselves, so try to talk about things they are intersted in—the stock market, business, or if you happen to see children's photos in their office, talk about kids. If you want a smile from a group, the simplest way to get it is to tell a joke. If you want a serious expression, keep talking while you make the photograph, concentrating on the right moment when all the people look sufficiently engrossed in what you are saying. Then take the picture.

With large groups it is hard to tell when everyone looks good. With groups of over six people, you should make at least three and possibly four exposures. The reason for this is that you will almost certainly catch someone in the group in a blink or bad expression. The

bigger the group, the more likely you will be to catch someone blinking. Draw people out if they are acting self-consciously and this will help alleviate most of the bad expressions.

Where possible, you should flank people in a photo so that tall people are near tall people and shorter folks near other short people. If possible arrange the photograph so that the tall people are at the back of the group or at either end, thus forming a more symmetrical composition.

With really large groups, where you may have to use a wide-angle lens, avoid placing anyone's head near the corners of the frame area. You will elongate the person's head and stretch the individual's face to unflattering proportions.

If shooting candids at parties or other social affairs, keep in mind that you should make as

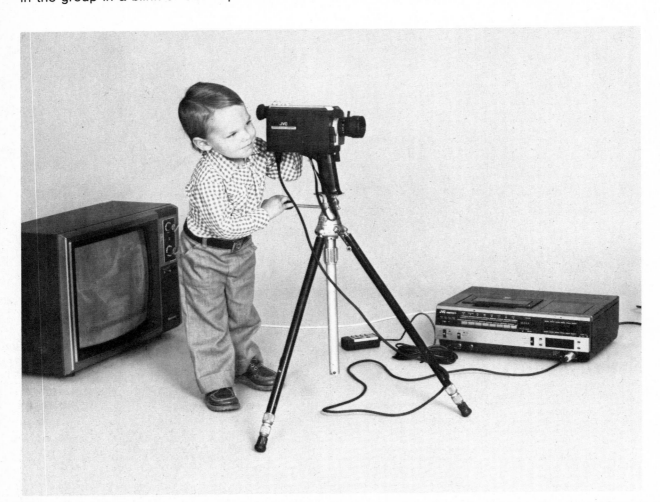

Publicity shots don't have to be award-winners, but they do have to convey basic ideas about a product or service. Here the idea that video tape is so easy to use that a child could do it is handily presented.

many group photos with as many pleasant, *recognizable* faces as is possible within the period of time you are allotted. If it is impossible to photograph the group as is (people talking in groups when at social affairs tend to close ranks and form a circle or semi-circle—very difficult to photograph), walk up to the person at the end of the group and either nudge him slightly into a better photographic position, or interrupt the group and inform them politely that you want to make an informal candid photograph and would they please continue what they were doing and not pay any attention to you.

The closer the group of people is to forming a straight line, the easier they are to focus on and when using flash, the easier they are to properly expose. If shooting available light and the group is in a semi-circle, you will

normally not have enough depth of field with a wide aperture to get everyone in focus unless you switch over to a wide-angle lens. If using straight flash, you will have the depth of field problem solved because of the bright light output, but you will overexpose the people closer to camera and underexpose those farther away. This is a small point, but if you have to burn and dodge each person in the group photo when printing, you soon learn to get them lined up in more of a straight line.

If using bounce flash, be sure that the ceiling or wall surface you are using to bounce your flash off is suitable for your needs. For instance, all ceilings are not the same in terms of light reflectance. Some of the acoustic ceilings virtually eat light directed at them. Other types of ceilings look like acoustic panels but are really not and will reflect much

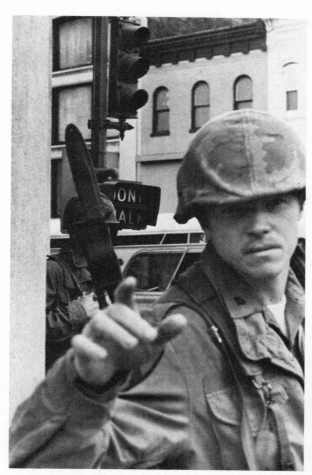

When covering spot news events like this demonstration in Washington, D.C., cover it from both sides. The picture editor will thank you.

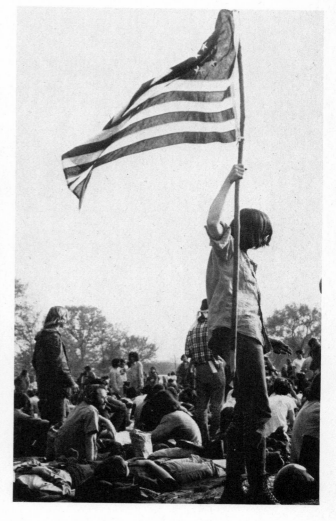

more light than you might imagine. Be sure to analyze the situation carefully before you begin shooting.

The general rule of thumb for bounce flash is to open up between two and three f-stops more than the reading calculated by measuring the distance from flash to ceiling (or wall) and the distance back down to the subject(s) divided into the guide number. For instance, with a 12-foot ceiling, measure the distance from flash to ceiling (say six feet), add the distance from ceiling to subject, say 10 feet; divide that into the guide number (say 160 for simplicity's sake), and you get f/10. Open up 2½ f-stops and that will give you f/4—your correct exposure.

Captioning and ID

It is essential you remember who's who after you take the photographs. You must write down, from left to right, the names of the people in your photograph. Number your caption sheet to the number of the roll of film you are shooting. Identify the film canister with a label or by writing on the metal with wax pencil. Identification of the person or event is all that is needed at the time of the shooting. Later on you will need to polish the information into a caption.

Captions generally are as short as possible, but must contain five vital statistics for each

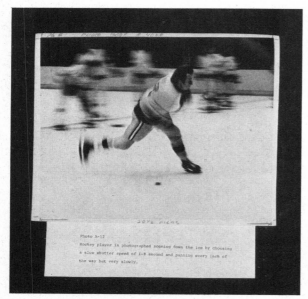

Photos can be captioned with a caption sheet that is separate from the photos, or it may be attached to each photo like this one.

and every photograph: who, what, when, where and why. Each caption must have the five W's or it may be useless to an editor. Accurate identifying information is also crucial for proper billing and filing of the prints and negatives.

When actually preparing captions, you can attach them directly to the photo by means of a strip of paper taped to the bottom of the print, or you may supply a separate caption or ID sheet. Keep the captions short and to the point, using only the pertinent information. If a photo is a dupe of another, briefly abbreviate the information on the secondary photograph or refer the reader to the caption information of the first photograph.

Breaking In

Like any area of photography in which you must deal with a middleman, a good portfolio is the order of the day. Show various types of photography including news, sports and feature photography.

If you are trying to break into news photography you will be seeing editors, and when you do, be armed with ideas for their publication. Review their magazine or newspaper before you go in to see them and comment on a feature of the periodical that lets them know you are aware of the type of material they feature. If possible come up with several ideas for photography or articles. Even if the majority of your ideas are rejected, it lets the editor know you are a thinking person capable of more than just good photography.

When interviewing to get jobs in public relations photography, you will be dealing with company publicists. They too will need new ideas for presentation of pictorial material, but for the most part you will be flying on your past achievements, unless you have the good backing of a friend or company employee.

Following both types of interviews, keep in touch. Don't let your initial contact go to waste. If you can follow up your visit a week or so later with an outline of several story ideas, or some ideas on exciting visuals at their facility, it will be to your advantage. Even if your note just stresses that you enjoyed the meeting, it will do a lot to help your contact remember you should a photographic need arise.

Legalities

Concerning the photographer's position regarding news photographs, the press photog-

rapher is allowed to legally photograph any person, scene or situation occurring in a public place. Further, the news photographer can photograph safely, without fear of legal reprisal, any person, scene or incident that can be seen from a public place.

Personalities, too, can be safely and legally photographed in public. This includes any type of public figure from sports stars to criminals. People in the public eye have few rights of privacy. For more information on press photographer's legal rights, see *Photography and the Law,* Watson-Guptill Publishers, New York, NY.

Pricing

There are several ways to price your work, depending on the agreements you make with the client beforehand. For instance, if the client wants you to make 15 pictures at a given event, you may charge him a per-picture cost if you are sure he will buy all those requested. If the client is not sure of his final needs and just wants you to shoot and he or she will look at proofs afterwards, you should charge an assignment rate that will cover your costs, time and, profit—say $75—and then charge a per-picture cost for every individual print he or she asks for.

You could also charge a straight day rate for your work, but many PR firms may not need your services for much more than a few hours at a time. An hourly rate such as $45 per hour might be more appropriate. Then you would charge your costs afterwards under the heading of "Expenses," and in addition you would charge a nominal print price; much less, however, than if you were simply charging a per-picture cost.

To protect yourself, you must charge for travel time and time spent waiting to get the job shot. If you spend only five minutes shooting but must wait an hour to shoot the job, you should be compenstated. Social events such as dinners and receptions are notorious for running overtime and if you don't make

PR photographers are often called on to make large group shots that show how many people attended an event. Most times, a wide-angle photo like this one is composed of two separate exposures during one—the lights above are very bright, while the crowd below is usually two stops less in exposure. Compromise in initial exposure and then correct in printing by burning in the top, and holding back the bottom section.

provisions, you will be losing money while you are cooling your heels.

If you plan to shoot mostly news events, you will probably be charging a day rate or half-day rate. This simplifies matters greatly because with a day rate the client pays your rate plus expenses and a print charge on top of that.

Ownership

You must establish beforehand who owns what rights to the photographs. If you are working as a free-lancer for a newspaper or magazine, the publication generally owns the pictures but will usually assign you the right to sell the photos elsewhere, provided the sale is not within a specified period of time and not to a direct competitor. With publications, the party that pays for the shooting of the pictures owns them.

With public relations photos, the negatives generally belong to the photographer. This allows you to profit from reprints, which could become a sizable part of your future income. The difference in ownership practices results in part from the power of newspapers and magazines in this country and also from the system of pricing. The publication reasons that since they are being charged your fee for your performing a service, and that they are

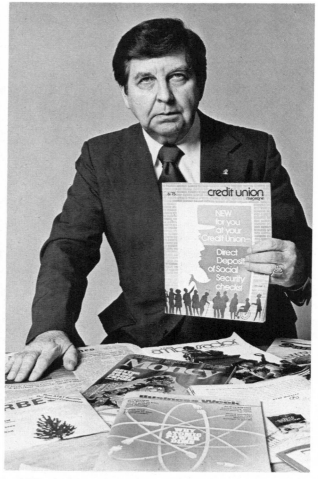

Here's a sampling of two different assignments the news/PR photographer might be called on to shoot. A formal studio portrait (left) was made with electronic flash and several props. Lighting is simple: a main light, fill light and a back light. The expression is also uncomplicated; serious and straightforward. The second shot (right) shows the same person depicting an editorial idea about his company's magazine. Pose and expression are intentionally different and less objective than in the portrait. This photo was made with a single flash with umbrella in front of a gray background.

picking up all costs, they own all rights to the photos made. It's as if you were commissioned as an artist to create something; or like an artisan, you are contracted out to build something. The client here retains ownership just as the patron would retain the artwork and the customer would retain the product of the artisan's labor.

Since public relations firms and companies are often only charged per-picture rates, ownership doesn't usually become an issue. For a single price the firm gets a single picture, of high quality, of a specified event. If they pay the per-picture rate again, they are entitled to another photograph, or reprints of same at a reduced rate. They would not, however, be entitled to own the negatives and subsequent sales unless they made prior arrangements to purchase the negatives outright. This is not generally a good idea unless the firm is willing to pay unusually well to retain the negatives.

Although many part-time photographers who decide to take up news or public relations photography won't end up on major dailies or with high-powered jobs at big magazines, it can be a great and interesting way to make extra money with your cameras and a way to foster excellent relations with an important segment of your city's business and commercial community.

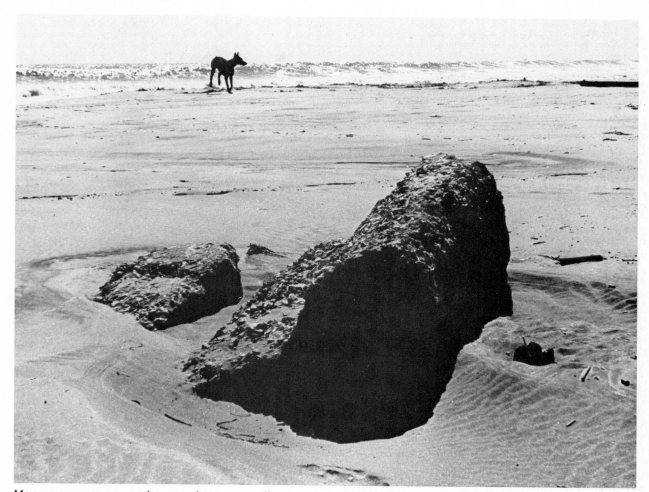

Many newspapers and magazines as well as newsletters and house organs are using more feature photography—pretty pictures that are used usually large and embellish the printed page. Here is an example of a beach photograph that illustrates the serenity of the beach in winter. Many photos like this one you would have in your files and could be sold from stock to local publications.

Children and Pets

What better way could there be to make extra money with your cameras than taking pictures of kids and pets? Children and animals are among the most intense sources of joy for people, and an endearing photo of either will have lasting value to the parents or pet owners. This type of photography is not easy; a lot of patience and understanding are called for. But the rewards can be great; people will pay dearly for a true likeness of their pet or child.

Both of these types of photography are grouped together here because they present similar problems. As mentioned, patience is required for both; and similar equipment, lighting and posing techniques are called for as well.

Getting Started

With either type of photography, you must put the word out to people to advertise your services. For children's photos, put up a business card and sample of your work in several local pediatricians' offices. These doctors' walls are filled with kids' photos anyway, and they will probably be glad to let you put up your card and photo. Another place to adver-

tise is in the local shopping circulars or newspapers, especially on Wednesdays or the day when the shopping coupons appear. There is a larger female audience, usually women with families, on these days than on any other day during the week. You may also try getting a small show of your work put up in the local bank, or other public lobby where people waiting will get a chance to notice your work.

These last two techniques work well for pet photography as well. In addition, try putting up samples of your work in pet stores, kennels and veterinarians' offices.

Pricing

Pricing your work becomes a special problem in light of the fact that with kids and pets, there is a distinct possibility that because of distractions or an unwillingness to pose, you may not get a single salable photograph. To cover yourself and to insure that your clients will get photos they like, charge a sitting fee as you would for adult portraiture. This fee is nonrefundable and will protect you from clients backing out and not ordering any prints. A sitting fee should be reasonable, particularly since a great deal of your future business will

Even small babies can be photographed well. Here, a small child only five months old was photographed in his portable crib. A single flash was bounced off the ceiling for the series.

be generated by word of mouth. The sitting fee is a photography charge and covers nothing more than your time and expertise. Use your pricing guidelines to determine a fee, and include direct costs, overhead, time and profit.

Remember that you will be charging per photo as well, so your fee should not resemble day-rate prices. Generally, a suitable sitting fee for such photography would be between $25 and $50.

On top of that you have a charge per print. You can set up minimums to insure that you will at least break even, or your first-print

A child's natural expressions are the ones that will last forever and will be the ones the parents will most likely buy. Here window light was augmented with bounce flash from above for a natural look.

To get children to relax, give them something to play with. The child on the left has my light meter, which did the trick of distracting him while I got ready to catch him in a candid shot.

charges can be on the high side to protect against small orders. Again refer to your cost and profit analysis to come up with a definite figure.

If a retake is called for, the first retake should be done free as a courtesy but the second or even more should be carefully analyzed to see if it is not somehow the fault of the client that the photos are not turning out. If a retake is called for because of something uncontrollable and you never even get to pick up a camera, then you should charge a minimal waiting fee to cover your time and reschedule the shooting for a later date. Generally, you should assume that the customer is always right (within reasonable limits) if you want repeat business. But if there is a problem that you see as unresolvable, refund the sitting fee and move on.

Equipment

Equipment needs are similar for both types of photography. Generally 35mm is best because it is the most flexible system, and 35mm lens systems provide greater inherent depth of field than medium- or large-format lenses.

You should use lenses a little longer than your normal lens—say 85-135mm. This is so you can remove yourself somewhat from curious subjects who like to poke at your lenses. A motor drive is often helpful to catch fleeting expressions, but the noise may sometimes prove to be an unnecessary distraction, especially with animals.

An electronic flash for stopping quick move-

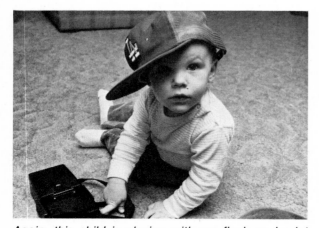

Again, this child is playing with my flash so he let me put the baseball hat on his head without too much fuss. Light is bounced off the ceiling.

Candid photographs of kids, even when their faces don't show, make good sellers to the parents.

ments is a must. Flash is used indoors and out for this type of photography. The flash should be powerful enough to use indoors as a bounce light, and you should have the capability of removing the flash unit from the camera.

You will also need a sturdy tripod and a long cable release, especially for child photography, so you can get out from behind the camera to interact with the child or pet. The kind that are made of soft rubber with a rubber bulb at one end are the best. They come in lengths of six, eight and 12 feet and are available at most camera stores.

Lighting

Indoors and out, lighting is similar for both types of photography. Outdoors, available light is called for but you must fill shadows with flash or reflector cards. See the chapter on outdoor portraiture for more information on controlling available light.

Indoors, straight flash is usually unacceptable for all but childrens' parties. The harsh shadows and deep contrast are unflattering for both kids and animals. Bounce flash gives soft, even lighting but often it is too soft and undirectional to realistically light the subject. Try merging bounce flash with directional, soft window light to give a beautiful, three-dimensional feeling to the scene. Measure the intensity of the window light falling on your subject and adjust the distance (or intensity) of the bounce flash so that the flash is at least ½ to one full f-stop less than your window light reading. You must be careful that you use a

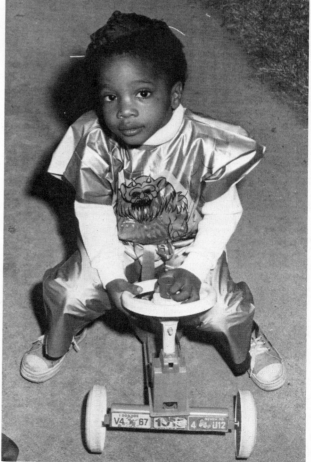

Kids' parties can be a great way to make extra money. Just photograph some of the cute things that go on, try to blend into the happenings, and you will have some priceless shots parents will love.

fast enough shutter (no slower than your X-sync speed) and that your subject is not moving around during exposure. Sometimes when you mix light sources, ghost images will result from a moving subject.

When working with kids or animals, I like to use available light as much as I can because it is most natural, indoors and out. I carry a tiny flash unit with me to use as a highlighter. It is weak in comparison to the available-light readings, usually two stops less in intensity, but it builds up highlights on cheek bones (non-furry ones) and puts a gleam (catchlight) in the subject's eyes. The little flash is old and inexpensive, costing less than $10 when new, but it has paid for itself over and over by adding just that extra touch which separates a good job from a great job.

Such a highlighter is particularly useful for picking up the frontal exposure when photographing furry animals. Fur cannot be adequately lit frontally and must therefore be lit from the rear. Most of the time bounce flash (synched via a sync cord) will provide enough fill for a good exposure. The highlighter will give you that extra "pop" in the eyes and face of the animal, and it can be easily fired by attaching it to the camera hot shoe.

Posing Children

Unlike adults, children will not respond well at all to posing instructions. You must there-

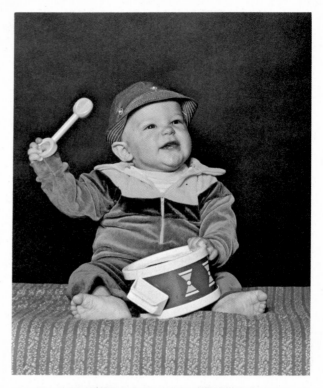

These three photos have several common denominators. The lighting is all electronic flash bounced into an umbrella. Flash stops the speedy movements of little subjects. Props are also common to all three shots. In each case, the prop became the vehicle that allowed the little guy to relax and elicit a natural, pleasing expression.

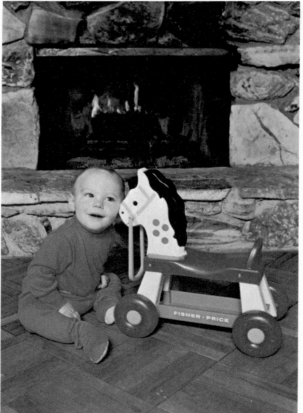

fore engage a child in some type of enjoyable activity in order to get a natural expression. Arrange to bring a few props suited to the child's age. These are to be used during the photo session and not beforehand. Their uniqueness wears off quickly enough as it is, so the props must not be seen until you are ready to make pictures.

Have everything set up and ready to go before the child comes into the room or onto the scene. To facilitate setting up, it is good to have an assistant along with you. He or she will not only be invaluable as you set up, but can also help you when you actually take the pictures by making amusing faces or operating a hand puppet or other toy. Your assistant can also help with things like turned-over collars, or mussed hair. If an assistant's presence will help speed up your operation, it is worth it to have one along.

ABOVE: *This likeable portrait of a child in his home was done in only a few minutes. As I recall, only a few exposures were made. The key was making the child positively anticipate the picture session. Lighting was accomplished with two portable, bounced electronic flash units.*

LEFT: *To get this little child to even crack a smile was a major achievement. Although she had her lollipop, the only way we got an acceptable picture was for her father and I to clown around off camera.*

Your biggest obstacle in getting good child photographs is the child who mugs for the camera. Little children under three don't usually have the sophistication yet to mug for the camera but older children do and will. This is why it is so important to photograph a child at work or play at one of his or her own special activities. If your subject is a Little Leaguer, hand over the mitt and ball; if your model is a fingerpainter, bring out the paints. A child engaged at his own special activity will also add to the authenticity and charm of the photographs. Dolls and special toys also help in both relaxing the child and adding naturalness to the photos.

The use of helpful distractions is a must in getting the child's attention. I often use a hand puppet or put my hand under a dark cloth and pretend it is a creature of some type (usually not a scary one). When this wears off, I hand over my car keys, or a

Using a tiny, weak flash at the camera and another flash off camera will give you a nice multiple lighting setup. Tiny flash is triggered by the hot-shoe, larger flash is triggered via a PC cord.

A panel of shots of a child doing different things or in different poses will be a big seller. Often, parents don't know this service can be performed. This is a reduction from a 16x20-size board.

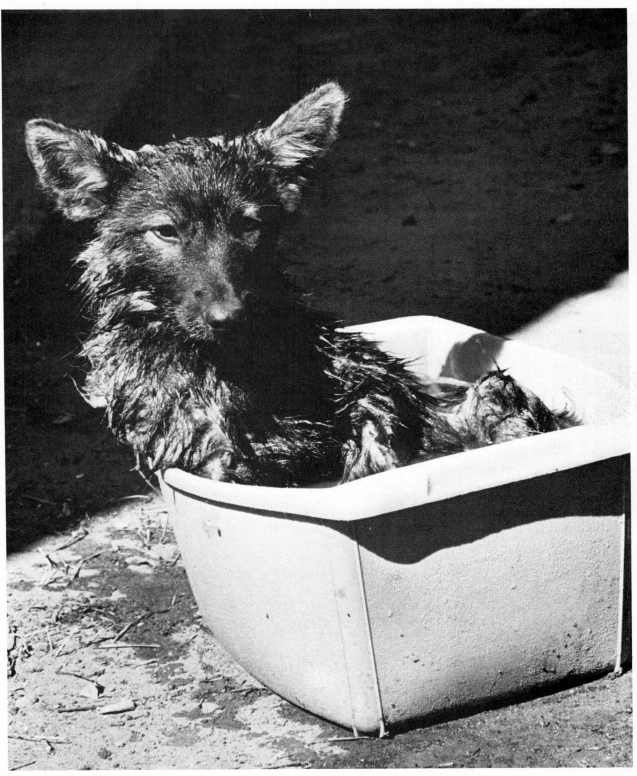

This is the exception to the rule that pets should look alert during a photo session. The idea here was to show a lazy pooch taking an afternoon bath.

quarter—anything that will temporarily amuse the child and make him or her trust me.

You may think the picture-taking process goes on quite a while. No way. In fact, a session will last no longer than 10 minutes with a small child, and often less. You don't have to call it a day, but you should take a break after 10 minutes of shooting. Reward the little one with something—a book or post card, anything positive. Thus, the child will work with you again in a few minutes. Use the interim time to let the child get away and resume a natural course of behavior. You, in the meantime, set up a different situation: change the lighting or props or location so that you give the impression of several different sittings. This will help your sales too.

You can usually shoot at least three different sittings within the course of a single shooting. At least you should aim for that. Your time will be around an hour, including breaks.

Always try to leave on a positive note. I try to let the kids help me put my equipment away. It gets them involved with what has just happened to them and lets them feel a little responsible. It also helps foster a good attitude about photographers and picture taking. If you have to come back again, or if you want repeat business in the future, try to leave on a good note each time.

Posing Animals

If you have never tried to make a portrait of a dog or cat, you cannot appreciate a good animal photograph. Believe me, it is an exercise in futility. The discussion here will center around domestic animals like dogs and cats, not wild animals.

You must have the pet owner with you so that the animal feels safe and not threatened. When possible it is good to work outside, but there are often too many distractions. There is also the problem of space. You need to restrict the movements of the animal to a small enough area for good photography. Outdoors, dogs and cats tend to want to roam around. Indoors, you must also restrict the animals' movements without threatening them. Corners are good, as are seamless sets, as long as the master is nearby and the space is not too small.

If possible, animals, like children, should be photographed in their own habitat with their own possessions. A cat likes its toys and a

Formal portraits have a lasting appeal. This photo, although made in a studio, was done using simple soft key light and a soft fill light on different sides of the camera.

This photo, done at the same time as the black-and-white portrait, has a completely different feeling. Color, a change of clothes, a different look and a little different type of lighting are all that are needed to give your client a variety of different sittings to choose from.

dog will like an old blanket or other belonging. These props will help keep the animal in the area you want. Food is also helpful in keeping an animal in one spot.

When you are fully set and ready to go, you must bring the animal to attention. This is easily done by whistling, or clicking your heels or making unusual sounds, but not too loud or you'll scare the animal. Whatever works to bring the animal to a state of alertness is what you must do. None of these methods will last for long, but do not be content to make exposures if the animal is listless at the moment.

More so than with any other type of portraiture, the owner expects a lifelike, animated likeness of his pet. You must therefore be sure that you get the animal to do what you want during the sitting. Treats and verbal commands from the master will help you get the animal in a variety of photogenic poses.

Most animals become lazy and inattentive after they have eaten, so keep them alert with the promise of food but do not let them have a full feeding until after the picture session. The exception to this is the hyperactive animal who is constantly moving. Eating may quiet this animal down enough to make some pictures.

Just as you would pay attention to a child's clothes, pay attention to the animal's grooming. Most animals will appreciate a combing or brushing and regard the action as special treatment.

It is important that you give the animal time to adjust to you and your equipment. This period can be when you arrive or just before you shoot, but if the animal is not made

Photographing friendly beasts takes a fast hand, a sharp eye and a lot of trickery and deceit. Here, Choo Choo strikes a charming pose while she waits to receive a treat from her master. Electronic flash was used for fill-in lighting.

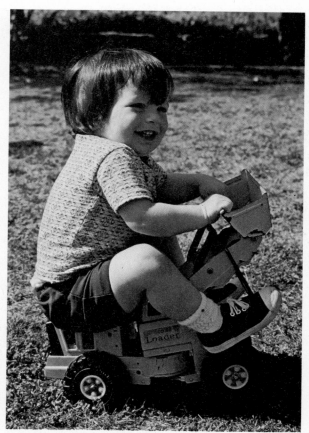

Careful framing and the right moment combine to make this shot a winner. Note how exposure was a compromise between shadow and highlight.

aware that you are not a threat before the photo session begins, you may not get any good photos. A frightened animal will perform terribly in front of the camera and the results will be fit only for the trash can.

For more information on photographing pets, see Walter Chandoha's fine book, *How to Photograph Cats, Dogs and Other Animals,* Crown Publishers, New York, NY.

Photographing children and animals are specialties in themselves from which you can earn a good living and immense personal satisfaction. Practice and patience are the essential elements at becoming accomplished at either or both. As the saying goes, if at first you don't succeed

Just the opposite reaction is found here. The dog was held alert by looking at someone eating across the table from her. Lighting is from window light with a fill card used to the left of camera.

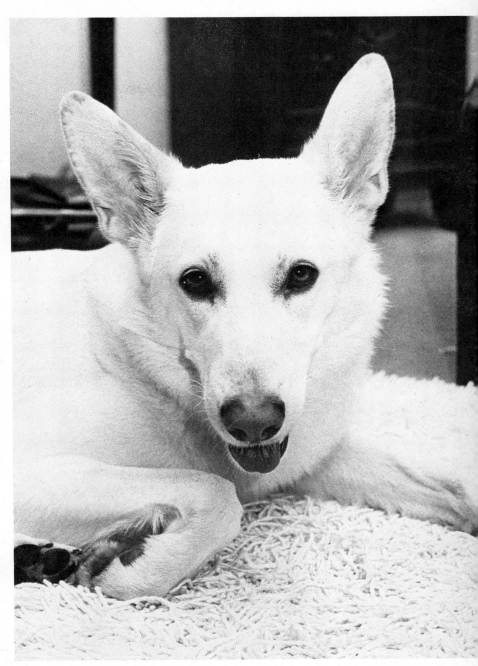

ABOVE: *This is a variation on the bear-skin-rug photo. The dog's beautiful face was highlighted by careful positioning. The dog kept wanting to lie down but I kept whistling, which would make him sit up alertly. Lighting is bounce flash.*

LEFT: *These three photos, taken at different times of my own dog's life, have special appeal for different reasons. The key to all of them, however, is that they really capture the essence of Spanky's personality.*

Architecture

Architectural photography is a specialized field of work that, on the surface, would seem most difficult to break into. However, there are many ways to make money shooting architecture, most of them a lot less glamorous than you would probably imagine. For instance, there is the business of shooting construction progressives for architects, contractors and builders. Or, there is real estate photography—working for an agency or string of agencies, providing the service of photographing multiple listings for display or advertising. Or, you can photograph architectural interiors for the makers of office or industrial equipment. The manufacturers of such equipment will pay good money for good pictures of their equipment in use on a site. Finally, there is what is generally perceived as ar-

Architectural detail of building below. None of the lines is corrected since the idea is to show the visual impact from the ground looking up. Inclusion of trees humanizes the structure as well as serving as a frame for the structural elements.

Finished architectural photographs describe the architect's dreams and the finished reality. By keeping the camera back parallel to the bulding's vertical lines, you will render the building perfectly vertical. Bright frontal lighting gives the building an open feeling while the appearance of the shadow side of the building gives it depth and the notion of three-dimensionality.

chitectural photography—photographing striking buildings in fabulous surroundings for glossy magazines. While you may do only a very small percentage of this type of work, there is a lot of money to be made shooting architecture. And, you don't need a lot of fancy equipment to do it.

Most architectural photographers shoot with 4x5 view cameras using exotic wide-field lenses and balloon bag bellows. But you don't always need such sophisticated equipment, especially to take record shots or nonillustrative type pictures. This chapter will show you

how to photograph architecture using your small camera and a selection of lenses, and how to get professional-looking results. Most photographers assume that with the small-format cameras you are not able to correct visual distortions and align vertical and horizontal planes. However, with a 35mm camera you have a much wider selection of lenses to choose from. With this diversity of focal lengths and some basic shooting techniques you can correct almost as many visual aberrations as you can with a view camera. Of course you don't get the large negative size, but then again, you don't have the expense either.

Architectural Basics

Most people forget when photographing buildings that they are three-dimensional objects and as such, must appear to have three dimensions when photographed in a two-dimensional medium. Buildings must appear to have volume. The easiest way to show volume is to show two or more sides of the structure. Flat, single planes look like cutouts pasted on a backdrop. With lighting and camera angle, you can make the building appear to have depth.

Inside or out, the more planes you show,

Keeping the camera perfectly vertical and being far enough from the structure to fill the frame without tipping the camera up or down will ensure perfect verticals. This photo was taken at an introductory phase of construction along Atlantic City's famed boardwalk.

Details of interior design are easily documented using bounce flash. Here, flash bounced off the ceiling to illuminate this brass bedframe is tinged with the warm tones of the brownish-colored ceiling. The effect enhances the old-time feeling of the room's decor.

the greater the impression of depth and also the greater the recognition of the various components of the structure. For this reason, wide-angle lenses are used almost exclusively in architectural photography. They allow the photographer to "back up" when there is no more room and to show spaciousness and volume.

Besides being three-dimensional, a building is also made of specific materials and fulfills a unique purpose. Photographically, it is the responsibility of the cameraman to show those materials and that building's function by lighting, angle and composition.

The most frequent problem encountered when photographing architecture is the convergence of vertical lines. In reality, the brain compensates for lines converging upward, and we perceive buildings as vertical and the horizon as horizontal. The lens cannot make that adjustment by itself, however. View cameras with their swings and tilts make it easy to control linear convergence as well as to control perspective—something that must be precise and accurate if the photo is to faithfully render reality.

The photographer must also be conscious of how the building relates to the environment it occupies. For instance, is a structure a sealed entity, enclosed totally from the outdoors, or is it a structure designed to let people perform their duties inside and out and thus more spatially open and free of enclosures? You have to capture on film these intrinsic qualites that have been incorporated into the architecture.

To be a good photographer of architecture, you must be well versed in the discplines of architecture. You should know how to read a sight plan or blueprint, and you should know enough about construction techniques and materials to have an intelligent conversation with an architect or builder. You must not only understand the terminology, but have a good instinct for what could and would be

Architectural photographs require precise metering for accurate exposure. An incident meter (right) can be used for measuring light falling on the structure, but a spot meter (left) can be more effectively used in architectural photography to define the brightness differences within the scene as well as the precise area you want to expose for.

Using a hand spirit level on the side and back of your camera body is a sure check to see if your camera is parallel to the vertical lines of a building. Check horizontal and vertical leveling for proper perspective control and if you are too close or too far from your subject, change lenses to compensate. Do not tip the camera up or down to include subject; this will undo your corrections.

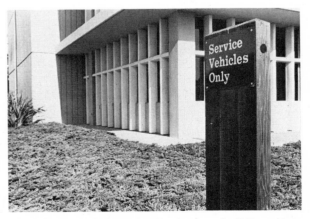

Another architectural detail of same building. Note how with small format, simply aligning verticals keeps the building standing upright in the photo.

required to illustrate and document a structure's existence. Often architects and contractors do not know what they want or how they want it done. Sometimes you must be able to assume what their photographic needs will be and act on your own instincts.

The best way to gain an understanding of architecture is to take a course in it. If you can't do that, the next best thing is to study architectural forms and techniques by taking books out at the public library. Whatever the method used to get acquainted with the profession, be assured that the more you know about the discipline, the more useful the information that will be conveyed in your photographs. Look at your information-gathering stage as an investment in your future profit-making abilities.

Equipment

As mentioned, this chapter will show you how to shoot architecture without a view camera. It should be noted, however, that there

are obvious limitations with small format. But, you can take accomplished architectural photos if you work around those limitations and use the small format to its fullest capability.

So, aside from your camera, you will need a sturdy tripod, and cable release, and a wide-angle lens; for 35mm cameras, a 35, 28, 24 or 21mm lens will be needed. You should also invest in some high-quality filters for black-and-white photography as well as a polarizer, which is used quite often for neutralizing nasty reflections and selectively darkening or lightening parts of the image area.

A more expensive yet extremely versatile tool of the architectural photographer is the spot meter. This allows the photographer to meter critical areas of the photo and gauge exposure accordingly. It will also tell you, by virtue of measuring a scene's light and dark extremes, whether you should even shoot the structure, or wait until a different part of the day for better lighting.

The final piece of equipment you will need,

1

2

These three photos represent the different effects daylight has on the shape of a building. These photos were taken at three different times of day all from the same place. This type of excercise may be assigned by the architect so that he can better see the way his building is perceived at different times of day. Photo No. 1 was taken early in the morning; the building shows great depth and the most important parts of the church, the front and entrance, are well illuminated. Photo No. 2 is taken at midday and because the sun is overhead, the building apppears one-dimensional. Photo No. 3 is taken late in the day and as a result the wrong parts of the church are emphasized. The front is in shadow while the less important side of the church takes on visual prominence because of sunlight.

3

Eliminating distracting elements from a scene will help the viewer's eye focus on the architecture. Here, Lucy the Elephant has been isolated from all the distracting telephone lines and custard stands that surround her by using a wide-angle lens and moving in close. Some distortion resulted but it was a small price to pay for eliminating surrounding distractions.

Here everything is working well together. Camera back is parallel, foreground and foliage have been included for emphasis, and a Chromofilter (one half clear, one half graduated tonally) used to darken upper portion of photograph.

and this is essential to small-format architectural photography, is a hand spirit level (see pg. 94). These are invaluable for aligning your camera back and tripod camera base in order to achieve accurate horizontal and vertical positioning.

Techniques

As already mentioned, the first and foremost requirement of an architectural photo is that the building be erect and the ground be a true horizontal representation. In order to achieve these true verticals and horizontals, the camera must itself be perfectly vertical and horizontal.

When arriving on a site to photograph a building, the first thing you should do is choose a suitable location that will show two

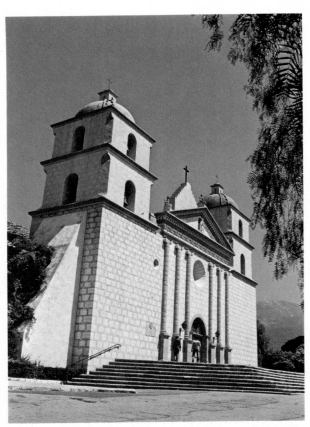

Framing the photo with foliage helps add depth and the warmth of nature to the building. Here the Santa Barbara Mission is photographed so that it is intentionally distorted. This keystoning is caused in part by the wide-angle lens used, and exaggerated by tipping the camera upward. Note that the inclusion of passersby in the scene helps lend scale to the structure.

or more sides of the structure, with one side preferably in shade, the other brightly illuminated by sunlight. It must be an effective location that allows the building to occupy the right amount of space in your viewfinder, and it must be an area free of distracting elements like parked cars and telephone wires.

A detail of the same mission can give an entirely different feeling to the same structure.

Once you have chosen a suitable location, set up your tripod and level the base, horizontally. When you look through the viewfinder, you will note that the ground appears natural and that the building appears normal, excluding its vertical lines. If you have to aim the camera upward to fit the entire building in the frame, you are going to get a keystoning effect and an unnatural rendering will result. You must therefore position your camera so that your camera back is vertical—you are not aiming it up or down to accommodate your subject matter.

What if it is a tall building that won't fit in the frame when the camera is vertically aligned? You must then go to a wider angle of view. You must choose a lens that accepts the building in the viewfinder, top to bottom. Or, you must bring the camera itself upward so that it is closer to the true center of the building. If you are near a high-rise, or a hillside, you might be able to do just that, but don't count on it. Another alternative is to literally back up a long way and use a telephoto lens to photograph the building from far off. You can thus accommodate the building in its entirety and align verticals more easily. A final, most expensive, alternative is to buy or rent a PC (perspective control) lens. These are wide-angle lenses whose elements actually shift within the lens barrel, thus allowing you to realign the focused image. Although these are quite exotic, they are often

If you can drop back far enough you can still render the building as perfectly upright, but your horizontal planes will recede slightly. Here you cannot see the building's far edge, so it looks corrected.

Note the lighting on this architectural close-up of sculpture at same mission. Lighting gives it form as well as visually describing the stone work details.

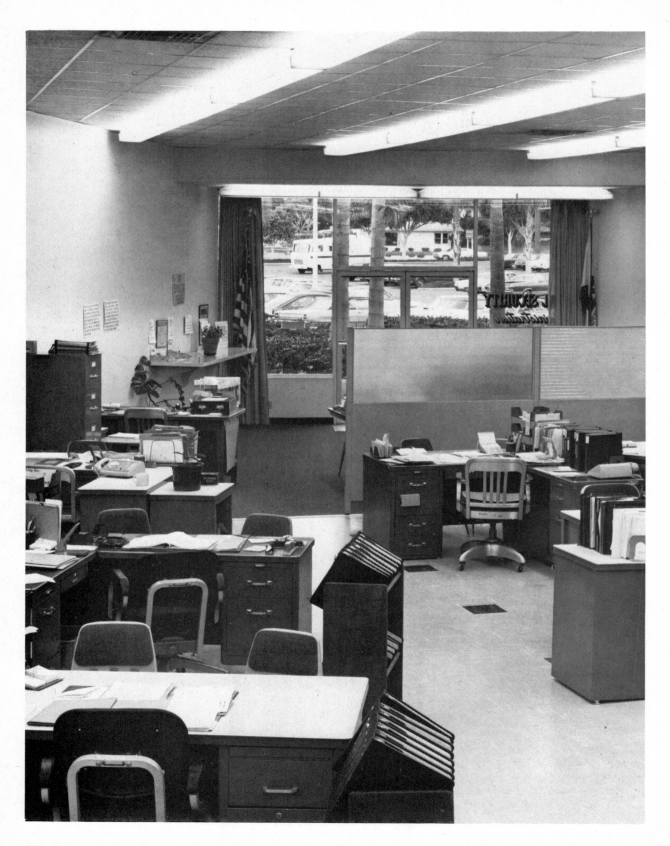

the only way to align a building to obtain an accurate rendering.

Exposure

Exposure is critical for making a good rendition of a structure. Often because of a building's sheer mass, the difference between the highlight and shadow sides of the building will be greater than the 4-5 f-stop range that black-and-white film is capable of handling. The eye, of course, adapts and accepts the difference between values. The film, however, will not.

The problem is further magnified when using color film where the ratio of light to dark becomes even more critical. Since it is impractical to wield a gigantic fill card in next to the shadow side of the building, it is often necessary to compromise in the area of exposure. If the extreme light and dark tones are unimportant, place the exposure somewhere between the shadow and highlight readings. Otherwise, since you have no provision for underdevelopment with color film, it will be necessary to expose for the highlights and allow the shadows to fall where they may. You could wait for another time of day when the ratio is less extreme, but often that is not practical. In black-and-white photography, you have the option of exposing the film for the shadows and reducing development. This helps the film accommodate the broad tonal range of the scene. You must be sure, however, that you don't have anything else on that particular roll of film that will be adversely affected by the underdevelopment.

Since overall sharpness is essential in architectural photography, you will be using longer exposures and smaller apertures to increase your depth of field. You will also be using slower-speed, higher-resolution films because your camera will be tripod-mounted. Your goal is maximum sharpness and maximum film resolution and to gain these, your exposure must be right on the button, particularly since the slower-speed films have considerably less exposure latitude than average or fast films.

LEFT: *Interiors often present drastic brightness ranges within the same scene. Note there is detail outside the office as well as inside. Careful exposure and development and careful printing helped bring out all of the detail. By getting up high and cropping in on the photo you get a great feeling of openness in the room.*

A spot meter will help greatly in determining proper exposure and determining light ratios. You must remember that a spot meter, like any exposure meter, gives its data in terms of medium (18-percent reflectance) gray. What this means is that whatever the meter sees, it gives you an aperture/time setting that will render that object medium gray. This is good and bad. If you point your spot meter at a sandstone building, the meter will give you an exposure to make it gray, not white. Conversely, the meter will give you an overexposed reading if you point it at coal-black marble. Either situation is unacceptable.

However, the spot meter will force you to think about exposure intelligently. Since you know how the meter thinks, you must find a medium gray for the meter to look at. The best medium gray comes off an 18-percent reflectance gray card. Sounds intelligent, doesn't it? There are compromises; green grass reflects about 18 percent of the light incident upon it, but there are different types of grass, with different reflectance values. You are much better carrying an 18-percent gray card and using it to meter your exposure. Use the spot meter to determine how light or how dark a given highlight or shadow is but base your exposure on the gray card for proper overall exposure.

Focusing

Just a few words are all that are needed to cover focusing, but it is important to mention because most people will assume that since they are using a tiny aperture, everything in the photo will automatically be sharp. This is not necessarily true. Remember, you are after maximum sharpness. Buildings and their surrounding landscaping occupy massive areas of space that severely tax the limits of depth of field.

Try to focus on a point between ⅓ and ½ of the way into your subject. Stop down and check depth of field with your depth-of-field preview. Vary the focus in and out until you have achieved the maximum depth at the taking aperture.

Lighting

Generally, it is assumed that the best light for photographing architecture is early-to-mid morning and mid-to-late afternoon. The reason for this is that the sun is lower in the sky and will more fully illuminate areas of the building hidden in shadow most of the day by

overhangs or balconies. The light at these times of day has a more specular quality and is tinged with warm tones, particularly early or late in the day.

If a building is textured, or has a unique pattern that is important to illustrate, the light should skim across the surface of the building. The closer to head-on that the light strikes the surface, the more texture and form will be eliminated. Conversely, you can obliterate texture and pattern almost entirely by choosing a time of day when the sun strikes that face of the building head on.

Examine the pictures on page 95 to see what difference the time of day makes when photographing architecture. Note that the prominent face of the structure should be in bright sun and thus highlighted. The secondary plane should naturally be in shadow. Look what happens when these planes are reversed and the secondary plane is in sun and the frontal plane in shadow. You get visual confusion—an illogical rendering of the structure. Again, examine the photo where both primary and secondary planes are illuminated.

Here, you get no depiction of form. The building looks one-dimensional and flat. The third photo is acceptable. The frontal, primary plane is brightly illuminated while the secondary plane is in deep enough shadow to provide good contrast.

Composition

The rules of good composition apply to good architecture photography, with certain modifications. Whereas in good scenic or people photography, your center of interest usually occupies one of the tic-tac-toe grid crosspoints, in architectural photography, the subject generally fills out the image area more and tends to be more centrally located.

In addition, since you are highlighting a structure, you must incorporate (or manufacture) compositional elements that will lead the eye to the center of interest. A pathway leading to the front of the building is an excellent way to attract attention to the point of interest. Another way of getting the building to stand out is to have it be the brightest part of the photograph. Darken subservient areas like

the sky or surrounding trees in printing, and slightly vignette the image by further darkening the four corners during printing.

Many times it will be necessary to humanize a composition. This will be especially necessary where your composition has no new landscaping or surrounding trees. You can help your composition by suspending a branch or some leaves over the camera and in the path of the lens so that the leaves form a dark area or frame. This will break up the large plane of the architecture and give it a touch of nature. You can carry these along with you (artificial ones) or cut a few sprigs

Here the assignment was to photograph the chapel in a hospital. With the camera on a tripod, two blips of the flash bounced off the ceiling were enough to supplement the existing light.

Painting with light is sometimes the only way to reasonably light a large structure like the interior of this auditorium. A single flash unit ignited at least 40 times for each side (opposite) was the main source of illumination. You can see where screen and overhead lights were turned on and thus were overexposed, but burning-in during printing solved the problem.

on location. Be sure the branches do not obscure a major part of the architecture or become too overbearing a part of your composition. These dark leaves (be sure they are out of direct sunlight) also supply needed perspective and convey a feeling of depth and distance.

When photographing buildings it may be important to show scale by including people, bicycles or cars in the photograph. These are indications of a building's relative size. Use people or items carefully and make sure they modify rather than disrupt your composition. Be advised that when using automobiles to show scale, their presence might very well date the photography. Although car models change much less frequently than they did 10 years ago, the appearance of an older car in the scene can have a negative connotation.

Interiors

When photographing interiors with 35mm format, you will have to learn to live with a lot more disortion than is evident when photographing exteriors. The simple reason is that you are more confined than when working outdoors. Also, you may be further limited in terms of the precise areas or equipment you must show.

You have the additional problem of light when working indoors or, more accurately, the lack of light. Modern commercial lighting systems excel in providing good visiblity for working conditions, but they leave a lot to be desired photographically. Large banks of fluorescents are difficult to photograph without overexposure. The light they produce is strictly a diffused, overhead type of lighting that is not particularly good for illuminating furniture and equipment.

It will therefore be advisable to bring accessory lighting on occasion. Several photofloods work well, provided they are well concealed and diffuse enough to match the room lighting. For larger rooms, consider doing a long time exposure and "painting" the room with light. This is done by putting the camera's shutter on "T" and walking through the room with a photoflood light, illuminating corners, highlighting certain areas and generally bringing up the overall light level. Be sure to turn off the room lights for at least ⅔ of the exposure or else they will overexpose.

You can paint with electronic flash too. The trick is to always remain between the camera and the light source and never aim the flash

or photoflood toward the lens; always illuminate the areas with your back to the lens. Wear dark clothes and move through the room swiftly or you will become part of the photographic record.

Determining exposure is the trickiest part of painting an interior (or exterior) of a building with light. The simplest method is to aim the light or flash at the far wall or area you wish to paint and take an exposure reading. You naturally want small apertures, so in all likelihood your exposure times will be rather long. With flash, you may have to move in closer to the area until you arrive at the f-stop you want. Proper exposure will be the one you have just measured, but only for the area that the arc of light covers. So, if your exposure is eight seconds at f/22 for the tungsten lamp, you will have to use that same exposure again each time you encounter an area you want illuminated that is of similar size. For instance, if the area of illumination is 12 feet by 12 feet, for every 12-foot square patch you want illuminated, you will need to paint that area for eight seconds at f/22.

With flash, the same is true. If your f-stop is f/22 at 10 feet and your flash is covering an 8x8-foot span, you will have to fire off your flash once for every 8x8-foot section of the room or exterior you want illuminated.

With interiors, after you have finished your painting exposure, turn on the room lights and make an exposure long enough for the lights to register and overpower your painted light exposure. This will give a more natural appearance to the photo—as if the illumination were provided by the room lights. Also, the shadows cast by the room lights will appear natural.

Filters

You will probably need several filters for photographing architecture. A pale yellow filter (No. 3) can be used in black-and-white work for darkening the sky slightly to provide better tonal separation between the sky and your subject. A No. 25 red filter will darken the sky much more dramatically. A green filter (No. 58) can be used to lighten foliage and grass for better tonal rendition.

For color and black-and-white, it is a good idea to have a polarizing filter for cutting nasty reflections and selectively lightening or darkening specific parts of the image area.

You can buy either glass or gelatin filters. The glass types are more permanent but more expensive. The gelatin ones are half the price but require more care to use.

Details

The 35mm format is ideal for photographing architectural details. The details of a building's construction tell a lot about the style of the design and the people for whom the building was designed. Details are not just door knockers and window hardware; a detail can be a long shot as well. For instance a wide-angle view of a wall or hallway could be classified as an architectural detail.

Use the creative aspects of your small-format system to accentuate line and space and move in close to small details. Try to photograph such details in the same lighting as your illustrative shots. This will add continuity to the overall group of photos.

Look for things that are not visible in the overall shots. For instance, get close and photograph the texture of the skin of the building. Photograph the ornate decorations, if present, and any unique design elements.

Construction pictures sometimes show the overall progression from a particular angle, here across the street from the job site.

Time Exposures

Many times, even at night, cars and people passing a structure make it impossible to photograph accurately. A way to move the cars and people out of the way is to use a long time exposure and allow them to pass unrecorded through the image area. Be sure there are no parked cars or people waiting for a bus in your picture, or they will record as near stationary objects. Also, be careful not to photograph automobiles so their lights are visible to the camera. These will leave streaks of light across the film.

At dusk or during the day your exposure will be too short for a time exposure so you may have to resort to neutral density filters, which effectively cut exposure without changing color or tonal values.

Double Exposures

When asked to photograph a building at night, unless the building is lighted by auxiliary lighting, you will not be able to show the

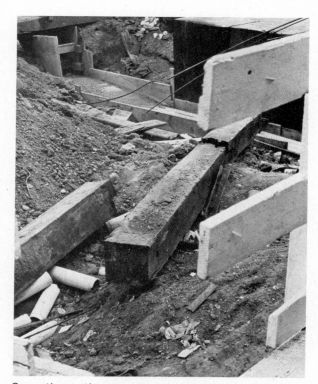

Sometimes the construction pictures will show close-ups of the construction. Here a potentially dangerous site situation is photographed. Note inclusion of fences to show how far back the public is kept from site.

exterior form of the building. If the inside lights are on, they will show up well but the outer form will be left to the imagination.

Double exposures are the only real way to deal with this problem. Set your tripod up and lock everything down securely. Near dusk, make one exposure of the building with enough ambient light falling on the structure to show details of the building. This works best when the light is diffused twilight. Wait until dark and then make another exposure on the same piece of film, with the interior lights on. The final result will be a night shot with detail in the exterior of the building. Underexpose your outside exposure by at least one, possibly two f-stops from the meter reading. This will make the exterior scene appear dark but with some detail. Expose the interior half of the photo normally.

The Markets

The following is a brief outline of the various markets in which you can expect to exercise your photographic talents. Architectural photography is one of the areas where there is still plenty of room for talented photographers to make a good living. Most architectural work is done by commercial photographers who do only this type of work as a single phase of their commercial business. There are very few specialists in this field, yet there is a definite need for this type of photography.

Construction Photographs

Pictures that document the various stages of construction not only are needed by architects and builders, but also are used by insurance companies, government agencies for verification of procedural codes, and the makers of equipment used on the site and supplies employed in the construction of the building.

Most photographs of this type are not the glamorous slick type of architectural shots you see in magazines, but rather dull, record shots of the various phases of construction. Buyers of such photographs are interested in tight, sharp pictures with lots of detail, and showing as much of the construction process as is possible.

Progressives are a series of photos taken from the exact same locations at regular intervals. They are records of successive phases of construction and should be taken from the same spot each time and ideally, at the same time of day. It will depend on the job and the

needs of the client how often a shot will need to be made. Some photographers find it useful to mark their tripod marks in chalk on a given spot. It is also useful to record the height and angle of the tripod as well as the f-stop used for the exposure. The more details you control the more alike the final shots will be and the more useful they will be to your client.

This type of work is not too rigorous or demanding but it can pay rather well. Most jobs are bid on and awarded by contract, the same as other phases of construction. Keep an eye out for public announcements of building contracts and pay frequent vists to the city building permit office.

Use your pricing formula to come up with a figure to submit. If it is large project, you can figure on progressives taken from up to 30 separate locations. This can really run up the bill. Also note the frequency with which you will be shooting at the site. I once knew a photographer who spent at least three days a week on the job site of a new subway system. Also, as a job progresses, new aspects of the building will need to be documented. You can make a substantial living doing nothing but construction record photographs.

Finished Architectural Photographs

Your clients will be the architects, architecture magazines and local newspapers interested in new architectural achievements. Also, you will probably be able to interest the owner

of the property in finished shots of his building or improvements.

The first thing you need to break into this market is a good portfolio. You will have to put this together on your own and it will have to be a pretty good offering if you expect to get much work.

It is extremely important when working with the architect to find out *exactly* what he wants in the way of photos. He may want to emphasize certain bold design concepts or he may want to record certain functional aspects, but whatever his intent, be sure you know the client's needs before picking up your camera.

The things you must find out are: How does the client want to use the photos, which are the essential views, which are the most important design elements, and what type of permissions or permits are needed for you to work on the job site? Find out the frequency at which photos will be needed and if the architect minds your taking photos of other phases of the operation for sale later to other parties. There is much to discuss beforehand so be sure to schedule a planning session with the architect before the job begins.

Real Estate Photography

In addition to the two types of architectural photography already mentioned, you can shoot photos of properties for real estate offices and make a fairly good income doing it.

Real estate shots don't take much expertise

These are not construction photos, but destruction photos made from either side of the gradually faltering hotel.

to do; they are simply attractive record shots of a property that is available for purchase. Real estate companies show prospective customers the photos of the various properties so that certain ones can be eliminated without the client having to visit each one in person.

The photos may be used by the selling agent alone, or may be reproduced and distributed throughout the firm and to other firms too if the property is a multiple listing. In addition, the photograph may be used for advertising in the real estate section of the newspaper or for local magazine advertising.

Generally only one or two exterior shots are needed but you will, on occasion, find a need to show the interior, especially on more expensive properties.

A real estate office in my area has an attractive way of using their real estate photographs. They take two or three houses within close proximity, either geographically or by price, and group nine or ten photos of the properties on a single 16x20 mount board. They have four of these boards usually displayed in their front window. The photos of each property consist of an exterior front view, an exterior rear view, and one or two interiors made with flash. They have found that since they are located in a shopping center, this method of advertising is a great way to generate walk-in trade. They use a single photographer, who shoots for them one morning and one afternoon a week. He can do five or six residences in half a day.

He schedules his shootings by finding out a little preliminary information and then making arrangements for the agent to leave a key, or for the owner to be at home. If a building faces east, he will schedule it for the morning; if it faces west, he will make it an afternoon shooting. If the building faces south he can shoot it morning or afternoon. If the building faces north (which means it never faces the sun and is always in shadow) he either waits for an overcast day or shoots the building backlighted.

He uses a 35mm SLR with two lenses, a 35mm and an 85mm, and shoots color negative film with a flash (equipped with wide-angle diffuser) on his camera for interiors. He generally shoots on the weekends and the real estate firm pays him $3.50 per shot. Not much, you say. Remember, I said he shoots five or six jobs in a morning, three to four shots per residence. You can figure it out. Each time out he is making $50-$60.

The real estate company thinks it is a good investment because it is a good way to inform passers-by that they have some very attractive properties for sale. They need make only a single sale to cover the cost of the photos.

As with other types of architectural photography, a good portfolio will help you get the jobs. Take it around to the offices of various real estate companies and try to line up commitments. If they like your work they may agree to try you out or they may have you do some work on speculation. By lining up several such offices and giving them a plan such as was used in the example, you can make yourself a fairly good weekly income. Or, you can supplement your normal income with money earned from real estate photography.

You may find that the larger real estate companies use a service or agency of photographers, but like anything else, if you go to them with good work at a good price, or offer

3

1

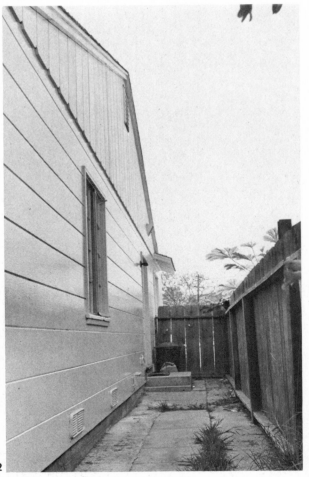

2

them a few ideas to promote themselves using your services, they are likely to give you a try.

Pricing

Since there are a number of different types of architectural photography discussed here, it is somewhat difficult to generalize about pricing. If you are doing real estate photos, pricing methods will be considerably different than those used when you are doing construction progressives.

Generally photographers charge by the job, by the photograph, or by the day. Many photographers prefer to charge a day rate, plus expenses, while others simply give the client a cost per photograph. This may be advantageous when making progressives, because they are relatively easy to make in comparison to architectural design details and/or finished illustrations.

Regardless of the system you choose, remember that you will have more consultation and research fees with architectural photography than with most other types. Either establish special fees for this or include them in your per-photograph cost. It might be a good idea to establish them as fixed costs and only add them to your billing if applicable rather than building them into the cost of each individual photo.

1,2,3,4. When the owner of this house purchased it, he wanted to show specific areas of the house that he either wanted to improve or that had been improved already. Photo No. 1 shows the condition of the front porch area. Photo No. 2 shows the new coat of paint on the structure. Photo No. 3 shows the condition of garage and side of house while Photo No. 4 shows the interior of the garage.

With real estate and store-front photography you have to charge on a per-photo basis because in most cases your work will be unsolicited. However, as your reputation grows and the demand for your services increases, you may find yourself in a position of being able to get a healthy day rate for this type of photography too.

Photographing Businesses

Photographing the exteriors of local businesses is not only a great way to pick up extra money, but it is a first-rate promotional tool. Many, if not most, small businesses have never had a picture made of their store, restaurant or office. You can be sure that most would be interested in having such a picture if it could be obtained reasonably. Once a photo has been made and purchased, the businessman or woman may call on you (you're the most logical choice) when a photographic need arises in his or her business.

Photographing exteriors is a simple and most inexpensive proposition. Simply choose a clear day, like a Sunday, when there is no traffic. You could also shoot on a weekday, early in the morning, provided that the sun sufficiently illuminates the structures. With your camera on a tripod (and possibly an on-camera flash present to fill deep shadows), shoot as many business fronts as possible. Make one horizontal and one vertical if possible; if not, make two angles of the building. Do this for every business on the block. In an hour you can usually shoot photos of at least 30 businesses.

Process the film and now you can take one of two different paths. You can either proof the film and mail out contacts along with a form letter stating your intentions and quoting your price—say, $5 for an 8x10; or you can print the film, making an 8x10 of the best angle of each business, and canvass the neighborhood, stopping at each store to make a sales pitch.

If you want to devote more time to the shooting aspect of the business, hire someone to do your canvassing and sales. A high-school student would be glad to work on a small commission.

There will be a certain amount of waste with this second method, since some owners will not be interested. However, many more will.

You can engage in this type of business any time, on weekends, or full time. And there

is a good profit to be made. If you sell 20 of those 30 prints at $5 each, you have made $100, less your expenses, which are minimal since they would involve only a few rolls of film and the cost of chemicals and paper.

Once you have sold a few photos, your sales techniques will improve and you will be able to persuade a hesitant potential customer. Thus, with this type of business you are not only becoming a noticed part of your business district, but you are priming potential customers and introducing them to your photographic skills. Be sure to include a business card, or stamp the back of each print with your name and address.

There are lots of ways to make money photographing architecture, and, as mentioned, there is not always a great deal of competition in this field. There are relatively few specialists when compared to other disciplines of photography. For someone with a little skill, an interest in building construction and design, some dedication and imagination, it's a wide-open market.

Photographing night windows presents special problems. Here a window at a dress shop turned out beautifully. You must be sure no stray light is falling on the outside of the windows. The only illumination should be that lighting the window garments. Sometimes you can use a polarizing filter over the lens to neutralize some of the reflections present. If the light is from car headlights, however, you are fighting a losing battle.

Photographing small businesses can be a lucrative sidelight to your business. How many of the buldings on this block do you suppose has ever had a photo made of it?

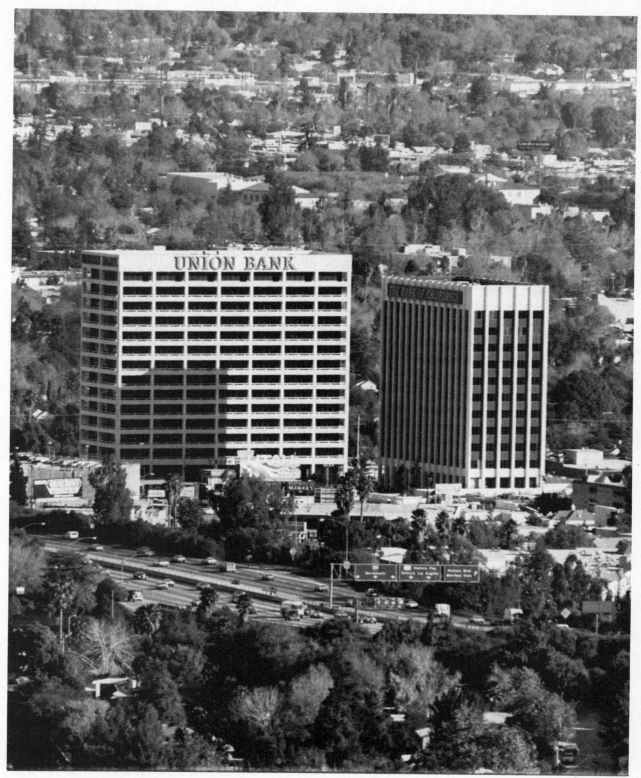

Often the only way to photograph large commercial buildings is from very far away with a long telephoto lens. This photo was made with a 400mm lens from several miles away.

Copying Photographs

Suppose I had a nickel for every time someone asked me if I could make a copy of a photograph of theirs that was irreplaceable—I'd be a very rich man. Everyone has a priceless snapshot or old portrait that he will eventually wish salvaged from the ravages of time or want duplicated to share with others. What is needed for copying in terms of technique and equipment is minimal, and this is an excellent way to build up confidence in your photographic technique as well as inspire present, and almost assuredly, future clients with your photographic wizardry.

Most of the time people's photographs are old and as a result, damaged. You will therefore need some basic retouching skills, at least print spotting. Your photographic technique is simply a matter of paying attention to details—focus, lighting, careful cropping and exact exposure. Once you've made a few copies, and have the eccentricities of your particular system worked out, you will be able to fly through the work, making up to a hundred copies a day if you have the business.

Promoting your services is a snap too. Local shoppers' guides and circulars as well as community bulletin boards will attract enough attention initially. Your clients will be anyone who has old, damaged or irreplaceable photographs. Later on you can expand your list of potential clients to include businesses such as publishers, architects, planners, magazines, museums, libraries—in short, any business or person needing photographic copies of their material. More about this later.

Basic Equipment and Technique

Aside from your normal camera, you will need a sturdy tripod, a cable release, and two high-intensity lights on stands and in reflectors. You may also need a slightly longer lens than your normal camera lens. The reason for this is that the normal camera lens, say 50mm for a 35mm camera, produces a somewhat curved rendition of a straight line. The effect is unnoticeable in scenic and people photography but where a perfectly straight line is required, such as in the reproduction of a rectangular photograph or document, the result is annoying and often, unacceptable. You can get around this phenomenon by using the centermost image area, leaving the outer 25 percent of the frame area unused. Also, it seems that the slower the lens speed, the less noticeable is this curvature of field. For instance, an f/2 lens would have less noticeable curvature than the faster, more expensive f/1.4 lenses. In any event, a 100mm to 135mm lens will have little objectionable curvature. If you plan to make copies of small areas of photos or documents, you may want to look into a macro lens in the same focal-length range.

Whether you use your normal lens or a slightly longer lens, you may still encounter problems when you copy small originals like snapshots. Non-close-focusing lenses may only have a minimum focusing distance of about three feet, hardly close enough to get a good-size image of a small photograph. One alternative is to use close-up lenses, which

This is the type of photo that often turns up to be copied. This particular copy was made from a faded and extremely dark original of snapshot size. Although the final print is still somewhat flat, it is a drastic improvement.

Align lights so that center of beam strikes center of copy material. If copy is curled you may have to adjust the lights away from a 45-degree angle, but normally the light beam should be aimed at a 45-degree angle from the lens axis, as shown.

are actually magnifying filters that attach to the front of your camera lens. These will allow you to focus closer on small images. An alternative that may be preferable is the use of extension tubes. These are accessories that fit between the lens and camera body and since they physically, not optically, alter the focal length, and hence do not interfere with the len's resolution characteristics, they can be used for more exacting work than can the close-up lenses, which may produce a loss of edge sharpness.

The basic technique is simple. Align your camera on the tripod over a clean flat area. In setting up, use a hand spirit level to check that your camera is perfectly level in both a horizontal and vertical direction. To either side of the tripod place your lights. You don't need anything extravagant; I have always used two 500-watt photofloods in old, beat-up

Here's a simple copy setup using two quartz lights and a 35mm camera. You have to be careful to watch out that shadows from the tripod legs don't fall across copy.

Smith-Victor reflectors. Make sure the lights are the same height and that their beams strike the center of the copying area. The lights should be positioned so that they are at a 45-degree angle to the lens axis (see drawing). This will produce a system that will minimize surface reflections emanating from the copy material.

Make sure your tripod legs don't cast shadows onto the copy material, and that they are set at a height that will permit you to vary image size by adjusting the tripod's center column rather than readjusting all three of the tripod legs.

If copying old photographs, you will undoubtedly find that when exposed to the hot lights, the prints will curl like a noodle. To hold the material down, you can use pushpins on the print borders (if the client won't object), double-sided adhesive tape (such as that sold by 3M) to wall-mount mounted photographs or, if you plan to do a lot of copying, the metal copy boards that hold the material in place with magnetic bars. These are efficient and will knock precious minutes off the copying procedure. As you begin to get more involved with your copy work, you may want to look into one of the 35mm copy stands which consist of a copying easel, center pole with an adjustable camera support, and two arms for the copy lights. The ultimate in copying equipment may be the Polaroid MP-4, a copying setup that will give you "instant" copies and can accommodate just about every small copying need.

Possibly your enlarger can be used for copying. Many enlargers permit you to remove the negative stage and condensors and replace them with your camera for copying. This setup is ideal where economy is desired, both financial and spatial, because your enlarging and copying needs can be done in one small working area.

You might also look into building a horizontal copy stand that would free you from the

1-3. Here is a series of generations in copy work. The original photo is old and faded but in generally good shape. The copy negative was made using the centermost area for maximum lens sharpness. Thumbtacks were used to hold the print in place on a stand-up copy board hung on a wall. Final print is developed in Kodak Selectol Soft print developer and burned, dodged and spotted. Copy is as good as original. Film used was Kodak Plus-X and developed for minimal contrast.

shadows cast by your tripod legs in a floor-copy setup. All you really need is a large bulletin board and a means of fastening the copy material to it. You also need enough room to position your lights at a 45-degree angle to the copy board.

Film Choice

Whether you are photographing a faded document or an old color photograph, the film you use should be the finest-grained, sharpest film that the job will permit. Using 35mm format films greatly reduces the choices of fine copying films available but nevertheless, there are a multitude of small format films that are more than adequate for copy work. It is important not to get into the habit of using the same film for every job, because one film will not be right for all types of jobs.

Take, for instance, a copying assignment calling for copies of a contrasty scene of two people taken outdoors. Since the copying procedure increases contrast over the original scene, you would not choose the finest-grain film available, say Kodak Panatomic-X, because it is also a very contrasty film. You might choose instead a film like Kodak Tri-X,

1

which has a lower overall contrast and will more truly render the tonal range of the original photograph.

In photographing copies with color film you have the additional problem of matching the film with the lights. If using photofloods or 3200° K. lights (that is the average normal color temperature of tungsten lights), you must use a film balanced for tungsten illumination, like Vericolor II, Type L (for long exposures). If copying the material onto slide film, you must use a Type B film for 3200° K. lights and a Type A color slide film for 3400° lights like photofloods. With slide film the color balance is more critical than with color negative films whose color balance will be corrected during printing.

If you need to copy high-contrast originals, you can use a film like Kodak High Contrast Copy Film, which has extremely fine grain and ultra-high resolving power and is available in 35mm cassettes. This film is ideal for copying maps, manuscripts, catalogs or any other high-contrast material, and the film can be filtered for exact control of contrast.

Although no one film is right for every situation, many people feel Kodak Plus-X is a very good all-around copy film. It is fine-grained and average in contrast. It is moderately fast (ASA 125) and can be developed in a variety of developers for different effects. A good developer for general-purpose copies is either HC-110 or D-76. Both deliver the film's rated speed and are fine-grain developers.

It is important to note that a film's characteristics can be further suited to a copying assignment by using a different developer. You should consult the film's data sheet for more information.

Special Problems

The following section deals with problems that will recur repeatedly in the copying trade. You should be advised that when entering into this field people will bring you the worst specimens of photography and art work and want you to deliver perfection. Some of what you will encounter is easily solved with a little background on troubleshooting.

One of the biggest problems that happens with old photographs is the yellow fade. It can be an overall cast or may look like a stain appearing only in one area. The remedy calls for yellow filtration. Since a filter transmits its

2

3

own color and blocks its complement, a yellow filter will lighten the yellow cast or stain and make it record closer to normal. Experiment with varying degrees of yellow filtration with each new situation and soon you will be able to "see" the filtration that will be needed to eradicate the stain.

With a 35mm SLR, buying glass filters can be terribly expensive if you need a lot of them. If doing a lot of copying, you may want to look into a gelatin filter holder that holds 3x3-inch gelatin filters. You can get virtually any type of filter in gel and while they aren't exactly cheap (about $5 per filter currently), they will be about half of what glass filters would cost.

If you are copying an original with a red stain, or a green chemical stain, use a filter of the same color as the stain.

If the original is faded and the image is faint, you have several options; you can copy the image on continuous-tone film like Plus-X

and develop for maximum contrast (i.e., over-develop 40 percent), or you can copy the faded material onto a higher-contrast material like Panatomic-X and develop normally.

When you have to vary development for the right contrast (develop more to increase contrast; develop less to reduce contrast), it is a good idea to make several series of images on the same roll of film. Space them far enough apart that you will be able to tell the difference. For instance, if copying a faded portrait, make three exposures, then make three more with the lens cap on to space them out. When rewinding the film, don't rewind the film leader. Go into the darkroom and pull out and cut off the first series of exposures and develop them. If they're not right, pull another group out of the cassette and develop them accordingly until you have a good negative.

If photographing blueprints, use an average continuous-tone film like Plus-X and filter it

Polaroid MP-4 copying system is a highly sophisticated copying setup designed for using types 51 (high-contrast), 52 (continuous-tone) and 55 (positive/negative) films as well various other black-and-white and color Polaroid films.

Transparencies can be copied right off the light box provided you use a lens shade and fill the frame with the image. You can also mask the transparent image to be copied.

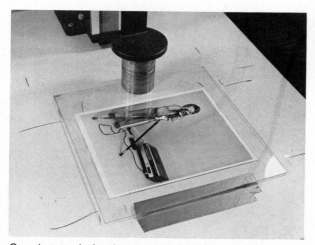

Copying curled prints can be done by placing the print under glass. Reflections are minimized on the glass if the lights are placed at a true 45-degree angle to the copy (see diagram on page 111).

with a red filter. Since red will darken the blue background, it will record as near black while the lines will record as white.

When copying material with fine lines, use a film such as Panatomic-X if the matter is continuous-toned, and High Contrast Copy film if the material is high-contrast. These films, if exposed and developed properly, will hold the finest details of the original.

For documents printed on faded yellow paper or parchment, use High Contrast Copy with a deep yellow filter that will lighten the copied paper and consequently bring out the printing.

If a print that needs to be copied comes to you badly wrinkled, you can straighten it out by wetting the print and flattening it with a squeegee face down on a sheet of clear glass. The print can then be copied through the opposite side of the glass.

Sometimes a customer will bring you a clipping from a newspaper or magazine he or she wants copied. Best results can be obtained by copying it on a high-contrast panchromatic film like Panatomic-X. Although the dot pattern of the halftone will still show in your copy, the tonal-range will look similar to the original.

For oil paintings or other material with rough reflective surfaces, use a polarizing filter over the lens to misdirect some of the reflections.

Special Hints

A few words should be mentioned about lighting and exposure because they are the prime ingredients in good copy work. Lighting on the copy must be even, and the only way you can tell if it is even is with a light meter. You cannot see subtle differences in light intensity. It is easiest by far to use a handheld incident meter and measure the four corners and center of the copy. If the readings are within ⅓ f-stop of each other, your lighting is even. If you don't have an incident meter, take your camera off the tripod and move in close to the copy. Use your in-camera meter to measure the corners and center. This will tell you if your lighting is even or not.

If the copy has any depth to it, use a small aperture to secure enough depth of field to get everything in focus. Otherwise, use an aperture between two and three f-stops down from wide open. This is the aperture of greatest sharpness. If too small an aperture is used resulting in a long exposure, reciprocity may

take effect, thus altering the needed exposure.

Do not make your final exposure measurement from the copy material. Use an 18-percent-reflectance gray card. It is by far the best method of exposure because whatever copy matter is before you, it will have a different rate of reflectance than the item you just copied. If you use a good, unscratched gray card you will be assured of even, consistent exposures.

One problem that occurs with copy lights, especially photofloods, is that as they age, they put out varying degrees of light. And a new bulb puts out considerably more light than a bulb that has been broken in. So even if you keep your copy lights in the same position all the time, it is always good to make the four-corner test once in a while to check for evenness.

A general rule for composing in the camera is to always align your verticals and horizon-

High-contrast copies are easy to make but you should know that poor exposures will cause thick lines to "bleed" (merge with surrounding white areas) and thin lines to separate. The thin lines will appear broken. Perfect exposure and development is necessary. This copy was made on Kodak high-contrast copy film, but there are many hi-con films to choose from.

tals with the inside frame edges in the viewfinder. If your camera is level, you will have straight lines provided your copy is aligned squarely. If you are copying a cockeyed original, align the long edge of the copy with the top long edge in the viewfinder. If you have a straight line parallel to a line in your viewfinder, chances are your copy will be square.

Sometimes you will not get what you saw in the viewfinder, but the difference is very minimal. For critical work, though, it's a good idea to get a focusing screen with criss-crossed vertical and horizontal lines. You can do this only if your SLR has interchangeable focusing screens, and many of the recent, automatic cameras don't have such a feature.

Two final deterrents to good copies are reflections and textured prints. We have talked about reflections in other areas of this chapter but it should be noted that other than the copy itself, the second leading source of reflections is extraneous room light. Turn off all the lights except your copy lights and pull all the window shades as a precaution.

Textured prints are another matter. It is very difficult to copy them conventionally. You must use four lights, placed north, south, east and west of the copy. This fills in the minute shadows created by the print texturing. This will not entirely eliminate the effect, but it will certainly help.

Restorations

Only a small amount of space will be given to restoring badly damaged photographs because it is such a specialized and exacting discipline. If you are a good print spotter and you receive a badly damaged print that needs restoring, make as fine a copy possible as you can and then with dyes and leads, if necessary, retouch the copy print. Never work on the original as you are inviting a lawsuit if disaster strikes.

Once your copy print is as good as you can make it, recopy it, again making the best copy possible. Duplicates can be made from this recopy negative.

If you need higher quality work than this two-generation system provides, you will have to shoot a larger format negative of the material, either 2¼-inch or 4x5, and have that negative sent out to a professional retoucher. The bill may be high, but this can be passed on, plus your profit, to the customer.

Pricing

For straight copy work, especially that

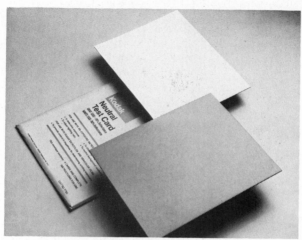

Perfect exposures can be obtained by pointing your in-camera meter or handheld spot meter at a perfect 18 percent gray card such as this Kodak test card. A meter, any meter, has only one aim in life—to turn all it sees into the same shade of 18 percent gray. If you base your exposure on the same gray, you can't go wrong.

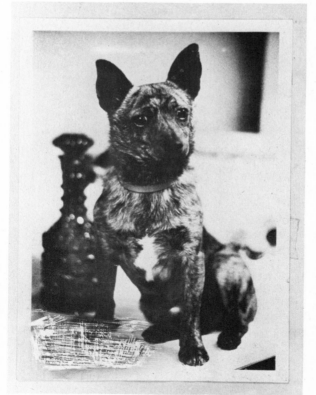

Here's a candidate for restoration. Scratches are pretty bad but print is not good either. Copy was made under glass, which slightly reduced contrast. Work print was made and spotted, and then recopied for extra prints.

which you receive from ads you've placed in circulars or cards on community bulletin boards, you should charge a straight set of fees for single, finished prints. A single 8x10 print from a copy negative you made should be worth no less than $15, probably more.

For copy work, your shooting time and equipment are minimal. You will find many photographers who have a stationary copy setup in a convenient corner so that the work can be done quickly. Prints made from the copy negative should be priced by size and number; the first print of a given size should cost the most, with additional ones costing less. Print prices should compare with your regular print prices for other types of photography you do in order to maintain a consistency throughout your pricing. Instead of charging $15 for an 8x10 print made from a copy negative, for instance, you may want to charge $10 for making the copy negative, and then charge your regular print prices.

Profits will come on reorders for which you can charge 50 percent of your negative fee plus your normal print prices. Large profits will also be made on orders that involve special handling like retouching or airbrushing. You can farm that type of work out, and double your costs. Profit should be at least 100 percent on these orders because of the added complexities.

Slide Copying

Nothing has been said thus far regarding slide copying because it involves different procedures requiring different equipment and having a different set of costs. You can make extra money copying slides, but you will be in competition with large photo labs and even Kodak itself, who can do the job very reasonably. In fact, you can presently get duplicate slides for only around 50 cents apiece. So how can you make money? Simple. Offer the service as part of your repertoire of copying services and simply send the work out to a major lab whose work you respect. Additionally, you can offer cropping and creative services, such as double exposures, titles, cropping and masking. Your fees then will come under the realm of photographic services and you can charge a healthy rate for the work.

Your clients then will include advertising agencies who might need color slide copies of artwork for a layout, publishers who might need copies of material ready for publication, real estate agencies who might need copies

of a color slide of a property for distribution to their agents, insurance companies who might need high-quality copies of personal property slides for inventory and identification; the list is nearly endless. Just use your imagination and chances are you will discover yet another application of this technique.

In the way of equipment you will need a slide copier, but not much more than that. You are better off getting an accessory bellows with a slide copier attached to the bellows. These are better than the type of copiers with nonadjusting distances. You will also have to learn to use the instrument, a somewhat complicated procedure, but if you follow the testing instructions that come with the unit, you will do just fine.

For illumination, you can use the light of reflected midday sunlight (not blue sky), tungsten light or electronic flash. Flash is convenient and accurate and will not change color temperature like daylight. The drawback is

ABOVE: *Gelatin filters are ideal for copying because they don't cost too much initially and you can store many of them in small photo albums like this one. Filter holders for any accessory filter size are available, or you can make a holder from a cardboard box. Note that filters are shown in Calumet 3x3-inch gel filter holders, which are cardboard masks to facilitate handling.*

RIGHT: *Makeshift slide copier can be used to effectively copy 35mm slides by using available light and Ektachrome Slide Duplicating film.*

that you have to perform countless tests to zero the system in. Once done, this lighting system is probably more consistent than any of the others. With tungsten you can use your in-camera meter to determine exposure, which is a real luxury. Also, you can merely choose the f-stop you want (usually f/16 or smaller) and vary the exposure time—something you can't do that easily with flash.

When copying slides onto daylight film remember one simple rule—if copying a Koda-

Sophisticated slide-copying machine like Bowens Illumitran (older model shown) has electronic flash built in and can be used with a variety of different films. Contrast can be selectively controlled with the newer models, although flashing with this type of unit will cut contrast excellently.

chrome original, always copy onto an Ektachrome (or similar to Ektachrome but another brand) film; if copying an Ektachrome type of slide, always copy it onto a Kodachrome material. The reason for the crossover is simple. When you use the same film twice in the copying procedure, you accent the bad points of the film. When you switch film types, you cancel out the film's bad points—i.e., its graininess or contrast—and replace them with acceptable equivalents.

You can also use Ektachrome Slide Duplicating Film, which is balanced for tungsten light and is a great all-around copy film.

If you get serious about working in slide duplicating, there are some machines around that are unparalleled for the creative control they give, plus speed and ease of operation. The Bowens Illumitran is a unit that contains a built-in electronic flash and a contrast control unit to let you vary the specific contrast of the copy. The Chroma Pro is a unit that has built-in dichroic color filters as well as electronic flash for color correction and creative effects. These units are comparatively expensive but as with anything else, if you like the work and you can establish the customers, they are a worthwhile investment.

These machines come all ready to go; you simply attach your 35mm SLR and your normal lens coupled with a bellows unit or a macro lens or enlarging lens.

You can enlarge or reduce slides, copy slides onto a variety of film stocks, crop slides, enlarge movie frames, double-expose slides with different slides for creative effects, zoom in or out with repeated exposures, add color for correction purposes or to produce abstract effects, or simply make up your own techniques.

If you don't want to go to the time and expense of making your own slides, send them out to a reputable color lab and simply supervise the duping operation. For this expertise, charge your customer the lab's price plus 100 percent.

If you are doing your own copies, charge the customers a setup fee, which is minimal, usually only $5-10 dollars; charge for costs like film; and then charge so much per slide duplicate—say $1 per dupe. You may find that you cannot compete price-wise with the large labs who have automated equipment, so before you get too involved in slide copying for money, check out your competition's quality and prices to see how you compare.

Gimmicks, Gizmos and Gadgets

There is a remarkably high number of ingenious devices and services on the market that you can use to make money in photography. Some of these items you have seen, like calendar masks and photo masks; these are ways you can personalize an item or idea with your photo or a photo of a friend. Other items are unique and I'm sure there will be many you have never even dreamed of.

What comes immediately to mind when reviewing such gizmos and gadgets is that they are remarkably promotable; in fact, some even promote themselves. Like the pet rock, they are grabbers; things that ignite your curiosity to look further. Some of these items you may find useful in promoting your own small business; some you may find will make a successful business all on their own.

In addition to listing these ingenious gimmicks, where possible, the supplier's full name and address is given. Surprisingly, you will find most of the items mentioned are rather inexpensive, yet their appeal can be great. You should be able to, in most instances, make 100 percent profit! That will be up to you and how you price and promote the service or product. Remember, however, that most of these items are unique and do not yet have a perceived value in the mind of the public. Therefore it is up to you to place a value on the item that will cover your costs and overhead as well as include a value for the ingenuity of the product itself. For instance, how much would you charge for performing the service of printing a special portrait onto a China plate? How much would someone be willing to spend if they had never seen the service offered before? If your cost is $5, would $10 be a good price, or how about $20? Ask a sampling of friends and family and see what they would pay. Don't be afraid to charge a high price if you think you can get it; after all, you can always lower your price.

What follows is an alphabetical list, by function, of many such gizmos, gadgets and services. Such a list can't possibly be complete because many items will come and go each year. You may also find that you can think of different uses for the product than those described. Regardless of the extent to which you use this section of the book, keep it handy, because there may be a time when you want to boost sagging sales with a catchy promotion, or you just may find that you want to try your hand at something a little different. This chapter, then, may provide you with just the inspiration you've been looking for.

Albums

Wooden albums (front and back) are a great way to set yourself apart from the crowd, particularly if you shoot a lot of weddings or even if you just want to offer the service to snapshooters or for binding an individual collection of photos like a modeling portfolio. They are available from *The Camille Company, 826 Bergen Street, Brooklyn, New York 11238.* You can also try *Lanwood Industries, 42-05 97th Place, Corona, New York 11368,* for a large collection of wooden album

Calendar and reward masks are a great way to customize and personalize a client's images. You can either offer these as services or use them to promote your photographic business. These shown are available from Porter's Camera Store.

covers and even wooden pages. *Art Leather Albums, 37 Moultrie Street, Brooklyn, New York 11222,* offers a huge variety of albums in every shape and surface as well as many of the small proofing albums. If you want an album with a rich look to it, one for the discriminating customer who can afford to spend a lot, look into albums from *Taprell Loomis, Department N-101, 2160 Superior Avenue, Cleveland, Ohio 44114.* They offer hand-rubbed wood covers and covers with delicate ornate scrollwork that will surround the cameoed photo you wish to place in the cover.

Bank Books

Porter's offers an ingenious promotional device known as a bank book that is really a coin bank shaped in the form of a savings passbook. Simply attach the photo of your choice on the front of the bank and slip on the die-cut bank top. It is a great gift idea for kids and can be part of a promotional package with your child portrait business.

Photo Belt Buckles

Porter's Camera Store, Inc., Box 628, Cedar Falls, Iowa 50613, offers all you'll need to sell personalized photo belt buckles. You can even shoot Polaroid shots of people or pets and insert a dried instant photo into the belt buckle right on the spot. The buckle openings are rounded and covered with a clear laminate for protection. They insert in minutes.

Bumperstickers

How about offering the service of personalized, custom bumperstickers? You can use a photo or a drawing or just simply a slogan. Write to *Bumperstickers, 13241 Harbor Boulevard, Garden Grove, California 92643.* If you have a walk-in type of business like a booth set up at a fair or race, you could use this type of promotion to bring in customers by offering free bumperstickers for signing up, or purchasing a print, etc. Of course, you build the price of obtaining the bumperstickers into the cost of your other products.

Business Cards

This is a service you may want to avail yourself of, being a photographer. You can

have your own photo, or a scenic photo of your choice, set attractively on a standard-size business card by the *Professional Yearbook Photographers of America, 3807 Charlotte Avenue, P.O. Box 90883, Nashville, Tennessee 37209.* The price of $23.95 includes typesetting and buys 1000 cards.

Buttons and Badge Makers

Badge-a-Mint, Ltd., Box 618, Dept. CT 119, Civic Industrial Park, La Salle, Illinois 61301, offers a button-making machine that allows you to insert photos or messages into sealed, laminated buttons that can be pinned to your clothing. I have seen people successfully selling Polaroid photos inserted into buttons at football games and summer carnivals. You can also set up and sell buttons like "Go 'Bama" or, "I went to the Rose Bowl" at football games and you'll find people will pay at least $2 for such a button. Use your imagination; there are any number of catchy slogans you can use. You may also want to insert a small photo into a mask for a button that says something like, "World's smartest USC fan." You will sell a lot of buttons if you can have an assistant pressing the buttons out for you while you make quick snapshots using a Polaroid or Kodak instant camera. The Badge-a-Mint device sells for around $25.

You can also obtain such badge makers through the *Edmund Scientific Catalog, 101 E. Gloucester Pike, Barrington, New Jersey 08007; Photographer's Specialized Services, 612 Summit Ave., Oconomowoc, Wisconsin 53066;* or *Bryce Enterprises, Country Drive, Plainview, New York 11803.*

Calendars

Photographic calendars are big business in book and card stores, but you can create your own, either for promotion of your own photography or as a service for customers. *TSP, 4142 Pearl Rd., Cleveland, Ohio 44109* offers photo masks with vertical or horizontal cutouts for your photos (either by contact printing or photographic enlargement) and features the 12 months of the year on the single mask. TSP also makes appointment calendar masks as well as photo masks in different languages.

Porter's offers calendar mats that are die cut and fit over the photo of your choice. You could also make your own calendars by photographing an existing calendar, one month at a time, on high-contrast film like Kodak High Contrast Copy Film. Then simply print the monthly copies on the size enlarging paper you desire, and either dry mount another photo onto the blank area of the print or make provisions in the original copy for double printing your photo.

You can also purchase blank-top calendars. All you need to do is mount your photograph to have a complete and attractive calendar. For more information, contact *Souder's, Inc., 92 Lexington Ave., Albany, New York 12206,* and specify the size calendar you happen to be interested in.

Charms

Like belt buckles and buttons, you can have your photos reproduced in miniature and mounted inside tiny charms and set on a bracelet for safekeeping. For more information, contact *Photo Charms, P.O. Box Drawer 491-R9, Greencastle, Indiana 46135;* or *Chromalloy Photographic Industries, 1706 Washington Ave., St. Louis, Missouri 63103.*

Composites

Composites are commonly known as head sheets. When a photographer photographs a school class, or Little League team, tiny photos of each player or student are assembled photographically onto one sheet of paper and collectively known as a composite. They are commonly done and are relatively inexpensive if the lab is doing the rest of the printing from your order. Composites are sometimes complimentary when dealing with a lab who specializes in school processing. They have great appeal to young and old as parents will want to remember their children's friends and classmates, and the kids will want to appear with everyone in the class or team so as not to be excluded.

You can deal with a company like *M&A Studios, Box 7000, Mobile, Alabama 36607,* which specializes in hand-lettered, well-designed composites, or deal with one of the large photographic laboratories like *Photo World, Box 21, Evansville, Indiana 47701,* or *Texcolor Inc., P.O. Box Drawer A, RF 180, Wichita Falls, Texas 76307,* which specialize in volume school work.

Emulsion Coatings

The following products can be used either to coat a nonphotographic object with photographic emulsion for printing in a darkroom, or as photographic emulsions all on their own although they are not photographic items.

Photo Aluminum is a specially anodized aluminum with a coating of photographic emulsion. The image will be black on the shiny silver surface. Available from *Porter's,* Photo Aluminum comes with five 8x10 sheets and one test-strip sheet. The aluminum sheets are developed normally in Dektol or similar developers and can be handled under normal OC safelight filters. You can use the aluminum prints to promote your photography business by printing up photo-signs with your work and business legend, or you can use them as exotic portrait prints (for an exotic price), or you can print graphic scenics on the aluminum, mount them on wood or a similar object and sell them in stores.

Silver Minnies are similar products available from *Porter's* except that they give a full-toned image on a wallet-sized piece of metal. The effect is reminiscent of the old-fashioned tintypes and when used with the ingrained oval holders that are included, they look like turn-of-the-century pieces.

Liquid Light is a photographic emulsion that can be applied to virtually any surface: glass, ceramics, wood, paper or cloth. The object is then treated just like a piece of photographic enlarging paper, and exposed in the darkroom under safelights; then it is sponged with normal developer, fixed and dried to give you a permanent image. A pint bottle is inexpensive and available in most camera stores or from *Rockland Colloid Corporation, 302 Piermont Ave., Piermont, New York 10968.*

Porter's U-Spread photographic emulsion is a similar product to Liquid Light and is applied with a normal paint brush onto virtually any surface you desire. Kits are sold in an eight-ounce size.

Rockland SC-12 Silk Screen Emulsion is just that, a device for creating silk screens from which additional prints are made. Although additional silk-screening material is necessary, you can create as many original color silk screens for T-shirts or printing as you desire. The kit is found in most stores or is available from Rockland Colloid.

PrintTint is another *Rockland* product that is used to color black-and-white photographic prints. Any combination of colors is possible

and the entire non-black image area can be dyed, or selective areas can be spotted with the fluid.

Tintype Photo Kit is a product of *Rockaloid, Inc.* and is just what it says, a device for creating realisitic tintypes. The effect is virtually indistinguishable from authentic tintypes. Tintype Photo Kit can be used in conjunction with your portrait business in which you feature "old-time portraits" with costumes and props. It is a very lucrative type of business you see often in department stores and shopping malls.

Fantasys

Fantasys are double-exposure devices or masks that are used primarily in the wedding trade. They are often offered as something you can learn via instruction or as actual masks for double printing. For more information on Bill Stockwell Fantasys (Bill Stockwell is a famous wedding photographer noted for his use of special effects), contact *W. Eugene Wright, Wilmington Photography, 212 N. Water, Wilmington, Illinois 60481*, or *Bill Stockwell's Casuals, 1105 Tedford Way, Oklahoma City, Oklahoma 73116.*

Folders

Folders that hold your photos in oval masks, or come with embossed, ornate gold leaf can enhance virtually any photograph. *Porter's Camera Store* sells different types of folders from their Gay 90's folders to their

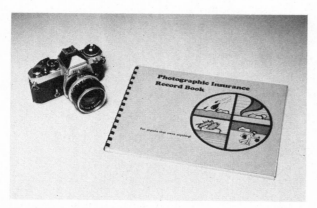

The *Photographic Insurance Record Book*, also available from Porter's, represents a small business in itself. Property and rooms are photographed while pages in the book provide space to list inventories. This can be offered as a photographic service that may mean thousands of dollars in insurance claim recovery for the homeowner who buys it from you.

modern PF-14 folders, which are modern cardboard folders designed to display an unmounted, unframed print. Delivering your prints in a folder as opposed to a manila envelope can mean the difference between a premium price and an average charge. Other companies make and sell folders that can be used to display full-size prints or for studio proofs. *Taprell Loomis* offers such studio proof folders with square and cameo shaped overlays with gold foil edges and a compact carrying case. For more information contact Taprell Loomis (address given earlier in this chapter).

Frames

Unique frames can also make the difference in your photography. For instance, you may be able to sell framed scenics to a store or chain of stores while your individual prints might be hard to move on their own. You can buy unique frames wholesale, if your volume warrants it, and make a handsome profit selling framed prints retail. You can also use such frames to display your work or to show your work to potential clients and offer the framed photos to customers as a deluxe custom service. Some handsome oval wooden frames with convex glass are available from *Sunlight Photography, P.O. Box 1687, Sausalito, California 94965*, or you can get authentic weathered wood frames from *Salt-of-the-Earth, Box 132, Luverne, Minnesota 56156.* You can get more modern acrylic plastic frames from *DAX Frames, 432 E. 91st St., New York, New York 10028.*

Greeting Cards

You can also offer your clients the service of creating greeting cards using either an attractive photo of the client and his family (which you have taken), or a beautiful scenic photo. You can purchase the type of card that is complete—all you need do is insert your photo. This type of card is available from *Porter's.* You can also get the type of greeting card that has a message double-printed on a piece of enlarging paper along with your photo. *Eastman Kodak* offers this service through its regional processing laboratories, or you can go through a large private lab in your area that offers the service.

Key Chain Viewers

Porter's as well as *Edmund Scientific* sell a type of key-chain plastic viewer that has one translucent end while the other end is a small

lens for viewing. The translucent end is removed and a tiny transparency (20x23mm—these can be cut from normal 35mm transparencies to fit the viewer) inserted. The end is snapped back in place and you have a permanently mounted transparency that can be viewed in virtually any light.

These viewers make handy free promotional devices or are products you can sell individually as novelty items. Both outfits sell the viewers by volume quite reasonably.

Laboratory Printing

Most labs won't handle complex printing of a photographic nature but you occasionally can find a lab that will handle your printing needs photographically. For instance, you can have catalog sheets, brochures, business cards, post cards or proposal covers printed by a company known as *Kolor View Press, 11854 W. Olympic, Los Angeles, California 90064*. An East-Coast lab that performs a similar service is *Dynacolor Graphics, 1182 N.W. 159th Drive, Miami, Florida 33169*.

Masks

Photo masks come in three basic types: the kind that can be sandwiched with your negative during printing to give you a masked image such as an oval mask; the kind of mask that lies on top of your enlarging paper in the easel and is opaque and thus supplies masking on the print surface; and the kind that is mounted or matted over a finished photograph. *Porter's* is the largest distributor of all

three types of masks that I know of. They sell 8x10 Kodalith print masks that say things like "World's Greatest Photographer" or "World's Greatest Golfer." You can get heart-shaped print masks or ovals or circles. They sell the same variety of shapes in 35mm negative masks. They make "Memory Mate" masks that can be used over the print to make a team and class shot on a single print. They make "Quotable Quotes" masks that are a collection of thirty-five 35mm masks of quotations that can be double printed with your negatives. They sell Reward Poster masks that mount over a photo or can be printed over an 8x10 print. They even make a mask kit for printing natural black borders around your prints.

There is no doubt that if you carefully choose the type of masks you wish to use in your promotions and services, you will interest a great many potential customers. For instance, if you shoot a lot of children's portraits, a Reward mask could sell an additional print order. If you shoot a lot of sports pictures, then a "World's Greatest . . . " would make sense. Quotations could be used over your scenics and sold mounted or framed. It depends greatly on the type of clientele you have and the type of photography you do whether you could use individual masks for additional profits.

Mounts

Mounting your photos on wood or Masonite will greatly enhance the appearance and val-

Keychain viewers available from a variety of sources make great giveaway and promotional items. You can also use them to advertise your photo services.

Porter's Photo Emulsion is an emulsion that can be spread onto any number of surfaces to produce unique photographs.

ue of the photograph. You can spray-mount large photos on to ¼-inch wood or Masonite in the conventional manner and then bevel the edges down to an angle and sand until smooth for a professional job. For smaller prints, you can use the two-sided tape or spray adhesive. Sanding and beveling will complete the job. Many labs will do the mounting for a reasonable service charge, which you can pass on to your clients. Mounting larger prints will, of course, cost more, but it is worth it if the photograph is valuable. The print can be sprayed and hung in the home and will be a permanent part of a home's decor.

Canvas-mounting prints is another method of improving the overall value of an ordinary photographic print. Canvas-mounting must be done under extreme pressure (the canvas pattern is indented into the base of the print) and is best done by a lab or framing service specializing in the service. There are canvas mount kits sold by *Seal* and *Ademco*, both of which are mounting equipment and supply dealers, but unless you are very familiar with dry-mounting techniques, you should leave this to an outside service.

Movies

You can photograph children's parties in Super 8 and sell the film to the parents. Children, especially small children, love to have their pictures taken with a movie camera because they can act out little scenes together as they see on TV or in the movies. If you are particularly good with kids, and have a little

Albums are a great way to offer a package photographic sale—a wedding album, a family album or an album of snapshots you have taken. The album ties together loose ends and is an excellent way to present your work samples.

imagination, you can direct a short movie with central characters (the birthday boy or girl, of course), a plot (not too detailed) and a lot of action. It will be a lot of fun for all involved, and the child's parents will very likely be glad to pay for the film.

Mugs and Plates

One of the most ingenious ways of making money with pictures is the photo mug. Basically, the photo plates and mugs work in the same way. You are given a clear, acrylic shell of a cup or plate, some inserts that include a slot or space for a photo, some lettering with which to design your own message, and finally, an upper shell that fits into the top of the plate or mug to seal it, the insert becoming a part of the unit. *Porter's* sells kits of two mugs and two plates, and kits of six mugs and six plates. You can also get them by writing to *Sims, 1441B North Jefferson, Abilene, Texas 79603;* or you can get the Thermo-Temp Mugs from *NEIL/Enterprises, Inc., 5145 N. Clark St., Chicago, Illinois 60640.*

Murals

Blowing up a client's photo to gigantic proportions is a great way to make money on existing pictures. There is no shooting for you to do unless you have originally furnished the photo; otherwise only supervision of the blow-up is called for. You must be careful not to allow the client to choose a photo that is soft, poorly composed, poorly exposed or badly lit. Blowing up such a photo will only accentuate its weak points.

Choose a crisp, sharp negative or slide and send it to a lab you know does good mural work. *Texcolor, Inc., P.O. Box Drawer A, Wichita Falls, Texas 76307,* makes color murals up to 30x40 inches. *Photo Murals of Florida, Inc., P.O. Box Drawer 11, Dept. R, Boynton Beach, Florida 33435,* makes up to 30x40-inch Cibachrome prints and up to 4x8-foot prints in black-and-white. Write for a price list.

Be sure that when a client examines his or her new mural, that it is viewed, not inspected. For example, do not go right up to the print, only a few feet away, and inspect it for grain and sharpness. Of course, it will look flawed. Large prints are meant to be viewed from four to six feet away, just as 8x10-inch prints are meant to be viewed at arm's length. They will appear sharp if viewed in this manner (if, indeed they are sharp and the enlargement has been done well).

Oil Portraits

This is a service that only your most discriminating customers will desire. *Chris Martin, 189 North Marginal, Jericho, New York 11753,* will draw free-hand, an oil painting from your photographs. This service has over 20 separate artists working for it. You can be sure the work will be relatively expensive, but it is, nevertheless, a service you can provide to your clients, making you a full-service photography business.

Electric Pen

If you've always wondered how photographers sign their prints in gold, and how much it looks just like a real signature, this is it. It is an electric pen that writes on gold foil in fine or bold letters. Simply position the foil over the area you want signed and sign with the pen. *Porter's* sells the pen and a roll of foil tape quite inexpensively.

While these signatures won't directly increase sales by virtue of their uniqueness, they will enhance the value of your work by personalizing it and showing the customer that he has purchased an original.

Place Mats

An item that you probably haven't seen too often is a photographic place mat. Attractive scenics can be blown up to place-mat size and laminated to form a handsome and salable home item. You can use color or black-and-white photographs and combine four, six or eight to sell as a set. The sky is the limit on marketing these attention-getters. For more information, contact *Kolor View Press, 11854 W. Olympic Blvd., Los Angeles, California 90064;* or *Duraplak Corporation, 7825 Deering St., Canoga Park, California 91304.*

Plaques

Plaques, like murals, are unique photo applications. While they won't be the bread and butter of your trade, knowing where and how to have them done will sometimes come in handy, not to mention make you some extra money. Redwood Plaques are available from *Chase Industries, Box 63, Burlington, Iowa 52601.* Walnut and modern plexiglass plaques are available from *Colortone Plaque Company, 3612 Centerview Ave., Wantagh, New York 11793.*

Postcards

Making postcards from your scenic photographs is a great way to bring in cash from your stock photos, but you can also offer the service to customers. Have your client's best scenic and vacation photos turned into post cards for his or her enjoyment or so he or she can send them to friends and relatives.

Eastman Kodak manufactures postcard-size black-and-white enlarging paper with the post card imprinting on the reverse side. These are as inexpensive to buy as normal black-and-white enlarging paper but you can send your own black-and-white postcards. Ask your camera store about ordering you some, or write to *Porter's,* they sell it too.

Porter's also sells preprinted postcards for which all you need do is peel off the backing paper and apply your own 3½x5-inch photo, color or black-and-white. They sell a pack of

Special-effects masks like these from H-L, Inc. of Dyer, Indiana, are a great way to produce unique special effects that are especially applicable in photographing weddings.

Porter's Fun Mugs and Party Plates are objects that can be used as sale items when photographing kids' parties, or when doing child portraiture, or as giveaways or promotional pieces.

25 for under $5.

If you want custom-printed postcards done in color by a professional printer, contact *Dexter Press, Route 303, West Nyack, New York 10994;* they specialize in all types of card and brochure printing from photographs and deal constantly with professional photographers' work.

Posters

Do you have an alluring shot of a great looking girl? Do you have a handsome scenic photo that looks especially beautiful when blown up big? You may have the makings of a great poster. Posters can be highly lucrative if the image is exciting and there is a public interest in the subject matter. For more information on making your photos into posters,

The electric pen from Porter's is a great way to personalize your photographs, or if you are doing custom lab work, you can have your customers' names emblazoned on an original print.

Photo greeting cards, also available from Porter's, are a great way to thank your yearly clientele or to offer as a service to customers. They take an insert of a photo rather than requiring the photo be printed on the greeting.

contact *Accents Inc., 968 N. Formosa, Los Angeles, California 90046; Colourpicture Publishers, Inc., 76 Atherton St., Boston, Massachusetts 02130;* or *Dukane Press, Inc., 2901 Simms St., Hollywood, Florida 33020.*

Proof Books

These are a handy way to augment your wedding sales. Many times you won't be able to sell two complete albums to a family but you will be able to sell an album of proofs which you usually have made anyway. It's like selling one and a half albums. Many makers of albums also make studio proof books, and they are available at your local camera store.

Puzzles

Another great way to make extra money and call attention to your enterprise is to make and sell photo puzzles of local scenics or pretty girls or just about any subject matter that is intricate and full-colored. Puzzles of local scenes or landmarks should sell well in your area and will attract much attention to you and your work if strategically placed for sale in your community. You may even decide they would make a good business all on their own. For more information on having a puzzle cut from an existing photograph, contact *Photographers Specialized Services,* address given elsewhere in this chapter.

Retouching and Restorations

It may, on occasion, be necessary to have your prints or large-format negatives extensively retouched. It may also be important for you to have a client's photo or negative restored. If after checking in your *Yellow Pages,* you don't find anyone who can perform these services in your area, contact some of the agencies who do retouching and restorations, nationwide. *Estelle Friedman Photo Retouching, Inc., 160 E. 38th St., New York, New York 10016,* is one such agency that works on transparencies, and prints, black-and-white and color; *Hughes & Wahnon, 3428 Hugo St., San Diego, California 92106,* does black-and-white and color as well as oil coloring. *George Tatgenhorst, 626 E. Providencia Ave., Apt. A, Burbank, California 91501,* does retouching and restorations, color and black-and-white. His rate is currently $10 per hour, so get an estimate if the restoration work needed is extensive. *Brogan's Art Service, 1531-D East Blvd., Charlotte, North Carolina 28203,* does restorations, oil coloring and airbrushing jobs.

Sing-Along Slides

Sing-along Slides from *Visual Horizons, 208 Westfall Rd., Rochester, New York 14620,* are great for parties, meetings, school assemblies, etc. All you need is a slide projector and a cassette recorder, and they supply the rest. Write for more information. It might be a great way to pick up extra money and promote the versatility of your business at the same time.

Special Effects

Special effects are available to you primarily through photofinishing labs throughout the country who do a large business in weddings. These effects, like a song sheet double-printed with the portrait of the bride and groom, or a double exposure of the church interior with a close-up of the bride and groom, are extremely popular for weddings; so much so that you hardly see a wedding done anymore without at least one misty, fantasy or special-effects shot.

If interested in labs who do a lot of special effects, try *Fine Art Color Lab, Dept. R119-5, 221 Park Ave., New York, New York 10003,* or a lab in your area if their specialty is special effects. If interested in printing your own, write to *Musto Graphics, 3477A Kennedy Blvd., Jersey City, New Jersey 07307.* They will sell you a kit of 16 different masks that you can print yourself with your own negatives or send to your lab to have printed.

Trading Cards

Tradin' Cards are a unique promotion done by *Group Photo Alliance, 875 Maude Ave., Mountain View, California 94043,* a West-Coast photo lab that specializes in sports and schools. Tradin' Cards have a photo of the Little Leaguer as well as his name, position

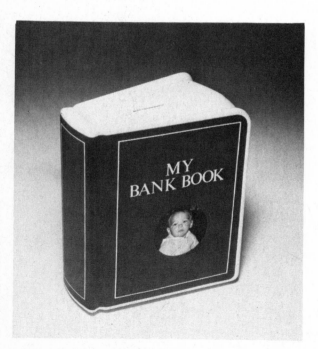

The Photo Bank Book from Porter's makes a great promotional piece when doing kids' pictures.

LIST OF SUPPLIERS

Accents, Inc.
968 N. Formosa
Los Angeles, CA 90046

Ademco Products
Division of EPOI
623 Stewart Ave.
Garden City, NY 11530

Art Leather Albums
37 Moultrie St.
Brooklyn, NY 11222

Badge-a-Mint, Ltd.
Box 618, Dept. CT 119
Civic Industrial Park
La Salle, IL 61301

Brogan's Art Service
1531-D East Blvd.
Charlotte, NC 28203

Bryce Enterprises
Country Drive
Plainview, NY 11803

Bumperstickers
13241 Harbor Blvd.
Garden Grove, CA 92643

Camille Company
826 Bergen St.
Brooklyn, NY 11238

Chase Industries
Box 63
Burlington, IA 52601

Chromalloy Photographic Industries
1706 Washington Ave.
St. Louis, MO 63103

Colortone Plaque Company
3612 Centerview Ave.
Wantagh, NY 11793

Colourpicture Publishers, Inc.
76 Atherton St.
Boston, MA 02130

DAX Frames
432 E. 91st St.
New York, NY 10028

Dexter Press
Route 303
West Nyack, NY 10994

Dukane Press, Inc.
2901 Simms St.
Hollywood, FL 33020

Duraplak Corporation
7825 Deering St.
Canoga Park, CA 91304

Dynacolor Graphics
1182 N.W. 159th Drive
Miami, FL 33169

Edmund Scientific
101 E. Gloucester Pike
Barrington, NJ 08007

and uniform number and look almost identical to actual baseball cards. If you photograph a lot of school sports, this might very well be worth investigating.

Surely there are many more gimmicks, gizmos, etc. on the market that you will not find here. There are more coming out all the time. If you stay on top of the professional and amateur photo magazines, you will catch the new products as they become current and you will get the jump on your competition.

You will probably find that these items are not always ends in themselves, but rather means to an end: the continued promotion of your photography business, or a way to attract attention and cultivate interest in you as a photographer. People don't normally buy what they don't feel they need unless they have become suitably interested in a new product or service. Catchy and unique promotional ideas are a great way to cultivate and refine that interest.

Fine Art Color Lab
Dept. R119-5
221 Park Ave
New York, NY 10003

Estelle Friedman Photo Retouching, Inc.
160 E. 38th St.
New York, NY 10016

Group Photo Alliance
875 Maude Ave.
Mountain View, CA 94043

Hughes & Wahnon
3428 Hugo St.
San Diego, CA 92106

Kolor View Press
11854 West Olympic
Los Angeles, CA 90064

Lanwood Industries
42-05 97th Place
Corona, NY 11368

M&A Studios
Box 7000
Mobile, AL 36607

Chris Martin
189 North Marginal
Jericho, NY 11753

Musto Graphics
3477A Kennedy Blvd.
Jersey City, NJ 07307

NEIL/Enterprises, Inc.
5145 N. Clark St.
Chicago, IL 60640

Photo Charms
P.O. Box Drawer 491 R-9
Greencastle, IN 46135

Photographers Specialized Services
612 Summit Ave.
Oconomowoc, WI 53066

Photo Murals of Florida, Inc.
Dept. R
P.O. Box 11
Boynton Beach, FL 33435

Photo World
Box 21
Evansville, IN 47701

Porter's Camera Store, Inc.
Box 628
Cedar Falls, IA 50613

Professional Yearbook Photographers of America
3807 Charlotte Ave.
P.O. Box 90883
Nashville, TN 37209

Rockland Colloid Corporation
302 Piermont Ave.
Piermont, NY 10968

Salt-of-the-Earth
Box 132
Luverne, MN 56156

Seal, Inc.
Naugatuck, CT 06770

Sims
1441B North Jefferson
Abilene, TX 79603

Souder's, Inc.
92 Lexington Ave.
Albany, NY 12206

Bill Stockwell's Casuals
1105 Tedford Way
Oklahoma City, OK 73116

Sunlight Photography
P.O. Box 1687
Sausalito, CA 94965

Taprell Loomis
Department N-101
2160 Superior Ave.
Cleveland, OH 44114

George Tatgenhorst
626 E. Providencia Ave.,
Apartment A
Burbank, CA 91501

Texcolor, Inc.
P.O. Box Drawer A
RF 180
Wichita Falls, TX 76307

TSP
4142 Pearl Rd.
Cleveland, OH 44109

Visual Horizons
208 Westfall Rd.
Rochester, NY 14620

W. Eugene Wright
Wilmington Photography
212 N. Water
Wilmington, IL 60481

Custom Developing and Printing

Chances are if you enjoy doing your own developing and printing, and you're pretty good at it and get consistent results, you already have the main ingredients necessary for another money-making venture—custom developing and printing. It seems as if the only types of photographic labs in business anymore are the custom labs that offer hand-done services, and the automated drugstore variety of photo-finishing. One costs a fortune to send your work to; the other doesn't cost much, but you may end up sending your work back a second time. There is a definite need in most communities for a small lab that offers good quality work for a reasonable price. You can become that lab

The first thing you need to go in business for yourself as a custom photo lab is a custom photo lab. This is my garage where my lab is. Originally there was no wall from the water heater over to the door on the right, yet this was a perfect area for a darkroom because only one wall and ceiling had to be built. The water heater, formerly located inside the darkroom enclosure area, was moved outside to the location shown.

for a reasonable investment in time and equipment.

If you are like most amateurs already doing their own darkroom work, you already have most of what you need to go into business as a custom lab. You could not compete with the larger labs unless you had a lot more sophisticated equipment, but if you can offer a mini-

Inside, on the dry side of the darkroom are two 4x5 Beseler enlargers for multiple printing. To complete the setup, a partition needs to be inserted between the enlargers to cut down on light scatter from each of the enlargers.

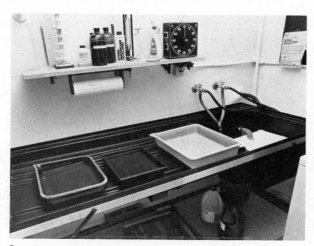

On the wet side of the darkroom is the darkroom sink, which in this case is six feet long. It is large enough to do all my printing and film processing.

mum of services and do them well, you will have all the business you can handle. For instance, a few of the services that you might offer with a small darkroom are developing 35mm and 120-size films, custom enlarging to 4x5, 5x7, 8x10 and 11x14-inch prints, making proof sheets from the developed rolls of film, making copy negatives, special-order film processing like push-processing or under-development, and print mounting. With only these few services, you may think that people will take their business to a larger, more sophisticated lab. You may lose a few customers this way but you will find many people who would rather deal with a smaller establishment where they will get personal service.

Many small businesses and schools do their own photography but not their own lab work. In addition, a great many amateurs like to shoot black-and-white film but don't have a darkroom, nor do they enjoy the less-than-satisfactory results that drugstore photofinishing gives them. Local papers, shopping circulars, and other publications all have a need for custom darkroom work, as do a growing number of professionals like doctors, lawyers and architects who use a camera in their professions but who don't find the time or can't see the point in doing their own lab work. These are your potential customers. In addition to these, you may find professional photographers who will call on you for service because you can offer them good results quickly and consistently. Professionals like dealing with a one-person establishment because they know that if you want to keep their business, you will have to give them good service, something they may not always get at a larger custom lab.

Since you will be operating out of your own home, and not a store, you need some way of communicating to the public the availability of your service. You can become known by placing ads in local newspapers, by putting up your business card at the local camera shop or by sending out direct mail pieces to camera clubs and area professional photographers. You can offer a free introductory service, like a free roll of film, or a free 8x10, for trying out your service. If you don't want peo-

ple coming to your house or apartment at all hours of the day and night, get yourself a post office box and have people send the work to you there. If fast service is needed, you can always make arrangements to deliver the film or prints in person.

You will find that once you are in business for a while, you may be eligible for wholesale prices on supplies or at least discounts from retailers if you order supplies in sufficient volume. Many photographic suppliers and camera stores are glad to offer you a sizable discount if it means repeat business for them. In some areas of the country you may need a resale license or similar permit before you can seek out a wholesaler. Check the current regulations in your municipality with the local Chamber of Commerce or Department of Permits and Licenses.

Pricing

Before anyone will use your service, you need an official price list. As in all types of free-lance photography, you must analyze your costs and figure in your time and profit to come up with a price that will insure you won't be losing money. With laboratory work especially, you must assume that since your equipment will be in use as often as you have work, it will be depreciating quite rapidly, more rapidly than under normal use. Therefore it will be necessary to figure that depreciation into the cost of your service. Roughly five percent of the cost of your prod-

uct and/or service should be directly related to the depreciation and replacement of your equipment.

With the rapid escalation of silver prices at this writing, it would be foolhardy to list a price list that could be followed verbatim. What I will do instead is list an approximate current price for each item. What will be significant to the reader is not the actual price, but the differences between prices for similar items and the differences in prices for greater numbers of prints or rolls processed, etc.

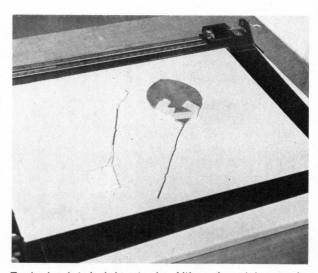

Typical print-dodging tools. Although not too pretty, they get the job done quite effectively.

Above the sink it is a good idea to have a light for print inspection and paper towels to clean up spills. Developers and mixing equipment are also located near the sink.

Print-dodging cards. Note the tape on one of cards that covers up a tiny hole which is used for special burning-in maneuvers. Corner of top card is cut out for burning in angular areas.

Black-and-White Film Processing
35mm, 20 exposures .. $3.50 per roll
35mm, 36 exposures .. $4.00 per roll
120 $3.50 per roll
220 $4.00 per roll
4x5 $1.00 per sheet

For 10 or more rolls or sheets, offer a 15 percent discount for each roll or sheet thereafter. For 20 or more rolls or sheets, offer 20 percent discount.

Special Processing plus 100%
Rush Processing plus 100%

Proofing (Black-and-White)
35mm, 20 exposures $2.00
35mm, 36 exposures $2.50
120 .. $2.00
220 .. $4.00
4x5 (four proofs to a sheet) $2.00

Apply the same volume discounts to proofing charges as you would do for volume film processing.

Enlarging (Black-and-White)
5x7 .. $5.00
8x10 .. $8.00
11x14 .. $11.00

For each additional print up to 10 prints, reduce the price by 30 percent. For instance, for five 5x7s from the same negative, the price would be $5 for the first print and $3.50 for the remaining four prints. For between 10 and 20 prints from the same negative, reduce the price 40 percent below the single-print price. For between 30 and 50 prints from the same negative, reduce the price 50 percent from the single-print price or establish a price for each individual order calling for more than 30 prints from a single negative.

Each print should be a good print with a minimum of burning and dodging. It should also be spotted. If you are using double-weight paper, you will need to raise your price 30 percent or more over single-weight prices. If you are using resin-coated papers, the weight of paper is not a consideration.

For prints requiring special printing proce-

Adjacent to the sink is a pegboard on which I have hung supplies that I need to use frequently.

dures such as excessive burning and dodging, charge an additional 100 percent for the special handling. For prints that are merely a little thin or a little hard and require printing on a harder or softer grade of paper, there should be no additional charge, because you are getting paid for making quality prints and that entails determining what the specific needs of each negative are.

Copy Negatives
4x5 or smaller $10.00

This price is for making a copy negative from nontransparent originals. Transparencies are a completely different matter (see the chapter on copying for more details on techniques of both). Your print prices should be the same as if you had not made the negative; however, you will more than likely be called on to make a number of prints from a single copy negative, so you should price the prints accordingly.

Print Mounting
5x7 .. $1.50
8x10 .. $2.50
11x14 ... $3.50

You may not find it advantageous to offer mounting services with your custom developing and printing service. It calls for special equipment and techniques and is not all that profitable unless you are also equipped to frame photos. See the chapter on photo finishing techniques for more details.

Darkroom Design

If you already have a darkroom in your house or apartment, disregard this section. However, if you are about to put in a darkroom, there are a few handy rules to remember that will save you a lot of aggravation.

If you are going to construct a temporary darkroom, you will not be able to make much money. You will spend most of your time putting it together and tearing it down. You will need a more permanent lab. Most people construct labs in spare bathrooms or in the basement or in a closet. In any area you choose, you will need both electricity and running water. You will also need a place you can make 100 percent lighttight. It is best to divide the darkroom into a dry side and a wet side. All of the film and paper processing is done on one side while all of the enlarging and other dry work is done on the other. You will also need a system of ventilation which will allow fumes to escape.

Your darkroom must be free of moisture and humidity. If it is not, a dehumidifier will be called for. If any construction must be done,

Motorized film agitator and drum allow you to standardize your film-processing procedure. Entire set-up sits on one of the rungs of the darkroom sink. Processing time and chemical consumption are reduced by using such setups.

If you're using conventional tanks, a water-bath system is recommended to keep chemicals in line with each other. Same-temperature processing for all steps including rinses will reduce grain size.

try to choose an area that is in a corner and will only need two walls constructed. In a recently constructed darkroom in my house, I chose an area in an alcove that merely had to have a single wall with a door installed. Where possible, when a wall or ceiling must be built, try to build it in multiples of four feet, thus capitalizing on the fact that most wallboard, drywall or paneling comes in 4x8-foot sheets.

A laundry room is perhaps the best location for a darkroom. It has running water, a drain (or standpipe which can be fashioned into a drain) and electricity, and is usually larger than a closet so it has plenty of room. Wherever additional plumbing or electricity must be done, you can save money in the long run by having a professional do the job for you, especially electrical work. If you are using the darkroom for business, it will be a legitimate tax-deductible expense anyway, so why risk a

bad wiring job and possible fire to save a few dollars? The same is true for your plumbing needs. If you need to have a plumber come out later for emergency service once your fixtures are in place, it will cost you twice as much. A good idea is to check the newspaper's classified section under handymen or home repairs and alterations. Here you will find people who can do general contracting, which includes plumbing, construction and electrical, but they are not as expensive as if you had a specialist come out for each job.

Although space doesn't permit here, it is a good idea to look at several darkroom designs before deciding how yours should look. Two excellent sources for darkroom designs are the *Eastman Kodak Encyclopedia of Photography,* pages 663-683; and Eastman Kodak publication K-13, *Photolab Design.* These sources will help you visualize how your darkroom should look and will give you needed hints on construction and design.

Darkroom Equipment

It is not the purpose of this section to outline the equipment that is needed in setting up a darkroom, but to determine what *else* is needed to add to a basic darkroom so that you can perform commercial processing and printing services. It is assumed that you already know what is needed in the setting up of a basic darkroom but in case you want more information, see *Petersen's Big Book of Photography,* pages 304-385; or *Petersen's PhotoGraphic Magazine's* series on "Basic Darkroom," which began in the January 1980 issue.

One of the necessary items in your expanded darkroom will be a commercial darkroom sink. If you will be doing a lot of printing and processing, you need an area that will accommodate all that activity and a product that will hold up to that kind of abuse from harsh photochemicals. Depending on the size and accessories, you can spend anywhere from $200 to $800 on a darkroom sink. If you equip the sink with temperature control valves, you can run the cost even higher. You could cut costs by making the sink out of wood, and then fiberglassing it. If you are interested in obtaining more information on stainless steel sinks, the following companies make them: Leedal, Inc., 2929 South Halsted Street, Chicago, Illinois 60608; Calumet Scientific, 1590 Touhy Avenue, Elk Grove Village, Illinois 60007; and California Stainless Manufacturing, 212 Euca-

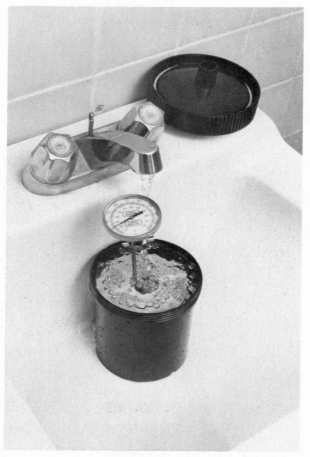

Small film batches can be effectively washed under running water.

lyptus Drive, El Segundo, California 90245. If you are looking for a less expensive molded rubber sink, contact Photo/Line, 1506 West 12th Street, Los Angeles, California 90245.

Another area in which your darkroom will need upgrading is film-processing gear. You simply will not be able to process large numbers of roll films with conventional inversion-type developing tanks. You can if you must, but remember you have to invert such systems every 30 or 60 seconds, depending on the size of the tank. This is time-consuming and not terribly consistent.

There are several alternatives. You can invest in a motorized agitator and film drums such as those made by Unicolor and Beseler. These free the darkroom worker from agitation procedures and they also drastically reduce the amount of chemistry needed to de-velop your film, thus providing needed economy. These agitators also provide uniform agitation and consistent results. Their constant agitation action also causes reduced processing time. You can process six rolls of 35mm film per drum, and with several drums and sets of film reels, you could process up to 18 rolls per hour.

Another way to go is to use 3½-gallon hard rubber tanks with daylight lids. These will accommodate up to a dozen reels of film at a time when the film is on spindles. You will spend more on chemistry, but you can use it over and over again via replenishment. Many chemicals come in 3½- or 5-gallon sizes to accommodate these large tanks. You can also process sheet film more readily in the larger tanks. If you use a water rinse between developer and fixer, you will need only two tanks

When using the motorized drums, film can be washed by inserting a tube down center of reels.

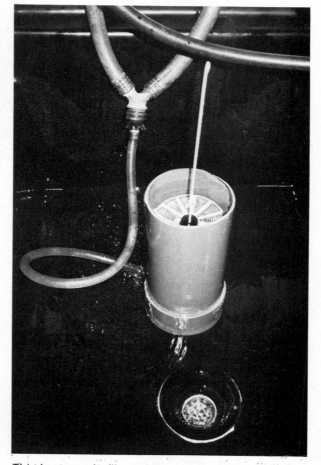

This homemade film washer works great for several rolls of 35mm or 120 film. Film is put on a spindle (made from a coat hanger) for easy handling.

This is a larger film washer, again made from four-inch plastic sewer pipe (PVC pipe). This can effectively wash 10 rolls of 35mm film.

Converted battery case is used to wash sheet film. Note aeration in water. As with other types of homemade film washers, hole is drilled in washer side slightly smaller than tube coming from water supply. That way it will fit into the washer snugly. Note in these photos that water supply is mixed into one hose via hose couplings.

which can remain permanently filled if covered and protected from oxidation. Developer must be replenished after each use.

To wash all that film, you are going to need a large and efficient film washer. You can use a 3½-gallon rubber film tank with a hole drilled in the lower part of one of the tank sides to accept a ½-inch hose that is connected to the sink faucet. The 3½-gallon tanks are also great for washing sheet film. You can also use a four-inch plastic (PVC) sewer pipe with coupling for a roll film washer. Simply attach the ½-inch hose that is connected to the faucet through a similar ½-inch hole drilled through the base of the washer. You could buy a commercial washer, too, but these are sometimes unnecessarily expensive.

With many rolls of film drying all at once, you will also need a system for effectively drying the film. Forced-air film-drying cabinets such as those made by Calumet and Califor-

Fix the film for twice the time it takes to fully clear. This is a good rule for all your commercial film-processing endeavors. Cut a piece of undeveloped film (the film leader works well) and throw it into the fixer you intend to use. Watch the film clear. If it clears totally in a minute and a half, fix for three minutes for best results.

Always use Photo-Flo or some other wetting agent as a final step prior to drying the film. You will eliminate water spots and countless hours of spotting.

nia Stainless Manufacturing are the best systems because they provide an enclosed atmosphere to keep dust out and they have a temperature control system to ensure that you do not dry your film at too hot a temperature. You can also dry your reels and tanks in the bottom of such dryers, and this will greatly speed up your film-processing operation. The enclosed atmosphere will also cut down on printing time, because you will have less dust

Special photo sponges are great for removing the excess Photo-Flo from the film. Go once down the base side, once down the emulsion side, let dry.

to clean off each negative and less spotting to do for each print.

You may also want to invest in a second enlarger if your darkroom is big enough. This way you can print on two enlargers at the same time and thus double your work output. More about this a little later. If you like the enlarger you currently have, get another one. You will be able to use the same lensboards and negative carriers and you will also be able to speed up the operation by working with two identical enlargers.

Production Techniques

Because you will be doing *custom* processing and printing, you had better be sure that the work you deliver is of the highest quality you can produce for the price. Otherwise, it will not be worth it for your customers to use your services. You must be especially careful to maintain quality from the beginning, when you are first starting out. The processes should be controlled so that your results are predictable and controlled no matter whether you are processing your first roll of the week or your 50th. How can you maintain quality? The easiest answer to that is to follow the instructions on the products you use to the letter. If the instructions on the developer say to use until you have processed so many rolls or square feet of film, do not exceed those limits or you will be asking for trouble.

Always be meticulously clean in your work habits and clean up after yourself as you go along. Keep plenty of dry towels on hand and always rinse your hands in fresh water before drying them.

Film Processing

Processing many rolls of film at a time may be frightening at first but it is almost the same as processing only a few at a time. Regardless of the system you may choose—whether you use drums, inversion tanks, deep tanks or dip-and-dunk tanks—your development time is the most crucial of all chemical times. It is best to use only one developer for all the films you process. That way you standardize your times and temperatures and can have the times for each temperature on the wall by your processing tanks. Interpolate time and temperatures so that you have an exact time for each temperature within the range you anticipate using in your darkroom. In a place where I once worked, we had a range of 65° F. in winter to 80° F. in summer. Beside the

developing tank in each of the darkrooms there was a chart giving the exact developing time for every single temperature from 65 to 80° F. There was nothing left to chance.

If you use the large tanks, your fixer temperature will be the same as that of your developer since they are stored together. Simply adjust your wash temperature so it matches the other two and you are in business. If you are careless about your wash water temperatures, you will never get consistent results. If your wash is much hotter or colder than your other chemicals, grain will result and at the extreme temperatures, reticulation.

To get consistent negatives, run tests to determine what the optimum development times are for the films you plan to develop. The times listed in the film package are not always the optimum times, although for the most part they are usually very close. Most labs tend to slightly underdevelop their film from 5 to 10 percent so as not to overdevelop the film. Petersen Publishing's labs do just that because they maintain they get a little better print from a slightly underdeveloped negative. You must be the judge since you are the one responsible for achieving accurate and pleasing results from your customer's film. If you find that a negative developed according to the manufacturer's recommendations yields the most pleasing print to both you and the customer, obviously this is the right time of development.

After you have been working with a certain individual's film you will begin to see a pattern of exposure that is unique to that individual

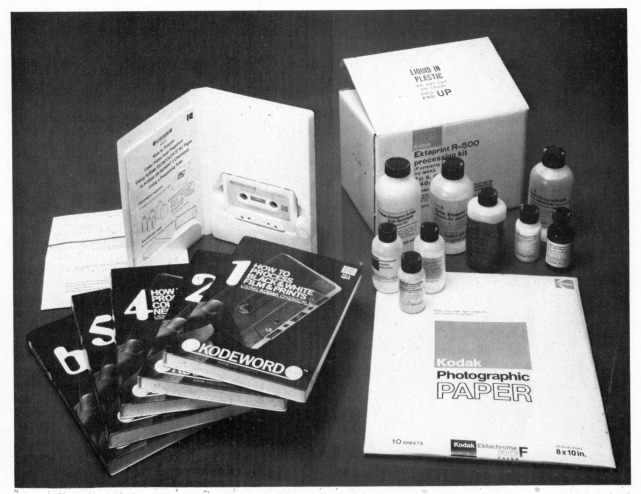

If you are ever stuck and don't know how to do a certain process you may be called on to perform, look into Kodak's Kodeword tapes, which consist of a tape that you follow along with the process. I have used these tapes as refreshers and have discovered some faults in my processing procedures.

Use large one-gallon sizes of chemicals and you will do less mixing and also save some money.

and his/her equipment. For instance, in shooting Kodak Tri-X film indoors, with flash, I rate the film at E.I. 200; when shooting the same film outdoors, I rate it at E.I. 250. My negatives are processed to the normal recommendation by Kodak and I get a very pleasing negative and resulting print. Some people however, expose their Tri-X at ASA 400, while other people I know shoot it at E.I. 125. It's a strange world but you have to adapt to these different needs if you are going to be successful as a custom film processor. Furthermore, you will often find photographers who want you to give their film increased development or decreased development. They may want to increase development to increase the contrast of the scene if the scene was flatly lit, or they may want to increase the film

Making custom contact sheets is easy, but the under- or overexposed frames must be dodged and burned to get a good overall print with fairly consistent tonal range in all frames.

speed by "pushing" the film in development. As a custom lab you should be prepared to offer push-processing as a service. There are many speed-increasing developers on the market and you should familiarize yourself with them.

Generally, you increase film speed by over-developing the film in a developer that will not increase the overall contrast to unacceptable levels. Speed-increasing developers enhance existing shadow detail and thus create an increase in film speed. Some of the most popular speed-increasing developers are Acufine and Perfection Super Speed, which comes in tablets. For more information and specific densitometric data on push-processing, see *Increasing Film Speed,* by Mike Stensvold, a book that is part of Petersen's How-To Photo-Graphic Library.

You may also be called on to decrease development, particularly if the film was exposed under contrasty lighting situations. You will then be instructed to develop the film from 10 to 30 percent less than usual.

Custom processing your own film means producing negatives that are not only well developed, but also free of dust, dirt and scratches. Careful washing and drying will ensure trouble-free negatives. If your local water supply is full of minerals, for a final wash step use a mixture of distilled water and Kodak Photo-Flo or some other wetting agent, and vigorously agitate the film for a full 30 seconds. This will remove most if not all of the sludge and grit from the film. Complement this procedure by carefully squeegeeing each side of the film once with a photo sponge that has been dipped in Photo-Flo and wrung out. Such sponges are available at your camera store and should be stored in an air-tight baggie when not in use.

After the film is completely dry, it should be removed from the drying cabinet and immediately cut and placed in protective glassine sleeves. This will facilitate the identifying procedure and also help ensure undamaged negatives. Remember, if you are air-drying roll film negatives, they do not dry entirely for at least 4-5 hours.

Proof Sheets

Custom proof sheets take time to make. Anyone can expose a sheet of paper under the enlarger in a proof frame and come up with a decent proof sheet, but customers want to see every frame, regardless of wheth-

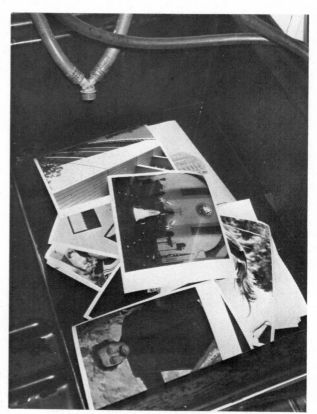

With fiber-based prints you can use a holding tank with fresh water and then wash them all together.

Multiple printing—printing more than one negative at a time—will help you improve your work output. You must be careful when processing many prints at a time. Here, a half-dozen prints are being placed in the developer at one-second intervals, emulsion down.

142

er they have under- or overexposed it. To create a perfectly exposed proof sheet, you must start with the enlarger at an optimum and consistent height, say 24 inches, and the same aperture, say, f/11. Your exposure has to be pretty consistent too, say 10 seconds. This will be right for the majority of negatives on the majority of rolls you process. For those frames that have been over- or underexposed, you must burn and dodge them just as you would parts of a print that were selectively too hot or too thin. You can do this by first increasing your exposure—if you want to double your exposure, try 20 seconds at f/16—and then holding back the underexposed frames, and burning in the overexposed frames (you can open the lens back up when you burn in

the overexposed frames so as not to have too long an exposure). A rectangular dodging tool and cutout burning-in card are the only special tools needed.

You may find that the contact sheets you make are flat (not contrasty) after being exposed through the proof frame. You can compensate by either going to a harder grade of paper or overdeveloping the print. If you develop a print that should normally be developed for 1½ minutes for 3 minutes, you can gain roughly ½ paper grade, provided your safelights are safe and do not fog the paper.

Multiple Printing

By multiple printing, I don't mean double-image prints, I mean printing more than one

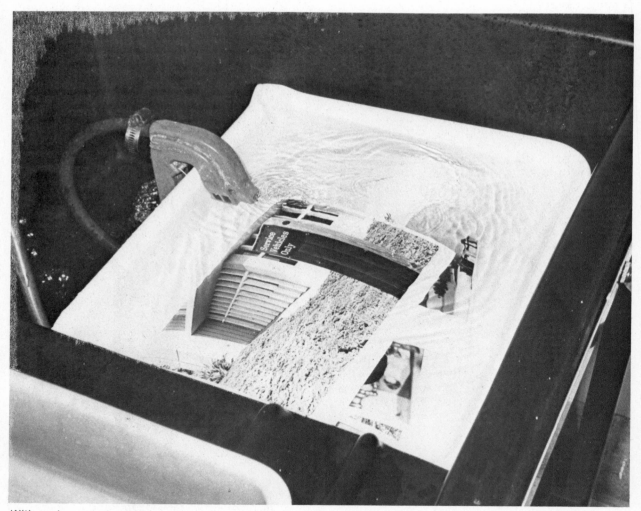

With resin-coated prints you must cut down the wet time and wash the prints immediately. Included in photo is Kodak Print Tray Siphon, a highly effective way to wash small numbers of prints.

negative at once. This can be accomplished by printing with two enlargers, or you can do it by removing the negative each time you expose a print, insert a new negative, make another print, and so forth. Then you process all the prints together. If you print full-frame images, you will begin to judge, to a very accurate degree, how much or how little exposure variation is needed to make a perfect print. You can thus "eyeball" a negative, make an exposure on a piece of paper, and go on to another negative. If you are printing a roll of negatives all exposed the same and under the same light, you can almost print every frame within a single second of every other frame.

When you are using two enlargers, you must be sure that the light of one does not

Small numbers of resin-coated prints can be dried by hanging them up just as you would your film.

fog the paper of the enlarger next to it. You can most easily avoid this spill light by erecting a board between the two enlargers. This will allow you to walk away from the first enlarger while it is exposing paper, and turn on a second enlarger without endangering the first print. Sounds complicated but all you are doing is working on a single negative at a time, only on two different enlargers. Things

With large numbers of prints, you may need to build a drying rack made up of stacked window screens (end view shown here). Built under a countertop, they are an effective and space-saving way to dry large numbers of prints.

You can double your processing fee by "push-processing" special orders. Perfection developers can be called on for pushing film and for special fine-grain applications.

get tricky when you start removing negatives after making an initial print and reinserting a new negative to work on. Thus you may be juggling six or eight negatives this way.

Multiple printing is the only way you are going to make any money custom printing. If you expose a test strip for each print, then develop it, then analyze it, then expose a good print, soup and evaluate it, you have taken perhaps 12 minutes. This means that no matter how fast you are, under that system, you can only produce five good prints in an hour. That is not going to make you any money unless you spend six hours a day printing. You must learn to print more than one negative, retain the mental information needed to print that negative, and move on to another.

After you have made several prints, now you must develop them together. It is not too bad when you have only a few prints, the problems begin when you have up to 30 prints to soup at once. How in the world do you do that, you ask? Very carefully.

The easiest way to develop a number of prints together is to hold all the prints on your palm, face up and ready to immerse in the developer. Regardless of whether you are souping 5 or 25 prints, you do it the same way. Start your timer and give yourself 10 seconds' lead time so you can get back to the tray and start exactly on the minute. At the right moment, lightly grab the top print at the lower corner of the print and immerse it emulsion down in developer with your fingertips. It should take one second to immerse one print—this is important and you should count out, "one-one thousand" each time you put a print in the developer. With your fingertips, dab the print in the center under the developer so as not to get your hands wet. How do you immerse the print in developer with your fingertips and not get your hands wet, you ask? Well, it sounds difficult, but the print offers some resistance from the center out to the corners on being forced into developer. That little bit of resistance gives you all the time you need to propel the print downward with your fingertips into the developer and not get your fingers wet.

Repeat the procedure for each print, counting out loud, "one-one thousand" each time you insert a print. When you get to the last print in your hand, invert it so it goes in the opposite direction the others did. This tells you it is the last print, and consequently

which print will be the last to leave the developer. Look at the clock once all the prints are in and see if it really took only one second to get each print in. If it really took two seconds each, that's all right, you simply take two seconds to pull each one out. Now, reach down and carefully turn the whole pile of prints upside down so the emulsion now faces up.

Fan the prints during development, flipping leisurely through the series several times during development. If you forget to invert the last print, note after you flip through the prints which one is the darkest, call that number one and remember at the end of the prescribed development time (which hopefully is at least two minutes) to remove it first.

When it is time to throw the prints into the stop bath, you cannot get your hands wet with acid and then go back into the developer. You will start staining prints and certainly contaminate the developer. Once the prints are wet, they are a lot easier to handle than when they are only partially wet. Grab the print on the ¼-inch print border, drag it up and out of the developer, flip it on route and drop it face down into the stop bath. Again, this should take only one second and you must count again if all your prints are going to be evenly developed.

You don't need to fan through the prints in the stop bath. If anything, you must hurry a little so as not to leave them in the acid too long. Again, flip the whole pile of prints over.

Repeat the same procedure and drag the prints up and into the hypo, one at a time at one-second intervals. It is preferable to have a deep hypo tray if printing lots of prints at a time. Not only can you fully immerse a print, but you can fill the tray quickly with prints.

This method of printing is not nearly as complicated as it sounds, but it does take practice to perfect. Start with only a few prints at a time and work your way up. When I first saw this method of development, I thought I'd never be able to print that fast, but after a few months, I got so that I could develop 40 prints in a minute and a half and every one would match! This system is ideal when you are making large numbers of prints

from a single negative. Instead of making five prints an hour the old way, you can now make 50.

It is important to remember when souping many prints at once to perform your test prints under the same conditions as you will be printing the multiples. For instance, if you have just made developer, and it has not cooled to room temperature, do not attempt to make a dozen prints from the same negative until the developer has stabilized. Similarly, don't attempt to make many prints at once when the developer is near exhaustion. Your results will be inconsistent at best and you may end up staining many of the prints.

One final word about custom printing. I once worked for a distinguished, elder photographer who taught me more about photography than anyone since. He told me there is no such thing as a straight print. He was ab-

1,2. Special printing techniques like printing with texture screens and multiple-image printing can be used to promote your photographic expertise. They can also be offered to your customers as a special service with their negatives.

1

solutely right. No matter how good the negative, there is always something you can do—a little holding-back, a little dodging; there is always something you can do to improve the image.

With all of these prints in a holding tank, be sure you have adequate facilities to fully wash all the prints. If you don't, wash only some at a time. Use hypo eliminator to cut your wash time but do not tax the system. You will pay with stained prints. There is nothing so exasperating as a hypo stain, because it doesn't usually show up until after the print has dried.

Any of the commercial print washers is good if you follow the washing instructions to the letter. I use an old Kodak tray siphon when printing small numbers (up to 30 or so prints) and wash them in the next size larger print tray.

I generally wash for one-third longer than is recommended to be on the safe side. I squeegee the prints to remove excess moisture and speed drying, and then I either place them on the print dryer or hang them up to dry if they are resin-coated prints. If not in a hurry for dry prints, I generally dry my fiber-based prints between towels and let them air-dry naturally. It helps preserve the rich black tone in the prints.

There are undoubtedly a lot more tricks of the trade that could be discussed in a chapter on custom lab work, but space just doesn't permit. If you enjoy working in the darkroom, and you must to embark on this type of business venture, you will figure out your own tricks of the trade to increase your volume or your quality. Regardless of the degree to which you become involved in this type of work, it can be a lucrative and immensely satisfying way to make extra money.

2

Photo-Finishing Techniques

Clearly, one of the main differences between professional and amateur photographers is the quality of the finished products they deliver. Often the creative and technical aspects of photography will be carried out flawlessly but the results are ruined in the final stages of preparation by a photographer who simply doesn't know better. It is unbelievable to see how many top professionals in the field don't know how to do their own spotting or mounting and leave that work to others. Of course, it may be more profitable to leave that end of the business to others, but if you do not know the fundamentals of good print finishing, how will you ever be able to instruct someone else satifactorily?

This chapter deals with quality, then. It will show you how to put the quality touches on a job for repeat sales and profit. People respect a good job and even if the photos you deliver merely fulfill the assignment, if you present them flat and spotted, bound carefully and captioned if necessary, the client will thank you for the effort in more ways than one. For instance, if you are submitting photos to a magazine or newspaper and you don't submit captions and haven't spotted the prints, the editor will be more likely to accept the minimum number of prints than if the work had been submitted with more care. The editor would also be more likely to pay less for that work than for top-quality pictures.

This isn't always the case, however. I can remember seeing the work of a major photographer appearing on five pages in a national magazine where the prints were so dirty that it totally detracted from the images themselves. All you could see was dust spots. I couldn't help but think at the time that the magazine was paying this photographer a lot of money for mediocre images.

Most people are different, however. They

Quality photographs begin by preventing dirt and grit from accumulating in your camera. A frequent check of the film pressure plate is a good idea.

take a great deal of pride in the images they produce and want them to be the best possible. With the mastery of a few easy techniques, you can upgrade the quality (and price) of your finished photographs and increase the feeling of satisfaction you get from producing high-quality pictures.

Prevention

The less time you spend spotting and retouching, the more time you can spend shooting and cultivating new customers. Your time is worth money and you are losing money if you have to spend extra hours spotting a print order.

The more care you take in keeping your equipment clean and dust-free, the less time you will spend spotting. Clean camera backs often and thoroughly with either anti-static brushes or aerosol cans of compressed gas.

A piece of grit or dirt can cause unbelievable problems if it lodges on the flat areas adjacent to your shutter curtain or on your film pressure plate. Film going rapidly past the film guides when dirt is lodged there will be scratched all the way across the emulsion. If lodged on the pressure plate, the dirt will leave a scratch on the base side of the film. Either way, it is a phenomenal nuisance to have to spot scratches the length of the print. Frequent cleaning will certainly help avoid those situations.

If you develop your own film, you have probably encountered dust that has dried on the film surface. This leaves a hailstorm of dust particles to spot on the prints. A way you can avoid dust drying on the film is to dry the film in a dust-free environment like a shower stall. Closets are about the worst spot to dry

Always keep lenses squeaky clean. Use lens tissue and cleaning fluid for best results.

Clean the back of the camera with an anti-static brush or can of aerosol dust remover. Dust the chambers and film guides too while you're at it.

By locking the shutter on "B," carefully examine and clean, if necessary, inside the camera-shutter area. Be careful not to touch the shutter curtain.

film because of all the cloth surfaces that trap dust. You can use film-drying cabinets or bags if you don't have a shower area handy, but you should definitely consider some means of prevention.

If you still get particles of grit drying in the film surface, it may be your water supply. You can clean up that problem by changing over to distilled water for your Photo-Flo rinse and then use a good clean photo sponge for squeegeeing. This will also help you reduce water spots (which, unfortunately, must also be spotted). These sponges must be kept in a sealed plastic bag when not in use to prevent dust from settling in the porous pockets of the sponge. They are available at most photo stores.

If you do your own printing, have the same aerosol cans or anti-static brushes on hand to blow the dust from the negatives before you put them into the enlarger to print. Also keep your enlarger and printing area flawlessly clean and you will help hold the need for spotting down to a minimum.

Spotting

To do your own spotting you will need some fine sable, or combination sable/synthetic spotting brushes. You can get a No. 0, 00 or 000 brush, the No. 000 brush being the finest. In the beginning you will not know which one works best for you, so get a selection. If you tend to get a lot of tiny spots on your prints, get a fine brush. If you need to spot larger areas, you will be using a wider brush. You will also need some cotton gloves to wear when spotting, and the spotting dyes themselves. There are a variety of dyes available, but the popular Spotone dyes work as well as any of them. Marshall also makes some very good dyes. The dyes are approximately the same tone as the enlarging paper; i.e., warm-tone, cold-blue-toned, etc. You should also get one or two retouching pencils, either in their own holders (in this case, you merely buy the lead) or as an ordinary pencil that can be sharpened. You want the softest lead possible so you will be able to

Print spotting is an art that requires patience to perfect. Here is a sample of the type of equipment needed. From left to right, the large clear bottle is print stabilizer for spotting color prints; the dyes and pigments are self explanatory—some are different tones for different paper types; brushes and knives round out the list. Also included is a retoucing pencil and a bottle of opaque for darkening pinholes on negatives.

apply light tone changes to big areas of the print.

For color prints you can buy color dyes which come in the primary colors and are mixed to match the color of the spot, or you can use your black-and-white dyes in a way that will be described a little later. You may also want to get black, gray and white watercolor retouching tubes. They are available from a variety of manufacturers and are great for toning larger areas or difficult-to-spot areas of the print.

You can spot a print with either watercolors or retouching dyes. The dye is more permanent, as it is actually absorbed into the emulsion. To apply the dye or watercolor to the print requires patience and a delicate touch. After dipping the brush in the dye (if using watercolors, squeeze some pigment onto the palette and mix with water to make a fluid), then you begin stroking the tip of the brush on an absorbent pad until the brush is almost dry to the touch. The point of the brush should also be well defined by this stroking

action. Now proceed to spot the area lightly, just barely touching the print with the brush. You will be amazed at how fast the print absorbs the dye. With watercolors, you will notice that the fluid is opaque and so you must match the tone of the surrounding area by combining your other watercolors to get the right tone. With dyes, the dye is absorbed gradually from light to dark so if you have a light spot, it will fill in very quickly. If you have a really light spot, dilute the dye with distilled water (never put water into the dye concentrate; simply dip the brush into the dye and then dip the brush in water and proceed to "dry" the point with a stroking action).

To effectively spot a print you must use what is known as a stippling motion. I always think of dotting an "i" when spotting because it is that type of motion. You barely touch the print surface by just lightly stabbing at the spot with the tip of your brush.

You must spot a print in good light or you will get eyestrain in a matter of a few minutes. Angle the print so there is no glare coming off

It is best to work with only one dye at a time. However, here, two dyes are being mixed to match the tone of a print. Work with the materials far enough away from your hands to avoid spilling.

the print surface. This not only makes it hard to see the dust spots but it adds to the fatigue your eyes will experience.

Be sure not to overdo it with retouching dyes because there is virtually no way to remove them, other than bleaching, once they have set. Watercolor can be diluted with water and removed or thinned, but not so with the dyes.

If you have a large area of spotting to do you will need to perform a "wash," which is a tonal darkening of a larger area. You can do this with dyes or watercolors but you must be very careful to match the fluid tone to the surrounding tones on the print before you begin the wash. This is done by placing your palette next to the print area to be worked on and slowly and gradually building up the right concentration of the dye or watercolor until you have matched the tone. Dilute the dyes by mixing with water. When you think you have got the right mixture to match the print, apply some to a piece of white paper and allow to dry and then compare (dyes will change color slightly when dry). If it is a perfect match, then proceed.

You use a different motion for a wash than for spotting dust spots. You use a swirling

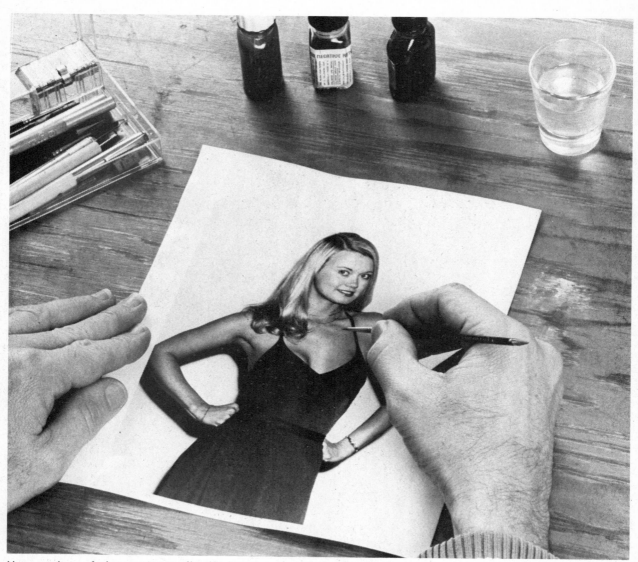

Have a glass of clear water to dip the brush in to dilute the dye. Never go back into the dye until the brush is dry. Not shown is a piece of absorbent paper to shape the brush with and remove excess dye.

Form a sharp point on the tip of the brush by rounding it on a piece of paper. Then apply the dye lightly. Note that print spotter is wearing cotton gloves to protect print surface from smudges and fingerprints.

Here's another angle. Just barely touch the area to be spotted. Several light applications will be all you need for the dye to take.

Your other hand should steady the print while you are spotting. Always steady the print by handling the print borders.

motion with very little dye on the brush. When you put the brush to the print surface, never let it rest; always keep the brush moving. If you stop the motion it will leave a small mark, and you want the tone to be continuous without light or dark areas. Be careful when working on areas that border other tones not to go into the other areas or you will darken those as well. When finished, let dry.

You can also use soft retouching pencils for a wash effect. In some instances, the pencils are much easier to control than the dyes. With a very soft pencil you gradually apply the lead with broad strokes, not using the pencil point, but the flat, dull side of the tip. This will apply an even, uniform layer of tone that can be layered until you achieve the exact tone you want. You cannot get the degree of darkness with the pencils that you can with dyes or watercolors. They are ideal, however, for toning down hot highlights in prints or de-emphasizing tonal mergers.

You must spray the print using a protective print spray after using pencils, because the lead will easily smudge, like charcoal, if not protected. Make sure all your print retouching is completed before you spray the print, however, as the sprays are impenetrable.

Black Spots

Up until now we have been talking about white spots that result from dust at the printing stage. How about black spots that result from dust being on the film before the film is developed. If you do not clean your camera equipment, these black spots will be frequent visitors. Also, certain photographic enlarging papers seem to have these black spots interspersed throughout the emulsion. Often they are not visible but if you have a pure white or light-toned background, they stand out like sore thumbs.

An easy way to get rid of small black spots is to carefully etch them out of the print surface. For this you can use a retoucher's abrading tool, which is a needle-like tool in a pencil-grip holder. You can also use an X-Acto knife handle with the X-Acto blade removed. Replace that blade with a regular razor blade that has been sliced in two, diagonally. The razor blade can be cut with an ordinary scissors and fits nicely into the X-Acto handle (see pg. 155).

If using the abrading tool, delicately peck at the center of the black spot until you begin to see the white of the paper base starting to

show through. You are in effect chipping microscopic particles of emulsion away in order to blend areas of black with areas of white sufficiently to give the appearance that the spot has disappeared. When inspected close-up, you will see that all you have done is to flake away part of the emulsion.

You can either chip a little away so that the spot appears to merge with the background, or chip it all away and then go back later, using retouching pencils or a weak dye solution, and spot the area back down to the right tone.

When using the adapted razor blade, the chipping action is even more delicate than with the abrading tool. Instead of pecking at the spot, you use the tip of the blade to fleck at the black spot. A minute or two of this light flecking action will almost completely remove the spot.

When you have larger black areas that you want removed, you can either go to a white

When spotting light areas like skin tones, work with an almost-dry brush. A "wet" brush is more likely to over-saturate the print with dye and cause more problems than you already have.

opaque watercolor pigment or use a bleach product. The white watercolors are very difficult to match with the paper base but if you have the patience, give it a try.

A bleaching product such as Spotoff (like Spotone) will reduce the black spot to paper-base white, a tone that is difficult to achieve, as mentioned. Spotoff comes with a bleacher and an accelerator. The two are mixed at the prescribed dilution for the type of work you are doing, and applied. Afterward, the print must be thoroughly rewashed and dried. If you don't wash the print sufficiently, a stain from the bleach will reappear at a later date to foil your efforts.

Once the print has dried again, it can be spotted normally to attain the exact, matching shade.

Spotting Color Prints

Color prints, by and large, are not that much more difficult to spot than are black-and-white prints. In fact, for small spots you can even use your black-and-white dyes to blend the spot to the desired intensity of the surrounding areas on the print. A color retoucher might cringe at this, but unless you get right up next to the spot, you can't tell it was spotted with gray dye.

For larger spots, you have a different set of problems and it will be difficult to get away with using conventional black-and-white retouching dyes. You will have to use color retouching pencils, dry color retouching dyes, or fluid color retouching dyes. You have a wide assortment of products available, even watercolors, but you should be well versed in color theory before you get involved with this. All of the products come with sufficient instructions to blend tones of a basic nature, but more complex tones will require a more exacting mixture of dyes.

Retouching

Since negative retouching is a complex venture and a little beyond the scope of this book, it is probably desirable and most profitable for the photographer to send his negative retouching out to a qualified technician. Retouching fees are around $15 per hour but you will pass that cost on to your customer. Besides, a good retoucher can put out quite a few negatives in one hour, making retouching a relatively inexpensive cost.

You cannot retouch small negatives like 35mm. The 120 size film is about the smallest

The blade at right is a special print-retouching tool. It is shown next to a standard X-Acto knife. The blade at right is an X-Acto handle with a dissected razor blade inserted. The razor blade is halved and cut diagonally and is very flexible, almost rubbery, to work with.

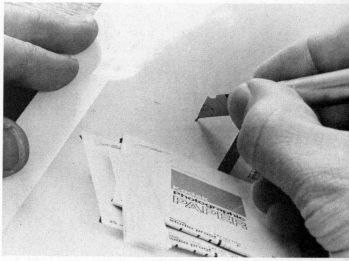

This razor-blade tool is used to fleck away at black spots on the print. This action gently destroys the print emulsion and effectively breaks up the black spot. You could also use bleach and then respot the light area but for small spots this works well.

most retouchers will work on unless the negative has been copied and enlarged.

If you are interested in doing your own negative retouching, or in investigating the field to determine its money-making potential, consult some of the excellent books on retouching, like *Photo Retouching and Restoration,* by Kalton C. Lahue, published by Petersen; or Kitty West's *Modern Retouching* Manual, published by Amphoto. Both are excellent source books and give practical instruction into all phases of negative and print retouching.

Cleaning and Preserving the Print

After much retouching, etching or spotting, the surface of the print will generally look like a mine field. There will be fingerprints, and greasy smudges from the oil in your hands.

You can usually clean the print surface by applying a light coat of alchohol with a cotton ball or Q-tip. A slightly stronger cleaning agent is Bestine, a solvent sold at most artist supply stores. Either of these will clean up most of the grit from the print surface, but often the print will still look like it was worked on. Spraying the print with a protective lacquer is the answer. A lacquer spray will not only hide surface imperfections if applied liberally, but it will also seal and protect any retouching you may have done on the print.

You can get these sprays in a variety of surfaces from matte-surface to glossy to clear (which has no surface-changing effect). You should be advised, however, that when using these sprays, you will slightly dull the range of tones in the print. With color prints you will notice that the colors themselves look just slightly darker. In black-and-white prints, the effect is slightly reduced contrast, a print that is slightly flatter tonally.

Spraying is especially advisable when dry-mounting a print. Burrs in the dry-mount plate and residue from the dry-mount cover sheet can combine to give a glossy print a sloppy appearance. Spraying will not only hide these defects, but it will also hide some of the impressions in the print surface created by a textured mount board. Also, any print that is going to be framed, I like to spray with a matte spray lacquer. It not only spruces up the print surface, but diminishes any potential glare that might be present after the photo is framed and hung.

With non-resin-coated prints, you can clean up the print surface with an ordinary paste wax. Simply buff the print surface with a very

light application of wax and you will remove fingerprints and grit, and give the print a very pleasing glow. Do not use this technique with any of the textured papers.

Mounting and Matting

Most of the time you will not be called on to mount a customer's photographs or to mat them for exhibition, but if you are prepared,

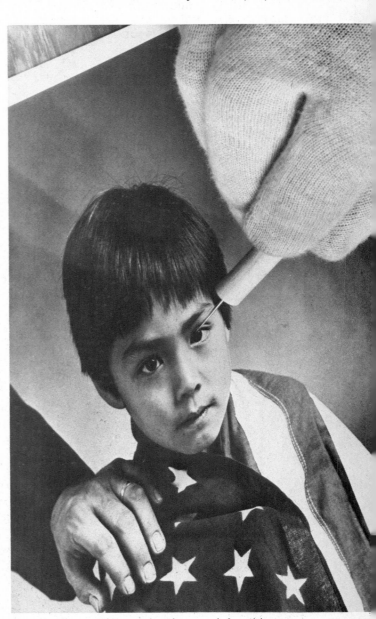

An abrading tool can also be used for this same purpose. This tool is not nearly as flexible but will work well. Here, a catchlight is being "etched" into the print surface.

you can save countless dollars by being able to do these things yourself.

There are many ways to mount photographs, ranging from the various mounting cements made by Eastman Kodak and others, to spray adhesives, to dry mounting. While the other systems work well for smaller prints there is nothing to compare with an expertly dry-mounted print.

To do dry mounting yourself, you will need a tacking iron, cotton gloves, dry-mount tissue, mount board, an accurate paper trimmer and a dry-mount press. It is not always necessary to own the more expensive items like a paper trimmer and press; you can often find do-it-yourself framing stores that will provide the use of the equipment at a nominal hourly rate. Many such places will also offer instruction if necessary.

The dry-mounting procedure is as follows: On a clean surface, set your print down, with the tacking iron plugged in and warmed up. Brush both sides of the print to remove any grit or particles, and then place a sheet of dry-mount tissue over the back side of the print. With the tacking iron, iron the tissue in place, starting several inches in from one corner and finishing in the area of the corner diagonal to it. Next, turn the print around and intersect that line at one of the corners, thus forming a cross on the print back (see photo). This pattern effectively attaches the tissue to the print but leaves the corners free to tack to the mount board.

Trim the borders from the print. Check to see that the trimmed edges are clean and that the print is square. Check to see that the tissue is cut square as well and that none is sticking out from under the print.

Position the trimmed print on the mount board so that it is equidistant from either side of the board but slightly closer to the top of

Anytime you work on the print surface, spray it with a protective lacquer to seal in the retouching.

the board than to the bottom. This is the optical center (slightly higher than true center) and the most pleasing area for a picture to be placed.

With your tacking iron, tack one corner of the print to the board, making sure that the print is perfectly aligned. Without allowing the print to move, tack down a second corner and then a third, leaving one corner unattached. This allows any air or wrinkles in the print sandwich an avenue of escape.

Now you are ready to mount the print. Using a suitable cover sheet (a Seal cover sheet is a durable, nonsticking cover sheet; otherwise, ordinary wax paper is good, although it wrinkles and must be replaced periodically) between the press top and the print, close the press for the prescribed time and at the right temperature for the dry-mount tissue and print base.

Many people say to turn the print upside down on a Formica counter and apply pressure for cooling, but I have always found that if the print is mounted at the proper time and temperature, you won't need to do this. However, at especially humid times of the year, I have found it necessary to raise the mounting temperature and cool the print under pressure for a good seal.

Although there are no set rules for mounting prints, it is normal to mount a print on the next size larger board. For instance, you would mount a 5x7 print on an 8x10-inch board, an 8x10 on an 11x14 board and so on. You could also flush-mount the photograph, which is often time saving. You simply mount the photograph on a board without trimming the print beforehand and then trim the borders off after mounting, leaving you with a full-bleed mount.

Another handsome way of presenting a print is to mat it. A mat is an overlay cut to fit over the print, cut to the exact size as the outer dimensions of the print. You need a special mat cutter like the Dexter Mat Cutter to mat prints because it has a control for varying the bevel angle of the cut.

To use the mat cutter well takes practice. You have to exert quite a bit of pressure on the handle and know exactly when to let up. You must outline the area to be cut in pencil beforehand and using a T-square, cut the mat to the *exact* intersection of the corners. If you go over or under you will have ruined the matting. The blades have to be extremely sharp and must be changed quite regularly.

Dry-mounting a print can make all the difference in good print presentation. Knowing how to do it can be a means to extra money. First you "tack" the dry-mount tissue to the back of the print using a cross-shaped motion.

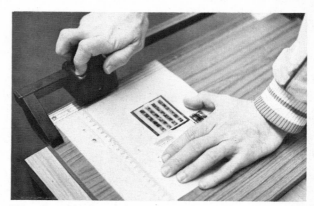

Trim the print borders and excess tissue.

Align the print on the mount board and tack three corners in place, leaving the fourth untacked. Make sure to tack only the tissue area, being careful not to drag the tacking iron onto the mountboard surface.

Once the mat is cut, it can be hinged with tape to the mount board that the photo is attached to or simply placed over the print and framed. If there are any burrs from the cutting they can be filed down with an emery board. Pencil lines can be erased with an art gum eraser. The positioning of the cut should take on the same proportions as in dry mounting. In other words, the print should fall above center on the board, so cut your mat accordingly.

You may find that once you have perfected your matting and mounting techniques, you can offer this service to customers as a service independent of your photographic services. You should be able to make a substantial profit on your matting and mounting service and if you add framing to the list, you can make still more.

Although you will be competing with framing stores for your matting services, many framing stores do not offer dry-mount services. Also, since you know photography, you can tell customers that you will treat their photos correctly.

In addition, you can offer your mounting services to customers who want a picture you've done to frame and hang on the wall. Offer the service as part of the total package. Tell them that if they want to frame the print, they should tie the picture to their home or office decor by choosing the proper colored mount board and mounting, which you can

supply. With enough prints, you can double the price of an order.

Currently, the going rate for dry-mounting is around $3 to $4 for a print under 16x20 inches. The larger prints are, of course, more. Matting services are about a dollar more. Once you have the techniques down, you will find that there isn't a great deal of work or cost involved in mounting or matting, and it is an aspect of your photographic services that will add greatly to your overall flexibility and profit-making ability.

Mailing and Packaging Photographs

Photos that are sent through the mails should be well protected from the perils of the postal system. Prints should be held between two pieces of cardboard a size larger than the prints with rubber bands. The package should be labeled clearly and stamped plainly, "Photos—Do Not Bend." You should also signify whether you are going to send the pictures first class or second class, etc. Generally, you will want the package to get there quickly so you will send it first class or parcel post. Both of these systems will get the package there in a minimum of time. If you are in a real hurry for the material to get there, send it express mail. It is expensive, but the post office guarantees next-day delivery.

If the material warrants captions, include them either on a separate sheet or attached to each individual photograph (see pg. 76).

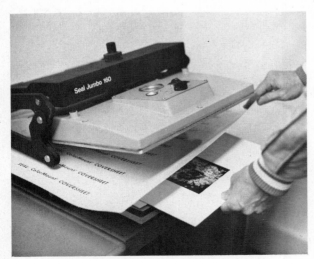

Insert the print/mountboard sandwich into a dry-mount press set for the prescribed temperature. Be sure to use a cover sheet to protect the print from abrasions in the mount plate.

Mount for the desired time and remove the print; allow it to cool according to recommendations.

On the back of each photograph should be your legend, "PHOTO BY HORACE SCHMUDLAPP," and if you are worried about unauthorized reproduction, include a stamp, "UNAUTHORIZED REPRODUCTION IS PROHIBITED." Also, your current address and phone number should appear back there as well. Rubber stamps for all of the above are cheap enough and save you the time of writing out each item. If you do write on the backs of prints, do not use felt tip pens, because the ink will bleed through the paper to the print.

If submitting slides, submit them in plastic pages and number the slides. I have a tiny rubber stamp with my legend, address and phone number and it fits down one side of a cardboard slide mount. It saves a lot of time. You can also get the tiny mailing labels; these also fit on one side of a 2x2 slide mount. Each slide should be numbered in pencil to correspond to a caption or ID sheet. This sheet should have either thumbnail captions or simply an identifying tag.

Never, ever, send glass slide mounts through the mail. They always seem to break and when they do, look out because they are not only dangerous to the person who will open the package, but glass particles will become embedded in your slides.

If submitting material to a publication on spec, always include return postage and a return mailer. I once sent 25 prints to a sporting magazine who would not return the unused material until I sent them return postage. Although this is an example of the extreme, it can and will happen, so include return postage and skip the problems.

If the material is valuable, like original transparencies, insure them for more than you believe they're worth.

If you go to all the trouble of making your photos the best they can possibly be, then go the extra yard and package them and insure them so that they arrive in the same top-notch condition in which you sent them.

Many of the techniques and practices outlined in this chapter may seem unnecessary to you at this point in your photo-business career, but as time goes on you will begin to see that the more details you can control regarding your work, the happier you will be and the happier your clients will be—and that happiness will manifest itself in the form of increased profits.

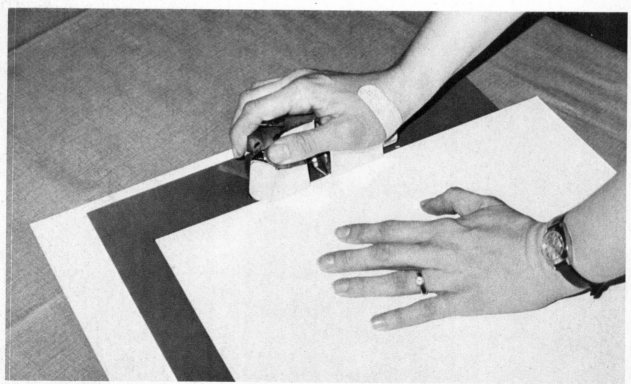

Dexter Mat Cutter in use. (Band-Aid is not from using mat cutter.)